PHOTOGRAPHY

FOR THE

PROFESSIONALS

by Robin Perry

LIVINGSTON PRESS WATERFORD, CONN. 06385

Visual Studies Workshop
Research Center
Rochester, N.Y.

Printed in the United States of America
by LIVINGSTON PRESS
Waterford, Conn. 06385

Library of Congress Number: LC-75–31045 2·28-77
ISBN: 0–915772–02–7

SECOND PRINTING, JANUARY 1977

Book Design by LIBRA Graphics, Inc.

OTHER BOOKS BY THE AUTHOR

Welcome for a Hero
The Trials Motorcyclist
Creative Color Photography
The Road Rider
The Woods Rider

Acknowledgements

Where does a book start? In this case, Photography for the Professionals started at the request of Dexter Press. I had written many columns or articles for them over the last ten years. I owe a great deal to Dexter for their help and encouragement through the years. Many friends in the Mandalas have also expressed a wish to have book of reference, essays or articles in chapter form that would act as a guide to the business of being a professional photographer. The Mandalas are the hundreds of photographers who have attended my Creative Color Seminars. A special thanks goes to Fred Spira of Spiratone who also encouraged me in the production of this book. And, of course, I can never forget Ken Lieberman who had much faith in me long before others. In many ways it was through Ken at Berkey K+L Custom Labs that I got my start. Also to Pat Liebig, my friendly advisor and reader.

I dedicate this book to my heirs — all the young professionals — who choose photography as their life work; as a way in which to earn their living; who love the art of photography as well and cast their lives, their soul, and perhaps their creative juices to the ever elusive quest for perfect photographs.

Contents

PREFACE: The Professional Photographer 11

1 Who Can Be a Photographer 15

2 Getting a Job in Photography 20

3 The Photographer's Portfolio 25

4 The Business Side of Photography 33

5 Selling without an Assignment 41

6 Pricing your Photographic Work 49

7 What Rights Do You Sell? 55

8 Submission Orders 61

9 Advertising & Promotion 68

10 Self Improvement through Reading 76

11 Mind Set or Concentration 83

12 Technician or Photographer 89

13 Photographer and the Art Director 95

14 The Photographer As a Writer 103

15 The Photographer As a Contractor 110

CONTENTS

16 Organizations, Exhibitions & Awards 118

17 Choosing a Camera System 126

18 Cameras: Buying, Selling & Servicing 132

19 Lenses: Wide, Normal & Telephoto 138

20 Fine Tuning with Filters 147

21 Special Effects Attachments 156

22 Flare & Reflections 163

23 Compressing the Contrast Ratio 170

24 Copying & Duplicating Techniques 176

25 Tricks, Props & Style 184

26 Meters & Metering Techniques 191

27 The Tricolor Temperature Meter 198

28 Something about Light 205

29 More about Light 212

30 The Case for the 8 × 10 Camera 219

31 Models & Fashion Photography 227

32 Small Product Photography 235

33 Annual Report Photography 244

34 Industrial Photography 251

35 Illustration Photography 259

36 Aerial Photography for Profit 267

37 Processing Color Films 274

38 Special Film Processing Techniques: 282

39 Color Printing Techniques Basic 288

40 Color Printing Techniques; Advanced 298

41 Color Printing Techniques on Films 306

42 End Papers ... 315

Appendix I The Commercial Price List 321
Appendix II The Day Rate Price List 323
Appendix III The Portrait Price List 325

The Professional Photographer

Photography started for me in 1933 or '34, I really can't remember the exact date. I was a Boy Scout in a New York church troop and although I eventually became an Eagle Scout and a Scoutmaster of many troops over the years, I must have been a Second Class scout at the time. I remember my Scoutmaster, a Mr. Berry, asked me to help him develop a roll of film in the Troop meeting place in the basement of the Church house.

I remember we had a little red light giving a soft quiet glow to our magic. And magic it was in those days. Consider that many professionals still used glass plates; the roll film was quite new and the Super Sensitive Verichrome was one of the latest

11

films. The news photographers carried 4 × 5 Speed Graphics and used the new foil-filled glass flashbulb for light.

The Verichrome film was unrolled in the dark and I was taught how to hold it against the curl and move my hands up and down with the film sliding in and out of the tray of developer, wetting it evenly. Mr. Berry showed me how to move the film to the short stop and then the fixer. When the lights were finally turned on and I saw the negative image, I was thrilled.

We contact printed the negatives in a print frame using Velox Contact paper. These were individually developed in the same MQ developer that we used for the negatives. The excitement of seeing the print image appear in the developer hasn't left me to this day, some forty years later. I still get the same thrill with black and white or color. Since that day in '33, thousands upon thousands of prints have been made by me. God willing, I shall have the pleasure of making thousands more before I die.

Many changes and refinements have been made since those days so long ago. This book is the story of some of those changes, but more important, it is the story for the people, the young men and women who love photography and have made it their life work.

When I first sat down to start this book, I wasn't sure just how it should be structured. I knew that in thirty-five years of professional photography, I had gained an enormous amount of miscellaneous knowledge. Knowledge, that in some cases, simply wasn't available to a student photographer. How to impart a lifetime of one of the most fascinating careers on earth to the neophyte, the amateur and the professional?

I decided that what I wanted to write about was my lifelong love affair with photography. I wanted to write about a professional life; I wanted to show the joys and the sorrows, the fun and the love, and the pitfalls and the rewards. I wanted to teach; I wanted to tell everyone who would read this book, everything I could about professional photography. I wanted it to be a reference book; a must for anyone who wants to enter the profession; a book of essays; a book of knowledge; a book so important that no photographer, amateur or professional would want to be without it. It would become a guide; a light at the end of a tunnel; a gentle push to those who find the complete joy of photography, a joy I never tire of.

There is no simplistic series of continuity in this book. You can pick it up and start reading at the beginning of any chapter that interests you, wherever your interest is caught. There aren't any photographs in this book as you have discovered. My purpose is to keep the attention on concepts rather than dilute the book with photographs that would only be an ego trip for me. This forces the reader to read and the writer to communicate with words. As a small child is thought to have said to her art teacher when asked what her painting meant she replied: "It's a picture to look at, it doesn't tell a story." My pictures are to look at.

The scope or theme? There really isn't any. An anthology, no. A compendium of photography perhaps? No, what it is, is a series of professional how-to articles for the professional photographer tied together in the common bond of photography. It is photography as I know it. You will find that many of the essays pertain to the business side of photography. This is desired by me. I have always related my

worth or rather the worth of my photographs to the price they bring in the market place. I am very fortunate that almost all of my personal photography, that photography done for my own pleasure, is now salable. So I am both an avid amateur and an accomplished professional. My hobby and my business are so entwined that I am no longer able to determine where one begins and the other ends. This is a philosophy and a way of life. So these essays are important to me, the aesthetic or philosophical and the pure how-to. I mean no pretentiousness or arrogance. I cast no aspersions on anyone else's philosophies. This is simply photography as I see it.

It is my hope that this book will serve as a guide to all who are interested in photography from the student to the professional be he amateur, a Sunday snapshooter, or a professional.

1 Who Can Be a Photographer

Almost anyone, but not everyone, can be a professional. Anyone can learn the mechanical functions of photography and almost anyone can learn the techniques of photography, but the professional photographer needs other skills in order to survive. The list reads like the duties of a housewife:

First and foremost a professional must be a businessman. Next, he (or she) must be an artist, a psychologist, an economist, a writer, a carpenter, an electrician, a painter, a plumber and so on. You might wonder why I list so many disparate crafts. Think of it this way; a professional photographer has to do many things that have nothing at all to do with photography. He must be somewhat of an extrovert,

gregarious and outgoing, firm but not pushy. Some people can't be professionals in the sense of having a studio and doing portraits or wedding or commercial photography because they are shy or introverted. A photographer must sell his wares; any professional has to be a salesperson. Even the freelancer must make a pitch to the agency art director. Surprisingly, many a sale is made, not on the basis of the quality of the photograph so much as the sales ability of the photographer. One can't just shyly, modestly stand on one foot and hope that the content of the photograph is going to sell without any push from the photographer.

A quick logical mind is one of the hallmarks of the successful photographer. Without one, the neophyte would find difficulty in inspiring the confidence of the art director or client. Today, photography demands so much more than just the ability to perform the photographic functions technically.

The portrait is more than just a true likeness, it is an incisive, intellectual statement of the sitter's character. In order to "see" this character, the photographer must be somewhat of a psychologist, a sociologist, a student of human behavior as well as a superb photographic technician. True, many photographers who call themselves portrait photographers are reasonably successful, but they are not the greats. Instead they supply the need for "likenesses."

A photographer specializing in children had better have a deep and all consuming love for children if he hopes to be successful. More important, he needs to know a great deal about children's reactions. Children are far more disparate than adults

in their responses to the camera and the photographer.

I would not hesitate a moment to take adult portraits in low light levels where a measure of "posing" is necessary. With very young children or babies, where the cooperation of the sitter is necessary for the success of the photograph, I would perhaps use strobe or some other way of "freezing" the image. This is not to say that I can't take some very attractive photographs of babies with existing light. I have done so.

Amusing children for "expression" with toys, whistles, clickers and other such paraphernalia is a way of life to many a child photographer, and some rather astonishing expressions have resulted, but I still consider baby photography documentary at this stage.

The commercial photographer has more problems. He has to find the best way to light a product or the best angle for a building. At first glance you would think commercial photography to have less of a requirement for the "intellectual statement." Not so. The statement must be made and is far more difficult to find. Mechanistic lighting, lit according to school diagrams, forget the fact that all products do have a personality of their own. The true greats in commercial photography have found the way to portray emotion in the photograph of a product. The selection of angle; the selection of lens; the selection of film; the selection of type of light; the selection of the direction of the light, all of these contribute enormously to the total effect visible in the final print or transparency.

Add to the product the requirements for a live

model and the problem is compounded ten-fold. Not only must the mystique of the photograph show the product in its best "light," but the model, she or he, must be of portrait quality and even beyond since the two, the product and the model, must be blended in a harmonious arrangement. Where one type of lighting might be best for the product, it might be disastrous to the model. The photographer must have additional skills in this example.

The Advertising Illustrator-Photographer must have still more skills. In some cases he might be required to build a set or locale, select props, color of walls, or types of cloths for the models. This requires taste, and the ability to style, and knowledge of artistic composition, to say nothing of the multiplicity of technical problems. All of this must be in consonance with the art director's concept. The concept in turn, is a complement to the copy and this again must be responsive to the client's marketing needs. The photographer has total responsibility to marry all these components into a homogeneous photograph. No wonder that there is always room for a good photographic advertising illustrator.

All of the above considerations place intellectual requirements on the ability of the photographer, requirements that almost cannot be taught in photographic schools. Some of the skills such as taste, style, artistic composition, ability to work with models, the perception to previsualize, are not available in courses, or if they are, one would have to attend many schools and in varied subjects.

Photography is a living, growing craft and the basic techniques can be learned quickly, but the finesse is in the intellect of the photographer. As he grows emotionally and intellectually, so does his

photography. The youngest of photographers, like the young in other professions have narrow and confined abilities. Until his life experiences meet with his photographic expertise, coalesce, and become one philosophy, he will remain a neophyte.

Add to the above the intricasies of operating as the executive officer of a small business with the multiple skills that any other business would hire in separate people, and you may wonder how photographers exist financially. The specialists in business: the accountant, the sales manager, the production manager to name just a few, are the alter egos of the photographer-businessman.

It is incumbent on the student photographer to acquire quickly, a working knowledge of those business skills that are necessary to his career. Make no mistake, without this knowledge the chances of success are diminished.

2 Getting a Job in Photography

Far and away the best way to break into photography is as an assistant to a photographer who has a studio that is well known. Preferably, the photographer would be a photographic illustrator as opposed to a food specialist or fashion photographer unless either of these specialties interest the student applicant. The illustrator has the advantage of a wider range of assignments generating a need for expertise in many fields. You would find that he does some catalogue, some food, some fashion, some magazine illustration, some of everything.

If your interest lies in journalism, then you must apply to newspapers. Most newspaper photographers are itinerant, changing jobs every year or so, so an

opportunity exists. Furthermore, small town newspapers offer more of a variety of assignments. They also use more photographs per photographer than the big city journals. The pay isn't as good but it is adequate for the type of photographer that applies.

Journalistic photography is a discipline in itself as well as a training ground for the illustrator. Almost all newspaper photography is done with the 35mm camera with the photographer acting as his own processor and printer. The National Press Photographer's Association holds monthly contests and the results are widely published. Winners become known to other newspapers making it easy to "step-up" to a better paying job or bigger newpaper. I put the step-up in quotes, because it is well known that there are certain small town newspapers where the use of the photographer is far more rewarding than being buried in the big city news desk. One can go to assignment after assignment and not see a photograph published. This can be frustrating.

Getting a job as staff photographer of a national magazine is an impossibility for the new professional. The pay is of the best, but the demands are stringent. Most are graduates of the newspaper field who have moved on up. This doesn't preclude the fact that the same magazines will use you on a freelance basis. Especially if you are in East Jebru and they don't have a stringer in the area. If you are settling in an out of the way place, by all means contact the magazines and the Associated Press and the United Press International. They are always looking for competent stringers who can cover a story quickly.

Getting a job with the local photographic studio is another avenue open to the just graduated pho-

tographer. The pay is slight but then it is a job in
your chosen field. You may wind up as a processor
or printer, but you can usually work yourself out of
the darkroom. The dangers are that you will get into
a photographic rut where the studio is doing one type
of work over and over again. So you don't gain as
much as you'd like in the way of experience. Some
small towns have some really sophisticated studios
covering a broad spectrum of photographic services,
so it isn't all bad. Beware of photographic organiza-
tions with a high volume in one type of photography.
They are usually dead end streets.

The large processing laboratories are advanta-
geous. Some of them process dye transfer prints,
perform duplicating functions, make strip films, and
many other exotic types of photography. The chance
to learn is worth the job. True, your function would
be routine or monotonous, but you could move around
within the plant.

A profession that has come a long way in recent
times is the industrial or in-plant photographer. I
can remember the time when only the largest of cor-
porations had a photographic department and even
they were the step-child of some other department.
All that has changed. Today almost every corporation
has found the need for even a rudimentary depart-
ment. The quality of the work performed is excellent
although it is usually somewhat structured and more
literal compared to the illustrator. Here, the need is
for technical excellence, knowledge of view camera
techniques and sometimes macro-photography. They
perform all sorts of functions from the engineering
drawing to the illustrations for the annual report.
Most of these departments function as small busi-
nesses within the corporate structure, the require-

ment to operate at a profit being a consideration. The graduate of the photographic school would do well to apply here; personnel departments are used to interviewing applicants with a college degree, though this shouldn't stop you.

Teaching is another photographic profession. The basic requirement would be at least a Bachelor's in Fine Arts, preferably a Master's. If you find that colleges and universities are crowded, try some of the private schools and also specialized schools such as art and photography seats of learning. Right now there are openings in the newer types of community colleges. The courses are usually funded out of either the National Endowment for the Arts or other such organizations on a state level.

One last item; if you apply for a job with a well known photographer don't ask for much money. Most of us feel that we are educating you at our expense. You won't get the job if you do. The competition is too great. There might be about 200 photographers whose names are known to you. The names are also known to each of the other 100,000 student or indigenous photographers in the United States. As an example, I regularly receive letters from European photographers asking for a job. Around March each year my mail is flooded with letters from June graduates, all looking for work. Those with salary demands are discarded, those that appreciate that working for me is a continuation of their education get consideration if I have an opening.

Wherever you land, you should strive to learn all you can and if and when you feel you have learned all there is to know there, move, and move quickly. If you don't you might very well become acclimated, start to settle down and your photographic education

will stall. On the other hand if you find the thing you want to do, there is no reason to continue the search — obviously.

The job market for photographers is always crowded and always will be in good times or bad. But those with the perseverance and those with the determination will succeed.

Be careful in what you say when being interviewed. You may find that you are more knowledgeable than the photographer you are to work for. If he feels threatened by you, he won't hire you. This piece of advice applies to any application for a job in any of the above suggested types of photographic establishments.

If you try everything everywhere and find that you cannot find any kind of a job, may I suggest that you work for yourself? (See chapters on Speculation.)

3 The Photographer's Portfolio

Every transaction between the seller and the buyer has the element of establishing credibility in the mind of the buyer. Where a product is involved, the buyer has the option of examining it and can make a determination as to whether or not he wishes to purchase it. Where a service is involved, the matter becomes somewhat complicated. There is an increased responsibility on the part of the seller to convince the buyer of his ability and facilities to perform as he says he can. Any smart selling person recognizes that the shortest distance to the buyer's billfold is through the ability of the seller to convince or "sell" the buyer.

The photographer is no exception to this transac-

tion. In fact, he has many more problems convincing buyers than many other purveyors of services; he can't show his product as an example, he can only show something *similar* to what the buyer needs or wants. He can't *prove* that he is better able to perform than the next person; he can't show *exactly* what a photograph is going to look like before it is taken. So there are many vague areas that are implied in the agreement between the seller and the buyer.

Most sellers of services, and in this case, photographers, use some sort of selling device to bridge the credibility gap. All too few give it the attention it deserves, especially so when you consider that it is the key to the sale. What form the device takes depends on many considerations; the distance between the buyer and the seller is one criteria I use. If I feel that I want to sell someone that is unavailable for direct contact, I use either a poster in color or a multi-photograph brochure, all via direct mail. If the distance is such that I feel I'd like to make a direct contact, then I prepare a portfolio.

Call it what you will, it is still a sales book, a brochure, a collection of samples made up with the idea of impressing the recipient with your capabilities. The form that the portfolio takes should be flexible. This is why most photographers don't use the scrapbook type of presentation. One should be able to slip samples in and out; you need to tailor-make the portfolio to suit the type of client who is to see it. For example, were you to call on motels and restaurants with the idea of selling color postcards or brochures, you would fill it with samples of that type. It would be ludicrous to show samples of fashion

photography in black and white no matter how good they are. Your prospective buyer *needs to know* what you can do, how well you can do it and what equipment and facilities you have to do it with. He is not interested in your fashion shots no matter how excellent. On the other hand, an art director at an agency or magazine would be turned off by color postcards and brochures, with the possible exception of a brochure of your studio or samples of your work. He is interested in your ability to perform for him and he wants to see demonstrated assignment capability. He also needs to see samples of your work that are close to the type of thing that he or his agency does for their clients.

Many young photographers come to see me and show me their portfolios, why, I don't know; perhaps they get a kick out of having an established photographer look at their work. But for whatever reason, I have stopped looking at them. Most of them show school photographs obviously taken under the watchful eye of the instructor and are usually super slick in color and beautifully mounted and matted. They are just as obviously unable to do the same work for a client. I discover this when I question technique shown in the samples.

For the young photographer just starting out, he doesn't have much of a choice. He must fill his portfolio with work that he has already produced, regardless of whether it is black and white or color; regardless of the pertinence to the viewer and regardless of the need for a more sophisticated portfolio. It is better to be honest with the art director, show exactly what you can do and without any attempt at puffery. If he thinks you have a talent that he can develop he

will see it. Many an art director is responsible for the success of a photographer; it pays to pay attention to what they say.

For the studio photographer; he needs to show that he has a studio, how big it is, what facilities he has, and some samples of the work. Many art directors like to see color processing facilities, especially when the photographer is located in the country. They are always in a hurry and the ability to follow a shooting with immediate processing is a distinct advantage. Some photographers have large format cameras and lenses; almost a must for certain types of studio setups. These must be shown.

Other facilities such as equipment trucks or vans, aerial ladders, or access to a "cherry picker" or having your own aircraft for aerial photographs, are types of unique capability that impress art directors, and should be shown in your Sales Brochure.

Each photographer who specializes tries to put his best foot forward by featuring the uniqueness of a special piece of equipment or capability, so show them in use.

The *Stock Photographer* shows his slides and slide files with sorting tables, slide mounting, copying and mailing facilities.

The *Magazine Illustrator* is trying for the top bucks so he has some very fine illustrations that show imagination with a high degree of competence and an understanding of magazine illustration style. His equipment is secondary.

The *Journalist* must show stories that he has produced. Preferably, published; yet the neophyte can assign himself and produce a hypothetical story to show his ability.

The *Sports specialist* must show some of the events he has covered and the sequential photographs he has taken. As to equipment, he might show his cameras and lenses, especially the telephotos and the extreme wide angles. The motor driven sequences are always an attention getter.

Tear sheets from previous ads of editorial illustrations are a must. Shots showing photographs taken with live models are most important. Working with live models is far and away the most difficult of all photographic assignments. For your sake I pray they are competent. Please don't show some trite photograph of a young woman standing by the office copier with a spread of papers in one hand and the other on her hip or lovingly caressing the copier.

Large format photography in the form of 8 × 10 transparencies are the mark of the highest type of technical photographers. The photography of food and other still lifes require the most in both equipment and facilities, not to speak of the capability of the photographer. Showing 8 × 10s in a portfolio is sure to win the approval of the art director or advertising manager. For awhile, I worked on the Smirnoff account and most everything was shot on 8 × 10s; those photographs are still working for me. The transparencies are seconds but near enough to look well.

The prestige of some of the accounts you have worked on is most important. Show tear sheets and if they have appeared in national magazines, strip off the mast head of the issue and dry mount it across your ad or illustration. If your photograph is better than the company or the placement, then show the photograph alone. Showing photographs done for well known corporations or agencies tells the pro-

spective client that others have found you capable. But be very careful of "dated" tear sheets or photographs. I have had to change my portfolio many times because the model's clothes gave the date away. Curiously, I am now in the process of returning really out-dated tear sheets to the portfolio simply because of the nostalgia craze. Real magazine illustrations have a timeless quality; those remain in the portfolio.

Quantity is related to Quality. Never forget that: 'tis better to have a few very good-to-excellent samples than to have a large quantity of mixed poor-to-good. Sometimes you're not the best judge of what's good and what's bad, so try to have help in deciding; try an art director at a good agency.

Arty photographs really don't have a place in your portfolio. They may turn on some people, but by and large your art director is going to think of these typed photographs as a cop out, meaning you can't do assignments. Remember, he is paid a fine salary to hire the best he can for the money he has. If you fail him, you lose a job, but he might lose his job for good. In general, art directors pick their photographers by demonstrated ability shown on previous assignments. I know, how can you get a job if they don't give you a chance? and you can't show samples unless they give you a job? Not so!

When I wanted to break into a certain magazine, I bought three consecutive issues. I picked out one or two stories in each and actually went to the expense of making photographs exactly as if I had the jobs. When I finished the six assignments, I asked for an interview. At the interview I showed the six articles and my ideas for the illustrations to accompany them. Since the art director interviewing

me was being shown his own magazine and had picked the photographer for the illustrations, he gave me about an hour and then took me to lunch; all the while discussing the feelings he liked or didn't like about my work. But because I had aimed my work directly at him and his magazine, he gave me my first big national assignment. One led to another and the rest is history.

The above method will always work. I really don't think that there is an account or an agency or a magazine that a good photographer can't break into with a good portfolio and samples aimed directly at the account or magazine article. There is always room for good photographers and they all start somewhere as beginners.

Take a good long hard look at what you call your portfolio. Are the samples fresh? Are the acetates clean and not scratched? Is there a good mix to your work? Is there something there with live models? Do you have to apologize for the condition of your slides? Do you put your best foot forward or are you making a half-hearted attempt?

On the positive side, the portfolio should have about twenty to thirty photographic prints; certainly not more. The range and style of your work can be shown in that number. Often photographers try to overwhelm ad managers or art directors with a gaggle of miscellaneous prints, good and bad; sort of a "shotgun" approach—scatter enough shots and maybe something will hit. This will not work. Twenty and thirty good ones showing a variety of technique and style will do. This same number should be mixed, black and white and color. The prints themselves should be flawless, needing no apology. There should be no specks or flecks, marks or blemishes of any

kind. The theory being that if you don't think enough of your own work to present clean prints how can you be expected to respond to the client in a like manner.

If you show slides in trays once again present a small highly selected group of about forty. Make sure the slides are in order and have some sort of cohesiveness if not continuity to the presentation.

Tear sheets are another matter. If you show them, the best way to present them is to have them placed in plastic laminations. Once wrinkled they look worse than old prints. Be sure to order the lightest lamination you can get. Fifty $8\frac{1}{2} \times 11$ in the heavy laminates are weighty.

Don't mount your prints. Matte boards are heavy and difficult to manage—the sign of the amateur.

Practice your presentation pitch on your wife or office help. See if you can cover the salient points in ten minutes or less. Art directors are very busy people and they will appreciate your concern for their time.

4 The Business Side of Photography

By now everyone has heard that photographers are poor business people. Many photographers think this is a badge of honor and they modestly admit to their lack of business acumen trying to project the impression that to be good at the business side of photography is to be a poor photographic artist and vice versa. This lack of concern with the economics of their chosen profession is nothing short of disastrous.

Beyond the constant discussion of pricing and price lists, few beginning photographers give anywhere near enough attention to setting up a business procedure and adhering to it. The studio photographers do fall into some sort of understanding of

their problems and this isn't due to their efforts as much as an ever-loving wife or secretary-receptionist. The freelancer just goes from bill to check and back again, hoping that at the end of the year he has a profit.

So many think that profit is another job. Well, it may be, but much real profit can be derived from other sources. One in particular is the matter of the purchase of equipment. Otherwise reasonable people seem to leave their senses when it comes to the purchase of new equipment. I have listened to some of the most outrageous rationalization and justifications as to why someone should sell his reasonably new SLR and buy a Stranisflex Special. Such rationalizations have no basis in good business practices. I suppose this comes about because photography is a fascinating hobby for most photographers and every new shiny toy is desirable.

Who was it that said: "The difference between men and boys is the price of their toys?" Some of todays "toys" are quite expensive and mistakes here are quite costly. (See chapter 17 on Camera systems) But it's not the scope of this chapter to go into the cost of equipment so much as to determine by discussion with the reader, money problems that touch on pricing, billing and collecting. Perhaps more important is *who* do you do business with? It takes awhile before a photographer gets burned working for some *types* of clients and he learns who not to do business with.

Kodak puts out a sophisticated booklet on the Basic Principles of Business Management with guidelines on how to control costs etc. What I am interested in here is a discussion of the types of business clients and the relationships with them.

The freelancer and the studio commercial photographer soon learn that some clients are poor payers; one of the worst is the advertising agency. Their problem is that they have to complete a job before they can bill the client. Sometimes this is months from the time the original photography is taken. This means the agency has to invest capital in photography, typography and printing before they get their money, so they are always behind in paying their bills. Some art directors will have the gall to tell you that they aren't paying you until they see some client money. This means you are investing in the client too. My point is that since you aren't sharing in the agency profits, why should you share in their money problems? I tell the art director just that. But much of the problem can be eliminated by carefully outlining your terms when discussing the job. So many photographers think that to talk about money is a sin! Are you aware that when you wait ninety days for your money you are allowing the agency to use that money at a cost of at least eight per cent? This is another reason why I insist on a purchase order and I spell out all the problems that I can foresee. I flat out won't wait for money longer than the usual thirty day wait. I tell clients that too. They will understand so long as the arrangements are made beforehand.

In the purchase order, I spell out the price of mileage and the cost of film and processing if that enters into it. Since I process my own, I charge for it separately. Who pays for the models? And how much? What are the charges for a cancellation? Most model agencies charge for cancellations so make sure your purchase order covers that. If you use the Day Rate as I do, make sure the time of day is spelled out.

Some art directors think that the day starts when you show up, preferably dawn, and ends at sunset. I charge half time for long distance travel, plus expenses of travel, and mileage when the job is close by. I spell out the day as any eight hour continuous period. I can lengthen that if I wish, but for the record I make sure it's spelled out on the Day Rate. (see sample Day Rate in appendix II).

Never charge a half day rate unless you ruin part of the day, but make sure it's your fault. The sun going in is not your fault.

Sometimes the art director at the agency wants to "see you about the job." Determine who is to pay for that time. If you are a freelancer with no studio base, you might be expected to go to the art director for that consultation without a fee. If you are young and new and this is a new account, yes, go for nothing. Should you own a studio with even one employee you can't leave without fee because you are carrying the overhead with you. These decisions are delicate since you don't want to offend the art director. Yet you can't afford to run around at his beck and call. Careful analysis is required. Are you doing other work with this agency? Have you been connected with them a long time? Have they been fair in the past? These are questions that only you can answer.

Supposing the client is the corporation's ad manager or the marketing manager bypassing the agency; what do you do about the price? How do you deal with this situation?

I find that more and more, the corporation people are becoming knowledgeable in their dealing with photographers. The modern marketing manager is well aware of what to pay and how to do business

with you. I find they pay more promptly too. As to price I give them the same price list as I would an agency. I charge what my work is worth. I realize that once I work directly for the company, the agency most likely won't have anything to do with me. So when I am called or I solicit them, I have already made the determination as to what to do.

If I have the account through the agency, and I am called by the client direct, I suggest that since I work for the agency would he mind if I coordinate with the art director? If there is a negative reply, I'm in a box. Right here, I would accept the job, try not to quote and call my art director and tell him what happened. If the answer is to coordinate with him, then there is no problem.

View camera work in the studio or on location is charged for by the individual photograph (see chapter 6 on pricing). The price of the photograph either includes all costs (what the traffic will bear) or a flat price. Should you be doing a catalogue for the agency I suggest the per photograph and per hour price list (see appendix II).

Doing business with the client directly sometimes means that he will order photography without a clear idea of exactly what his needs are. Rarely is the agency ordering any photography not planned and fitted to either an ad, brochure or catalogue. So question the ad or marketing manager. Without a layout you're working blind. This is a most dangerous situation that often leads to do-overs. Do-overs are a dreaded photographic disease. They're bad enough when the fault is yours, but when the fault lies with the client you must charge them. The present custom for a do-over having no relation to an error on the part

of the photographer is 50% of the original price plus full fee on expenses. This should be spelled out on both of your price lists. (see appendix II).

I mentioned earlier that you must work from a purchase order. Some photographers work this way and accept the purchase order with a letter written on the back of the Day Rate or Advertising Illustration Price List, and note that the reverse side is a part and condition of his acceptance. This binds the price list as a condition of the purchase order.

For advertising agencies and clients, these problems are fairly well handled with the procedure above. There are some art directors who make an error from time to time and obligate the agency in their mistake. I have done a job over again without fee to pull an art director out, hoping that he will show his appreciation with additional work. Since you are the owner of your own business, you can make adjustments from time to time to suit the situation.

Dealing with record companies, greeting card, calendars, and other publishers, I find I need the same purchase order agreement except that I try to find out if they have a credit rating. Twice I have had to swallow posters because the company went out of business. Since I work on speculation in this area as well as by assignment, I wasn't hurt with expenses, but I recommend a Dun & Bradstreet Rating or a credit bureau rating from their locality.

Publishers are usually slow but good. I am most fortunate here since all the publishers I have done business with have paid promptly. Corporation clients pay the best and almost always work by purchase order. Still, I try to check them out if I haven't heard of them.

I use the Standard Rate & Data Red books: Standard Directory of Advertising Agencies and the Standard Directory of Advertisers has a wealth of information relative to both the advertising agency and the corporation client. In my case, if they're not in these books, they're really small and I watch my step.

These books give you the names of all the art directors at each agency with names and addresses and telephone numbers. The same with the Advertiser's book; they contain the names of the advertising manager or the marketing manager as well as every other executive officer. They even spell out how much the ad budget is and how much goes to what media. Subscriptions to these books are a must for the studio Advertising Illustrator.

The same company puts out another book that identifies every magazine besides the names, addresses and phone numbers. They also show the circulation and advertising rates. It's called "Consumer Magazine and Farm publication." This too is used to make a mailing list for solicitation. I get this free from a friendly advertising agency or buy a single copy direct from the publisher.

Easily the biggest problem is the result of a lack of communication. That word has been bandied about so much that it has lost its emphasis. As a photographer, try to anticipate that you know your business but the client might not understand. When in doubt, call, write or speak about money or whatever is on your mind. Try to do as much communicating as you can or as possible before you accept the job. So many photographers leave things unsaid that should be brought out in the open.

One last word about paying your bills. I have

been lucky having been able to pay my bills in ten days. And in ordering the last twenty-five years, I have built up an enormous credit rating with very little money to work with since I never took in more than $70,000 a year. By taking advantage of every discount when they were offered and by paying more than just promptly, I discovered recently that I have credit up to something like $60,000 for the asking. Far beyond my needs, of course, but a line of credit like that is nice to have yet foolish should I take advantage of it. From time to time I need to buy something expensive from a company that doesn't know me. This credit rating is easily as valuable as my photographic ability.

5 Selling without an Assignment

Almost every professional will tell you that you shouldn't work without an assignment and many go further and suggest that you don't move until you have a purchase order. This may be very well for those photographers who have commercial studios and deal with or are open to, clients off the street so to speak or those who call in response to an ad in the yellow pages of the phone book. But for those photographers not quite fully established and employing others, selling without an assignment must be a way of life — lets call it what it really is — speculation.

Rather than get involved in an argument over the semantics of purchase orders or no, I'd prefer to define basic philosophies. In particular, I feel that if a

41

photographer wishes to *choose* his own clients or sell the photographs he likes to make, then he must work on speculation. On the other hand, if he accepts assignments and work that is not necessarily to his liking then he is "doing what the client tells him to do," and he'd better have a purchase order.

Another thing, photographers who are extremely self-confident *choose* to be independent and of necessity, must sell without purchase order. Call it what you will, when you sell by speculation, you'd better be good; you can't hide behind shoddy work. Astonishingly, most photographers are inept — many successful photographers are inept — Those that are so, are not inept as *businesspersons*.

This means that this dichotomy — the technique of photography and the technique of business are not equally desirous or rather equally necessary for a successful photographic business. Being a business-person first is more necessary than being a competent photographer. This is galling to the photographic elitist who believes that photographic technique is akin to the Holy Writ. His distain knows no bounds. Yet I believe that photographic technique is required for the freelancer, the studio owner who works by speculation, and many other free souls in photography.

You can tell who lacks self-confidence — they are worried about the inroads into *their* locality of the 99¢ 'ers or perhaps they are the proponents of licensing photographers. Their lack of confidence manifests itself by the need for outside protection — what they lack in ability to rise above the competition, they expect the state in all its patrimony to will them a heritage of protection.

I personally abhor any kind of control over the

actions of professional photographers as to the performance of photography as a business. Just as I reject the notion that photographers should be considered "professionals." This struggle to identify with prestige is a worthy ambition, but one that should be earned by years of exemplary professional conduct.

Go to any town in the United States or Canada and ask for the best photographer in town and you will be surprised to find that you will be sent to the best "professional" in town, not necessarily the best "technical" photographer. Merits, Masters, PPofA and PPofC notwithstanding, the best professional is the one loved by his friends and fellowtownspeople.

Every small town studio in North America speculates every time they take a photograph. Iron bound contracts for portraits are rare, indeed, they're almost non-existant. The arrangement between the customer in portraiture is understood. The understanding is that the photographer will make the best portrait he can, but if the sitter really feels that he or she doesn't like it at all, they do not have to pay for it. To force a sitter is to invite bad-mouthing by the sitter, friends and family. Surprisingly, bad publicity travels faster than compliments.

The same applies to the commercial photographer; poor or shoddy work should not be paid for. I know — someone out there is saying, what if the photograph is good and the client is just a nitpicker. My comment is that communications broke down. Before the photograph was taken, all of the requests of the client were ignored or the photographer overstated his ability to produce. In all probability, the last is most appropriate.

Magazine illustrators are all working on specula-

tion. Just because the art director calls and gives you the "assignment" doesn't mean that automatic payment for a photograph that doesn't satisfy him is mandatory. Even if he issues a purchase order, the understanding is that you will satisfy him. To force him to pay because you hold the legal paper in your hand is foolhardy since you will lose the account—a Pyrrhic Victory.

Back to the small town studio for a moment. Most photographers have heard so much about the value of advertising and promotion that they begin to think that they are the panacea of all business ills. They're not, nowhere near capable solving all problems. If your area is economically depressed and you are in the portrait business, there is just so much you can do, or should do in the way of advertising and/or promotion. Too much is a waste; many photographers don't know how much is effective and how much is wasted.

There are other ways to solve poor business and one of the best—and easiest—is speculation. If business won't come to you, you go to it. This is difficult for the studio owner to value in his mind. He has a place of business and advertising is supposed to bring the business to him; to leave the store and knock on doors, so to speak is, eating humble pie. Yet, this is exactly what must be done when business cannot be pumped up by advertising. People in business will respond to the direct solicitation. To use the cliché; eyeball to eyeball. When a prospective client reads your advertising he still can refuse to respond without loss or without having to say no. Direct contact requires a firm character on the part of the photographer and a much firmer one on the part of the

client so eyeballed—he will find it difficult to refuse your request in person.

Almost all contact type selling is more successful than either telephone solicitation, direct mail or advertising. Speculation by mail, such as mailing photographs to magazines as an example is not as effective as personal contact. I have often found that when I make a personal visit, the art director will try to find something he can use even if it is a filler, simply because he feels that I have made an effort to see him and he needs to repay me for my efforts. This is a form of intimidation that works.

For freelancers such as myself, speculation is a way of life. Quite tenuous at times, enormously rewarding at others. I direct mail many slides to prospective customers. Years of solicitation to the same people such as record album and greeting card publishers have established me with them. There are enough sales during the year to warrant continuous mailings. From their point of view, they have purchased and used enumerable slides from these offerings. They tend to expect that there is something useful in what I send.

This works both ways. I have noticed that recently, many of the companies are contacting me, asking me for a selection of slides on a specific subject that they are looking for. The more I sell to any one company, the more they tend to do business with me. The relationship grows with every submission. The more you bombard them with submission on speculation, the more you reinforce your intimidation factor. You make them feel guilty, eventually, they will buy once having bought, will continue to find useful slides from your submissions.

The side of speculation where you take a photograph unbeknownst to the client of his place of business or product, is the most difficult of all speculation. For one thing, the photograph cannot be used by resubmitting to another source because of the particular nature of it. It is useless, except to that prospective customer. You must know what you are doing to practice this form of speculation. The way to succeed is to be able to make a better photograph than your predecessor. Even with the better photograph in front of him, the client is reluctant to purchase since he has already spent money for the first photograph which would become useless. Then again, a better photograph than the one he commissioned makes him feel as if he didn't use good judgment the first time.

Yet, there are many clients who strive for some sort of perfection and when they see a better photograph of their product or business they will buy. You can almost tell who they are by the type of business literature they put out, such as well done advertising and brochures. Most successful businesspersons are well aware of the value of excellent photography and are willing to scrap mediocre work in favor of an improvement.

One way to break into commercial business in your locality is to photograph on speculation any product or plant location and make certain that your photograph is superior to anything you have seen of theirs. There are many faults committed by other photographers and hindsight is always easier than foresight so retake the client's photograph being careful not to commit the same errors as your predecessor. I know that in photography of dining rooms, motel rooms and many architectural photo-

graphs, the most common error is neglecting to show the in-out relationship of the room to something outside.

This type of photograph is difficult and few master the technique and sometimes those that know how are lazy and simply don't do what they should.

Many photographers photograph products with frontal lighting; something that is almost not done. This is the difference between an illustration and a documentary photograph. Most transparencies have too great a contrast ratio; another error. Dropped tones so that the printer can't record the detail although it does show on the transparency is another sign of poor or inept photography. All of these can be corrected and if you wish to succeed in speculation you must know more about good photography than the competition.

The portrait field is no exception to speculation. Many a famous photographer began by offering "free sittings" depending on the high quality of his work to sell prints. One I know offered such sittings to famous people in his area and capitalized on the "snob" appeal of showing a famous person in his window. Success begats success and people like to do business with successful photographers, so photographs of famous people in your window imply that you are successful, artistically if not financially.

Assignments, purchase orders and documents pertaining to the work to be performed are necessary where you are accepting a client who has a shaky financial condition or who you suspect might be a slow payer. It's a shame that a photographer has to get into such a position, but sometimes it can't be helped. Every photographer has a record of dead-

beats and the freelancer working without either of the above is no exception. If it's any consolation, all businesses expect a certain amount of loss due to non-payment. But all the documents do is give you legal clout, admittedly, this is necessary.

The records for speculation are not worse than the purchase order system, in the matter of payment. They are about the same. The difference is that without the purchase order, you have no legal grounds for recovery.

There is a law in the United States that says that unsolicited material may be kept or thrown away without financial obligation. But, it cannot be used in the sense that photographs can be printed for ads brochures, or editorially. The way to avoid this sort of problem is first to make sure you are dealing with reputable concerns. Next, always send your first submissions with SASE. What is known in the trade as a stamped, self-addressed envelope. I always send a label and folded envelope with a glassine of postage. This is nothing more than good manners. Especially so, when you are sending unsolicited material for the first time. Registered or insured mail is an indication of how you value your work. I suggest you register and request a return receipt.

So the freelancer works without a client sometimes and enjoys the freedom of not being told what to do. He makes the photographs he likes, as he likes and when he likes. These are send out to magazines, record album companies, greeting card companies and publishers. His mailings are constant and it isn't very long before he has built up a trade and a market for his work. Low overhead, lower taxes and freedom are the hallmarks of this kind of work. But, one must be quite competent, not only as a photographer but as a businessperson.

6 Pricing your Photographic Work

Present day methods of pricing photographs and photographic services evolved from the practices started before the turn of the century. It was customary in the last half of the nineteenth century to price each photograph as an individual. Should an 1850 customer have wanted two photographs, two separate photographs had to be made; negatives weren't that common. The prices charged varied and kept pace with the general economy.

Portrait studios in the early 1900s had glass plate negatives and were able to make more than one print from a single negative. Someone, I don't know who, determined that the price for the second print should be lower since most of the effort; sitting, developing

49

the negative, retouching the plate, was accomplished in making the first print. Therefore the second should be less. It soon followed that subsequent prints would also drop in price as the total order increased. This practice continued for portrait studios and is still common today.

Some studios doing portrait photography resisted the trend. During my early days when I was involved for almost ten years of portraiture, I separated the structure so that a sitting fee was charged isolated from the print charges, making print charges identical in an attempt to stabilize the value of the prints. Later on during that same period, I was well known enough to charge a single price per photograph without mention of the sitting fee. In those days, the first, second or third prints were all the same price. Eventually, I was able to charge an enormous price for my work and needed no identification of costs, fees or other devices in order to sell my work.

The commercial photographer had a similar problem and his system was close to that of the portrait photographer with a minor difference. Where the portrait photographer charged a diminished price per print after the original or a sitting fee, the commercial photographer charged a fixed price for the first view and reprints were relatively inexpensive. For at least forty years an 8 x 10 glossy reprint in most studios in the United States could be purchased for as little as $1.50. I understand that there are still places where this is true today. I would hope that the original photographic price has risen since the mid-thirties.

Most commercial studios charge for the services according to a variety of factors such as time, dis-

tance, size of camera, black & white or color, number of views on any one assignment and many others. These studios have refined and refined their price list to take care of almost any contingency the client might conceivably bring up. This system is still practiced today in the vast majority of small commercial studios across the land. Many preface these prices with out-of-pocket expenses as extras. The larger the studio, the larger the price list, since the variety of work requires different prices. As an example; aerials are priced higher and separately from architectural views. The theory behind this is that aerials require more technique. Since the cost of the rental of the plane is usually listed as an expense, the reasoning isn't logical. I must admit I did charge more as an aerial photographer, but I had reason to. I flew my own plane, used surplus army aerial cameras and my expertise was greater than the ordinary commercial photographer who rented a plane and shot his Hassie out the window. However, modern films, papers, camera and lenses have improved to where the difference between photographs taken with a K-20 and a Pentax 6 x 7 cannot be discerned on a 16 x 20 color print. So there is no reason to go to the old fashioned system.

The journalist photographer working for a magazine or newspaper started out on a salary and give or take some variations this is still the practice today. I would expect the salaries have improved with the general state of the economy. These photographers are more often than not, moonlighters. Their work brings them in contact with many potential clients for extra work beyond the needs of the paper. It would be folly to resist. I know of few who do.

The large studio photographic illustrator generally working for advertising agencies has a price system that I would call "what the traffic will bear." He has developed guide lines that fix a price high enough to cover all costs and yet priced to suit the use. As an example, an industrial magazine ad is less than a consumer magazine ad (all other things being equal.). This practice evolved from the fact that the photographer felt he should receive a percentage based on the cost of the page in the magazine. A full color ad in Nuts & Bolts magazine might cost the agency and ultimately the client, $2,000. The identical ad in the present day "Time" is $38,000.

The freelance photographer works on a different system. He charges by a fee system known as the Day Rate. This rises or falls depending on the economy, but in general it is his reputation that governs the price structure. The Day Rate is primarily a labor charge and all expenses, and I mean all, are listed separately as expenses. These photographers rarely process their work themselves. So a laboratory near their base is a must. Most work in color and in transparency material. This means that the original photograph must be well done since there is no chance for corrections by the lab. Filtration and exposure must be right on the ball. I have seen some Day Rate price lists where the cost of each roll of film is charged for. The reason for this is that since the fee is a labor charge only, the client can and often does ask for almost continual shooting. This means many rolls can be shot in a day. It might be considered "shotgun" photography but it is a must on many types of photography such as annual reports and catalogues.

The majority of photography calling for the Day Rate is of the small camera variety. Rarely is the Day

Rate used with the large view camera. Another inter-
esting point is that the Day Rate is almost never used
within the studio proper. The use of the studio has
so many additional expenses attached to it that many
use the per unit or per photograph price structure.
(See Appendix II).

It is difficult to set up actual prices. By the time
this is printed the economy with inflation would
change any figure, so I will try to deal with concepts
rather than actual prices. Pricing is relative and
many factors set the beginning. In general most
photographers starting out price themselves too low.
A studio just being built for the first time can de-
mand more money than a freelancer. His studio is
impressive and sets a visible standard. Anyone
building a studio already knows approximately what
he is able to charge by the competition he has for one
thing; another is the location; still another the state
of the national economy and still another; the state
of the local economy. There are other factors that
must be fed into the computer such as your reputa-
tion if you have one; another is what this type of
photograph goes for around your locality. Of course,
all of the above concerns itself with the cost of doing
business. But photographers are notorious for ignor-
ing that facet. An otherwise intelligent, analytical
person becomes vague and incoherent when pinned
down to a price. Photography is that sort of profes-
sion where the thrill of the assignment is more im-
portant than what you get for it. Frankly, I wouldn't
have it any other way. The point of this is to attempt
to place the need for earning money in juxtaposition
to the need for satisfaction in photography.

For the beginner having trouble with pricing, I
might suggest that there are many published pricing

books on the market. They could be used as guides but not as gospel. I find that they are so general as to be useless. For instance, such quotations as: "A single commercial black & white photograph of a gas station varies from a low of $10 to $50." Here, the spread is so great as to be useless as a guide. The systems and practices in these books do help though.

This is one reason why belonging to various photographic associations is helpful. Most have printed surveys of prices, and most larger associations have a trade journal in which pricing is a popular subject. Back issues may reveal good information.

7 What Rights Do You Sell?

Ever since Fox Talbot made one of the first glass plate negatives, photographers have had the problem of who owns the negatives and what rights belong to the client when a photograph is purchased. I would have hoped that by this time the subject would have been exhausted, but with each crop of new photographers entering the profession, the questions arise to plague us once more. Perhaps a discussion is in order. Let's discuss basic principles first.

Most professionals consider that negatives, color or black and white are an ingredient of the process of the photograph, similar to the position of the chemistry; a sort of element in the manufacture and as such should not even be discussed let alone

questioned as to the ownership. I am one who subscribes to this practice. Still, the question does come up although not with the highly successful, but the beginner and moderately successful photographers. Some photographers, notably the commercial types do release negatives from time to time and thereby prolong the question.

Portrait photographers get most of the requests and they rightly refuse since their ability and technique are entrapped in a negative. Most customers are aware that color labs advertise and in fact many have sent a slide to be made into 11 × 14 or 16 × 20 prints. I find that the large studios catering to well-to-do customers have less of this annoyance than the smaller and less expensive studios. The best way to handle such requests should they arise, is to say, "The negatives are my property and are an ingredient in the manufacture of your photograph. Only the right to buy reproductions is yours and yours alone."

If this doesn't satisfy your customer, then you will have to remain adamant and placate him in some other way.

Studios that maintain help in the darkroom depend on the reprint business both black & white and color to pay for the help. Many studios claim that the reprint business is 20% of the gross and to lose that is unconscionable.

Some studios such as my own, have the philosophy that they want only original photography and give away negatives of subjects that have no further interest except in the area of reprints. I give the negatives away since I don't want to be bothered with requests for reprints. The prices are so low for commercial prints that it isn't worth it to maintain a darkroom for that purpose. Since I don't do any por-

traits to speak of, there is no need to worry about reprints there. Illustrations on assignment for magazines rarely have the negative of the type that would be asked for. Most are part of a further process in photography and never visible. Most magazines are given transparencies rather than prints. Even my transparencies are copies on Duplicating film, almost never an original piece of film. This is so because so many of my illustrations contain more than one image and I make a duplicate, usually enlarged. It is this that arrives at the art director's desk, the originals remaining in file. The art director always returns the photographs after printing anyway.

As to rights to reproduce the image, that is another question — one that has plagued photographers for years. Perhaps the first consideration should be a list of those rights in common practice today:

North American Rights
World Rights
1st Reproduction Rights
All Rights

Add to any of the above such phrases that pertain to the type of photography that you are selling, such as: "Posters," Greeting Cards," etc. It is customary to bill with phrases that identify the exact area of the rights you are releasing. Should you wish to retain specific rights, it's best to spell that out on the invoice also. In general, photographers tend to understate their meaning in an invoice. There is no well defined language that must be used. Any phrase that says exactly what you want to sell and what you want to retain, is the phrase to use. As to what the client expects, it's best to ask.

You'll often get a purchase order from an advertising agency that will spell out rights that are un-

reasonable. Read the back and the fine print and if you're in agreement, perform the work. More often, you'll have to write or call and explain to the art director that you can't release this right or that.

When accepting assignments it is customary to release most rights. After all, the client, agency or corporation, is paying you your fee. In most circumstances you wouldn't care to keep the rights to factory shots, interior and exterior. You certainly can't keep slides of personnel shots for an annual report, so most problems are confined to stock shots or editorial assignments where the photographs taken can or could be used for other purposes. Defining the use of your photographs is up to you. If you wish to restrict them to certain uses, fine, just spell it out.

Often, a client or agency will contract you for a lower priced photograph and then use it for an ad which you would have charged more for. You must anticipate this possibility and spell it out on the invoice. I use the phrase: "The photographs are taken and billed for specific use in collateral material only, rights to use these photographs in any use other than specified are charged for separately."

In the interest of good relations, it's best to talk about this possibility before you accept the assignment. This comes up when the photographer charges a Day Rate rather than a per picture price. As an example, I often do annual reports and then find that something I shot becomes an ad in some industrial magazine. I don't raise any objection because my Day Rate is high enough to cover such problems. Then, too, sometimes I suggest such a use in order to get the client to hire me. Since the Day Rate usually involves the use of the smaller camera and out on location, I feel the client is paying enough. Studio

views on 4 × 5 film or larger are priced separately and here, too, the use is spelled out.

Editorial photography made by assignment is easier to define. The art director picks what he wants and you have free use of anything else you shot that might be useful elsewhere, providing there is no conflict. When an agency hires you to photograph a specific layout for an ad, you don't have any rights for the use of the photograph elsewhere, since it's the art director's creativity that you're translating into a photograph. Your ad price should be high enough to cover your needs.

Magazines usually pay according to their circulation. The largest circulations at this writing are in TV Guide, Reader's Digest, Family Circle, Woman's Day and so on. The circulation figures are from Standard Rate & Data and are known as ABC figures. The ASMP publishes a ranking list from time to time as do publications such as the Standard Rate & Data.

There is an enormous amount of trust in our business and I have found little reason to distrust. Maybe because the bigger the client, the less they feel the need to cheat you.

If you maintain stock files, you must keep accurate records of your sales so that there is no conflict. A greeting card sale must be protected for all time from your selling the same photograph to another firm. If the situation ever did arise, you should contact the first publisher. However, I doubt if I would ever try this stunt even with a time lag of five or ten years in between. You would plant a doubt in the mind of your client as to your ethics.

Words such as: "subsidiary," "ancillary," and "residual" are often found on invoices. These are

euphemisms for "secondary" or "remainder" and are used to define charges for the second use. Second use means the same photograph used for a different purpose, not a repeat. Large clients are used to paying for second use. I doubt if I would mention that you charge for second use, but some photographers use the phrase: "Subsidiary rights retained by the photographer." This seems to cover the point.

I can't think of any purpose in using any phrase to limit the amount of time that a client is allowed. Copyrights are for twenty-seven years at this moment and they can be renewed for another twenty-seven upon application. Once something is published and distributed with the copyright symbol, it can be reproduced at any time during the copyright period.

8 Submission Orders

These are four-part snap-out printed forms that accompany slides and transparencies submitted to any type of client. To give some specifics: all advertising agencies, record companies, greeting card companies, poster companies, all magazines, calendar manufacturers, book publishers, both trade and school book, all encyclopedia companies, agents and representatives, and occasionally, the advertising manager or art director at a large corporation . . . anyone who is sent your photographic work and isn't billed at the same time, gets one with the slides.

The important thing here is that you have spelled out on this submission order all the conditions of your submission.

The absolute first item typed on this order, even before you list the contents, is a phrase that tells the recipient *exactly how long they may retain them!* After the name, address, the date and how ordered is typed on the top of the form, there is a blank double bar. Type the following phrase in that space: A HOLDING FEE WILL BE CHARGED FOR EACH TRANSPARENCY HELD BEYOND THREE WEEKS, UNLESS OTHER ARRANGEMENTS ARE MADE.

I don't think it needs explanation. It says it all. So many of the greeting card companies and most especially the encyclopedia people try to hold the transparencies as long as they can. Not to make up their minds so much as to look them all over and pick the best from all the photographers submitting. So they try to stall you by saying: "We can't make up our minds yet," or: "The client is away for a few weeks." (No need to mention all the excuses.)

As to the charges; if they call and say that they are considering two or three, I usually say, return the others and extend the time for the three they are holding for another three weeks. To prevent any misunderstanding, I keep the submission log on my desk and I check it *DAILY*. When something is coming due, I call them or if they are too far away, I send an air mail letter that tells them they are about to be charged.

The charges are in two forms. I pick one that applies. If the submission is one or two or perhaps three slides, I charge the going rate for that type of slide and for the proposed use. (Say a record cover.) It will be the minimum that the ASMP lists as the average sale, or I will use my own experience which would stand up in a court of law. If I have sold covers

and I have, the average is, at this writing, about $350. I bill them for all three at $350 each.

If the client is serious, I will get two back immediately. If not, I get all three back.

The other charge is a "Holding Charge." I charge $15 a day for holding transparencies beyond the agreed upon or stipulated time. Rarely have I invoked this because it almost always destroys the relationship with that client. But, by notifying him that he is incurring this charge, he will either send them back, buy one or ask for an extension. I grant the extension if all others are sent back. Remember, as long as much of your work is stalled at a client, you can't use it to earn a living. Sometimes, although rarely, they hold topical slides to prevent other art directors from seeing them. I avoid this since everything I send out is a duplicate.

Then I list each transparency by title, number and size. If you are the type of photographer who has poor filing habits and hasn't solved the filing problems, you won't be able to identify the slides properly. The key to this whole business of Submission Orders is to give the impression that you are a businessperson and have a well organized system.

If there are restrictions, as most of mine have on them, you have to state: "#179, Green Solar Sunset, restricted for greeting cards and posters." This must be stated since you sold those rights to the greeting card company.

Another phrase might be: "Available for one time rights, North America."

Do not leave out information regarding slides that have been previously published. Sometimes if the art director knows that this has been published as a cover for something or as a record album cover

he might feel that the recognition is worth the decision to buy it. On the other hand he might feel that it is over used.

Another condition that must be on the Submission Order is the phrase, "It is understood that the purchased transparency will be returned to the photographer after separations are made." I don't know how many slides I have had to track down after publication. Yesterday's ad illustration is only good to wrap fish in. Getting my slide and a copy of the ad back are the most difficult parts of dealing with art directors.

You can type this information or have it printed. The more you have printed, the more they will pay attention to it. And make sure that it is at least in 12 point type. Anything less and the courts will say the type is too small to have been noticed.

The second sheet of the four-part snap-out should be the yellow acknowledgment sheet—the one that says: "Please sign and return." They won't often do that but they should.

Obviously, I need not mention that the date and number must appear on each copy of the Submission Order. And don't forget who ordered or suggested you send a submission of your slides.

If you are sending your work without a request, you could be causing yourself some trouble. A request to see some work implies that they will return it and that they have the responsibility to return it to you in as good an order as you sent it. Without a request, they could ignore all that is written above and likely will, especially if you have not included stamps, a label and an envelope for the return. This isn't necessary with the requested order but most definitely is with unsolicited material.

I have sold many items that I really don't think would have sold had not my methods of submission been so clear, concise and accurate. The extra courtesy of the stamps and the addressed envelope has made me welcome where others are ignored. Professionalism is always admired.

Keep a looseleaf or hard-cover log, with the Submission Orders listed in numerical order. If you tear one up, log and write: "cancelled" and place your initials in the space. Your log needs, besides the number, the client, preferably two names, a person and a company. Remember, always send to the company to fix the responsibility on them rather than to a person. Someday you may get, "Oh, he's no longer with us." Send the slides to the attention of a specific person, but address it to the corporate name of the company.

The "date sent" column has the date of the order. Make sure they match. The "date returned," too, should be accurate and you will need additional columns if they keep some slides and return others. I list those that are bought and those that are returned in separate columns; the log also acts as a record of sales.

I make great use of Carter's "Hi-Liters," colored felt tip marking pens for highlighting sales and returns. Green is the color of money so I highlight green for a sale. Red is the color for the return. Just a glance at the page shows me that those with no color have not been returned.

The Submission Orders act as custody receipts, too. Sometimes I send much work abroad where I have seven different agents who handle my work. I use the Submission Order as a means of identifying the material they're holding.

When the slides are returned, I throw away the yellow acknowledgment sheet and keep my file copy. I note the date returned and whether or not everything came back with it.

Sales are also recorded on the file envelope, as are the submissions. This tells at a glance that the slide is out. Since I usually make ten of every slide in order to cover all agents and representatives, seeing a slide in the file envelope means nothing. The information on the envelope is all important. If there is a restriction on the slide due to sales, I note that on the file envelope, too.

Sounds like a lot of work, and it is. One thing will happen. You'll be more selective as to which you consider are good slides and deserve keeping and submitting. The garbage will fall by the wayside as just too much to record to be worthwhile.

After typing, the Submission Order accompanies the slide in the same package. I use the Air-Pac shipping bags as I have found these to be the easiest to send, the lightest, the cheapest and the best. I send them First Class with Special Delivery, insure for the minimum, and request a return receipt. I make all this out in the office so that a minimum of time is spent at the Post Office.

When the return receipts come back to me, I staple them to the file copy of the Submission Order. This is necessary for legal purposes and the date on it is the date I use to figure the time that they have the slides. I don't throw these out until the slide that was sold is separated and returned to me. Then I file the file copy and throw away the receipt.

Just recently, I have discovered that some of the greeting card companies are copying the slides that are sent on submissions in order to comply with the

"send back" time limits imposed by myself and others. This is their way of building a file and they could steal the slides by copying and even use them. We would never know in most cases. So I have tried to place another phrase on the order: "Not to be copied." They tell me this is just a reminder and that the slides are not good enough for reproduction?

Many companies print four-part snap-out forms. A few are Gray Arc, Fidelity and Regent Forms.

9 Advertising & Promotion

The photographic business is like any other business in the sense that it must have a continual advertising and promotional program. By the word "program" I don't mean one or two advertisements occasionally inserted prior to a holiday or even a program of ads designed by the photographer, but a well-coordinated schedule that would include flyers, brochures, posters, radio spots, ads in various magazines, press releases of your activities that warrant attention, and stationery. Your program would contain any or all of the above depending on your needs and also the type of work you do. If you are not interested in the general public, then you won't need radio or television. A freelancer needs something to send to art

directors and editors. Portrait studios need a special series of ads aimed at the different holidays in addition to a general advertising schedule.

One reason many studios send prints out for judging state and regional association meetings is to give them the ammunition for a press release if and when they win an award. Some studio photographers send the local newspaper an item even when they are going to another city to attend a convention, or for whatever purpose, and the local newspapers should be bombarded with news items of your activities, especially if you advertise in the same newspaper. Once you are considered "an advertiser," the editors are receptive to your releases.

The Kodak company puts out a well coordinated advertising program for studios. The ads are expertly designed, and they have a direct mail campaign that is tied to the ads. The company has these campaigns for different parts of the year and different events: Christmas, Valentine's Day, Easter, June weddings and special campaigns for babies, children, family groups, grandparents, etc. The campaigns are so good that if used by a studio in their entirety, they are bound to increase the studio's volume. You could never buy such a service from an agency. It would cost thousands just to design it. The price that Kodak charges for the printed material with your imprint is nominal.

The only drawback is if two studios supplying the same service to the same community find the duplication of effort detrimental. As an example, years ago I owned a studio doing all types of photography, and I used the Kodak mat service for about a year. When I found a competitive studio had started to run the same or similar ads in the same paper, I

very quickly stopped my series and after about six months I discovered that not only had I not lost any business, but we were getting business from the competitors use of the Kodak mat service. What had happened was that my name had become identified with the style and type of ad, and when the ads continued, a number of customers assumed my name was at the bottom of the ad. That was a free ride.

That little anecdote is a good reason for designing your own program or campaign. I mention it here as a warning.

Commercial types need to advertise, too, but mostly in trade journals such as the nationwide Advertising Age, Art Direction and Printer's Ink. This can get expensive. I used these and other magazines aimed at the advertising agency. A four-color insert costs, not only for the one time insertion, but for the cost of the printing. I went that route, but I planned it well. I had the single page insert printed by Dexter Press, one of the color postcard manufacturers, and a great savings over the cost of local printers. I have had many one and two page inserts printed, and the prestige and advertising value is inestimable. Often, the clients I am after don't spend as much on advertising as I do. How much do you spend? You can't break that down. It has to be what is needed. If I had to set a budget I would suggest it be as much as you can spare. I don't think you can over spend. You can misspend, however, if your aim is poorly directed.

For the freelancer, the neophyte advertising illustrator, or the commercial studio just getting into doing its own promos, I would suggest starting with color postcards, then graduate to an 8, 10, 12, 14 picture brochure and use direct mail. I find that for my

purposes direct mail is easily the best. I use both the four-color brochure and a four-color poster, printed on one side so that the art directors can tack it up in their office – a constant reminder that I am available. The brochure should show a number of things: your studio if you have one, your equipment, your work (samples) and your other facilities. What it should not show is prices. (See Chapter 6 on pricing.)

Art directors, advertising managers, and the clients need to know what facilities you have if you are a studio. They also need to know something about your equipment, at least that which pertains to sports photography or large format studio still lifes, products, kitchens for food preparation, dressing rooms for models, props, etc. If you are a freelancer and work on location assignment, then aim your broadsides toward your equipment and some of your better work. These brochures should be mailed to a select list. Try to address your labels to a specific name, such as the advertising manager if a client, and the art director if an agency.

Follow up the mailing with a telephone call about a week later. Make this calling a habit. You are going to do it for the rest of your life, so get used to it. Out of sight, out of mind. This is one reason why I think the poster is the better idea.

I mentioned the poster in each Creative Color Workshop I taught and a number of students (professionals in their own right) went home and sent me posters. One in particular sent me a poster patterned after mine, however he had neglected to place his name *inside* the poster; he had it added at the bottom. The danger here is that it can be cut off and tacked up. Mine cannot since the name ROBIN PERRY is buried in the center of the poster.

Any agency will tell you that repeated onslaughts

of direct mail or advertisements are necessary. Sometimes people don't react until they have been bombarded many times. I find that I must make contact with my clients on a three months basis, so I devised a telephone list with dates and every day I make the calls for that day. This is expensive since I do not do any local work; all my calls are long distance. What with someone not at his desk, or out of town or whatever, I make many useless calls. That, and secretaries who place you on "hold" when you are calling long distance, can make life hell.

Parallel with advertising is the need for a program of public relations. Besides the blurbs to the local newspaper mentioned earlier, a photographer must gain some exposure in trade magazines so that he is noticed by other photographers and art directors who read them. This happens to be a surprising number. My experience is that I have been noticed by ADs this way. The pay is fair, not great, but everything is relative. If you are just breaking in, the chance to be in the magazine is worth the effort. If you are already established, the pay means as much as the exposure. The editors are always on the look out for new, younger photographers or portfolios that are different. So don't copy someone else's style. Develop your own.

The mechanics are simple. Write a letter of inquiry requesting permission to mail a portfolio in if you are too far away to visit. If you are in New York, where three of the magazines are located, the best bet is a personal visit to show your portfolio to the picture editor.

The writing of articles for the photographic magazines is another way of gaining attention to your name. This is almost more difficult than the portfolio route. The magazines need illustrated articles more

than they need portfolios. They run out of good ideas for articles, so if you have any writing talent and can come up with a subject that hasn't been done to death and can illustrate it well, you will have the pleasure of seeing your name and being paid for it. Make sure you have model releases of anyone who is visible, editorial use or no.

When something you have photographed appears in any national or regional, I suggest buying three issues. Have one plastic coated and placed in your portfolio, and save the other two. You may want to photograph one for reproduction in a brochure. The last is a spare. Incidentally, cut off the mast with the name of the magazine and dry mount that across all three copies. One mast for each copy. This way you gain reflected glory from the magazine. If the magazine is Pig Slaughtering, cut the ad out if the ad is worth saving and forget about the mast. Sometimes it's best to not show ads you have done. The bigger you are, the less you need to show completed ads. ADs often get sidetracked looking at the design of the ads, and if the AD you worked for did a poor job, you will bear the brunt of the criticism. Remember, you wish to keep their minds on your work and ability.

The business of awards is a questionable one. In the beginning of your photographic life you need recognition, psychological supports; reinforcement of your knowledge of your own worth. Joining those organizations that award ribbons, degrees, etc., is a worthwhile venture. You can turn the awards and attendance into publicity releases as I mentioned earlier. The added advantage of learning from the speakers at the conventions should not be passed over lightly.

Awards are usually accompanied by a plaque, cup, or certificate. Framed and installed on your wall,

they serve to impress your clients. If you achieve the award of Associate, Craftsman, Master, or the highest of them all, the Fellow, in any of the associations, this fact should also be included on your stationery. They serve to reinforce your credibility.

Serving on convention committees, acting as a speaker, being elected to office in any of the associations can also be turned into free publicity. However, you pay for this last feature with an enormous amount of sometimes thankless work. Bear that in mind.

If there ever was a single characteristic that seems to be common to all the advertising of photographers, it has to be aggrandizement. Perhaps a nicer word would be puffery. Sometimes I wonder if the photographer is mindful that the majority of prospective clients are aware of this characteristic when they read the ads in the yellow pages of the local phone book. Some of the phrases in my telephone directory are: "World-Wide Assignments," "One of (*town, city*) foremost color specialists," "The largest photo service of its kind," "Specialist in Documentary films, Weddings & Commercial."

The list goes on and on and when you read these phrases, you wonder how a small studio photographer in East Podunek can be so talented in so many fields. I see these phrases on stationery, business cards and on price lists. I think one of the ones that really tickles me is the phrase I saw the other day: "Specialist in Aerial Photography." Since I am a pilot with some 6,000 hours, a Senior Flight Instructor, Commercial licensed with Multi-Engine Land and Single Engine Sea ratings, I felt that I would be qualified to ask the photographer about his qualifications. It turned out that he rented a Cessna or a Piper Tri-

Pacer and shot obliques out of the window. More power to him. That's the cheapest and the best way to photograph obliques. (See Chapter 36 on Aerial Photos.) But to advertise "Specialist," I would think something less grand would have served him better and not destroyed his credibility with clients.

Someday, there may be a "Truth in Advertising" law that would question some of these practices.

10 Self Improvement through Reading

The key to success in photography or anything else for that matter is education. Nothing profound there. Having a college education isn't necessarily the answer although I am of the mind that all knowledge is helpful. Education for the professional photographer is dichotomous with two distinct, yet parallel lines of direction, with the primary thrust toward technical competence, and the secondary toward intellectual awareness.

For years society has implied that one couldn't get anywhere without a college education. Four years of structured learning in a liberal arts school leading to a degree in Fine Arts does not, most emphatically, does not, equip one for the practice of professional

photography, nor is a guarantee made. Even if you attended a school of professional photography you would not be capable of assuming professional duties upon graduation, there are simply too many minor functions that cannot be taught in so short a time as a college course contains.

Photography is so multi-faceted that it has tens of specialties each with particular techniques and specialized hardware. And too, each student of photography leans in slightly different directions as his knowledge increases. Few students know exactly what they want to do at the beginning of their freshman year. The colleges know this and tend to generalize their courses. This is one reason why the student intending to go to college to learn to become a photographer should go to a school where the curriculum is evenly split between technical requirements in photography and a broad base in liberal arts.

College is not necessarily the panacea for this dilemma. The same subjects or enough of them to accomplish your purpose, can be learned empirically. The fledgling professional's problem is what subjects will fit him for his chosen profession. At this writing I know of no school of higher learning that has pinpointed their curriculum toward the professional photographer, although there are a number of schools that come close with their emphasis on professional photography. If he intends to teach himself, he has to select subjects that I think should include Art, Art appreciation, Practical Art courses, English Literature, Design, Graphics, Psychology, Humanities, sociology, Journalism and on a more practical level; reading, spelling, grammar, elementary bookkeeping, typing, mathematics and business

letter writing. These subjects are broad enough to be a base for any specialty and they are all available from the average college or as separate courses or groups of courses at Community colleges and Adult Education programs.

If you scratched the surface of most of the older photographers, you would find that their knowledge of photography was gained by self-teaching, with a few exceptions. And many have degrees in other fields since photography and related subjects simply wasn't taught as widely as it is now. Self teaching is an honorable endeavor but it requires great control of your time and the ability to discipline yourself.

Your first photographic job has a great deal to do with which specialty you pick and consequently, the subjects you want to study. Had I not gotten my first job in photography with a studio specializing in advertising photography and instead had started my career with a newspaper, I might very well have become a photo-journalist.

College does make you aware of all facets of photography and enables you to make a decision early enough to prepare for the specialty. Just a few short years ago, all photographers were either Portrait, Commercial or Photo-journalists with few people branching out into food, legal or medical photography. This all-round experience was a good teacher since most of us eventually settled on one or another specialty. But we took a dozen years to find ourselves. Modern students can quickly absorb general photography in half the time.

Some people are either too old to go to college full time or find that it is impractical due to family obligations, so they are forced to develop a course for themselves by reading. Any really successful person

is a voracious reader, consuming prodigious amounts of literature from the trade journal, to the current events magazine, to the local newspaper and to a tome on applied psychology. I find I am reading some thirty periodicals, a daily paper, a weekly paper and at least two books a week. In order to do this and function as both a photographer and a human being with daily contact with others, I have had to learn to husband my time and use it efficiently. It is interesting to note that many of the skills and much of the learning has been obtained within the last twelve years and long after I left formal education.

One big advantage to teaching yourself is that you are able to dispense with the "fat" and select only the meaty subjects, and, of course, you are able to design your own course of instruction so that it is responsive to your needs. The key subject is *reading*.

In the beginning of this chapter I mentioned the primary thrust being toward technical competence and this is best realized by reading all photographic magazines and clipping copiously, the articles you need to save for further reference. I wouldn't suggest saving the entire issue—quickly scan and then clip the interesting parts for future study. Subscribe to all the American magazines including the so-called "amateur" magazines, a misnomer if I ever heard one. I often hear professionals saying they would never subscribe to the "amateur" magazines. What nonsense! Photography is photography. To say such a thing is to label oneself ignorant.

As a minimum I read Popular Photography, Modern Photography, Camera 35 and Petersen's Photographic; these are called "amateur" magazines and are more than worthwhile. For a minimum of

the so-called "professional" magazines, I read The Professional Photographer, The Rangefinder, Photomethods, Studio Photography, Industrial Photography, Technical Photography and some foreign professional magazines.

Besides the photographic magazines, may I suggest something for the thrust toward intellectual awareness. First, for current events, I like Time, Newsweek and World News & Business Reports, pick one, and in the newspapers, the N.Y. Times or the Wall Street Journal, if these are available in your area. The Journal is rated as one of the best general newspapers in the country even though it is better known for it's financial news.

For your liberal arts training, select the subjects from the beginning of this chapter and develop the habit of reading thought—provoking books. If you don't have an inclination toward literature try lighter reading, but pick something that is at least provocative or enlightening or even inspirational.

Read with a dictionary present. This is the simplest way to advance one's knowledge. If you can develop the habit of using the dictionary you will find your vocabulary improving from tenth grade grammar to a higher level. I have heard it said that television is a great teacher, and it is, up to the age of twelve. Just recently I heard a TV commentator explain that newscasts are prepared with the simplest of grammar so as not to exceed the intelligence of a twelve year old person. What a wonderful opportunity the television networks have to raise the literacy level of the American people, if they would but raise the level of English in the newscasts. To purposely talk down to the public is a shame.

How does education help you in photography?

In many ways. As one example, let me remind you that advertisers spend hundreds of thousands of dollars on page rate advertising, and they are quite concerned, as is the advertising agency, who is hired to do the photography. Many an assignment has been won on the basis of the photographer's demeanor and his impression on either the client or the agency as well as his photographic excellence. After all, the client is entrusting quite a large responsibility on the photographer and his money is up front. If you speak with grade school diction or are the least inarticulate, he might question the agency's selection. However, the agency too would have long ago determined your erudition so that becomes an exercise in semantics.

This is why letter writing is so important to the photographer. Your letters of solicitation to agencies or clients are really you since that letter is the only way they have to judge you. So make sure that you choose your words carefully, and be especially sure of your spelling and punctuation. I regularly receive letters from photographers with misspelt words and dangling modifiers. I am not impressed and act accordingly.

Clients are wary too of the obfuscator who clouds the page with hyperbole and rhetoric attempting to be obsequious only serves to exacerbate the correspondence. So write without aggrandizement or take the risk of losing your audience. The previous two sentences are just too unnatural, a businessman today wants a forthright letter, in clear language, properly spelled and the sentences and paragraphs in reasonably simple grammar. In short, don't try to impress with anything but quiet dignity.

Grace and style are two attributes of quality that

are recognized and admired and serve to impress possible clients. Not everybody can convey such impressions but a photographer aspiring to big accounts in advertising or portraiture must exude confidence and self-assurance. Again, knowledge is the key as knowledge affects your manner. People in high places don't want a clumsy clown cluttering the carpet. (Excuse the alliteration.)

Your ability as a photographer is directly related to your education and life experience and especially so in the field of portraiture. They do give you away. If you have produced effective portraits that show your expertise in capturing what I call the *personality mystique,* you will be successful since it takes intelligence to evoke expression, mood and feeling in a portrait. If your portraits show inane, bland faces with little or no feeling, no matter how correct the color balance is, you have failed as a photographer. This is the reason why you may often see a portrait with great human dignity that survives in spite of poor technique. Technique is easier to learn than how to capture the quality of a character. Usually, I see excellent technique—thanks to the laboratories—and poor imaging.

This is one reason why the less educated who go into photography tend to become general commercial photographers. I mean to cast no aspersions here, but to inspire all callings of our profession to greater heights through self-improvement reading.

11 Mind Set or Concentration

Mind set is a condition of mental thinking . . . a form of concentration so deep and so powerful that upon reaching that state, nothing is impossible. Think of this condition as that of a high-powered rifle compared to a scatter gun . . . a simile that has great importance to the photographer searching for success, financial or esthetic. Unfortunately, it takes quite a while to develop, but it can be learned.

The point is that without an ability to think in intensive terms about a specific assignment—without an in-depth study of even the simplest photographic chores, results are mediocre. If more photographers thought before they grabbed a camera, they would increase their chances for success.

Photography has been called a discipline. I agree with that. My dictionary cites discipline as: "... *to bring to a state of order and obedience by training and control...*." This is the eleventh of twelve definitions, but the closest to my feelings.

Concentration is an incipient form of mind set. Concentration is the amateur form of mind set. Thinking about a problem would be even more elementary than concentration. Thinking, concentration, and mind set are all progressive forms of using reasoning powers to solve problems. Correct, as used here is, admittedly, ambiguous, but my intention is that "correct" will mean the procedure that suggests the best photograph under a given set of circumstances.

Each year that I teach my Creative Color Workshops, I am astonished at the number of professional photographers that do not have a prescribed procedure or method for approaching a photographic assignment. In questioning them, I find that they tend to go into the studio with a client, turn on a light and pick up a camera. Or, if on location, they do the same thing; attempt to think *through* the camera. With the possible exception of "found" or "grab" shots in certain types of journalism, almost every form of photography can be done in the mind without a camera. I am always astonished that otherwise successful photographers have reached an impasse in their careers at a time when they should be reaching greater glories.

In trying to analyze why photographers are halted in mid-career, I have discovered the difficulty arises from distraction; emotional, physical, and environmental. In delving further, I think I have found the answer.

Many of the newer, younger photographers are hedonistic, with a need to be entertained. I think this stems from the use of television as a baby-sitter. So many seem to have grown up entertained by television without being taught self-amusement, or self-motivation. I checked some statistics, and was appalled to find that on Saturday or Sunday in prime time, some 100,000,000 sets are on. And what are they looking at: murder, mayhem, police and medical stories in the format of the old-fashioned confession and detective magazines. What is happening is that people are getting mentally lazy, and more important, they're wasting their lives looking at show after show. Television has many advantages, with many educational shows that have improved man's communication and knowledge, but it also has an insidious way of diverting or distracting meaningful thought.

Well, this chapter isn't about the effect of television on the mind so much as to point out that modern children are not taught to read, to study, or to think. This effectively prevents them from learning thinking procedures or processes. As far as concentration is concerned, I find few people able to keep their attention on a problem for any length of time, and as to mind set, impossible.

There are other types of distraction: one is success, or resting on one's laurels which begats laziness. How often have I known famous photographers who quit when they reached the top. You simply can't coast on your reputation, else someone will creep up on you from behind.

Our forebears studied, read books and in general were self-motivated. Involved with craft projects or hobbies that included others, their attention was

consumed with their activities. These plus the need to earn a living often by one's own wit, firmed up the thinking process. The rewards were numerous — a healthy, thinking mind and physical fitness. This last, one can't get in an easy chair in front of the telly.

Nowadays people are not used to failure. I mean failure after great effort, not disappointment in wishful thinking. Yet, any reasonably successful person will tell you that he achieved true success, *because of his failures*, not in spite of them. Failure firms the character, strengthens the backbone and shores up the determination, but only in those who have that certain something, that certain ability to bounce back from minor disasters and go on to greater glories. So few realize the quality of their character and the abilities of their mind; so few use their full capabilities. Yet, character needs to be tested again and again.

Photography presents problems daily that need to be thought about constantly and in depth. Not just the technical-mechanical, but the emotional aspects of the photograph. The more thinking you do about a photographic problem the better.

A method I use might be of use to those who are not in the habit of working in this manner:

When I receive an assignment from WOMAN'S DAY magazine to illustrate an article or fiction piece, the art director will send me a Xerox to read. I read, away from a photographic environment, usually in the living room with no distraction. I keep a yellow legal-size pad next to me and I try to abstract the meat of the story or article, reduce it to a two or three sentence paragraph. When this is done, I put the

script aside and go do something else, but I try to think about the assignment. I'll get an idea in bed at night. I write it down. I'll get another in the shower or shaving (I have pads next to the bed, in every room, and in the car), and perhaps another while driving to the post office or running errands.

Then I sit down with the notes once again and mentally draw my illustration. Once I have the mental image, I start to break it down into photographic procedure. I choose a camera, a lens, film, filters, types of lighting, what models I want, props, etc., and I write everything down. By the time I get around to shooting the photograph, the work is really done. The actual shooting is anti-climatic.

Of course this procedure can be shortened up for jobs that require immediate photography, but the procedure should remain the same. Surprisingly, the more you think about something, the more you discover about it. In looking back over notes of some of my better photographs, I find the depth of thought has enabled me to make higher quality illustrations. Constant thinking about anything should bring forth facets not readily seen in a cursory examination. Once the habit of in-depth thinking becomes ingrained, the brain achieves mind-set and the solutions to problems, photographic or otherwise, pop into your mind.

Years ago, I attended the US Army Command & General Staff College at Fort Leavenworth, Kansas. This school is known as the "problem-solving" college of staff planning and I'll always remember the large sign over the main study hall. It said: "ARE YOU CONTRIBUTING TO THE SOLUTION OF THE PROBLEM OR ARE YOU PART OF IT?"

For all its faults, the military does have enormous experience in teaching problem solving techniques and other considerations leading to the decision making process. Mind set or concentration is a part of the decision making process.

12 Technician or Photographer

The age old question argued by photographers and artists even since photography came into being is whether or not photography is an art or a craft; are the practitioners true artists or are they technicians? I've tried to solve that enigma myself many times. The reason that there is even a question is because of the camera's ability to make an image without the operator having to have any training, technique or talent. Even a monkey can take good photographs.

Then, too, someone says a picture is "good." By what yardstick or by what criteria does one make this determination? And who are the people making judgments? What are their credentials? All of these questions and many more pose problems for a photog-

rapher. He or she would like to call photography a profession or perhaps an art, if only to call themselves "Professional Photographers" or "Photographic Artists." We all need to belong to a group or cult; we all need labels. This need is fostered by ambition.

The artist, the one with the brush or pen realizes that the entire quality of his work rests upon his own talent or ability. The quality of the paint, brushes, or pens has little effect on the quality of his painting, drawing or what have you. True, training does effect his quality. But then he doesn't have a laboratory to correct his mistakes. Everything he does is on the canvas or the paper. Most artists consider photographers to be cheats. Most photographers are aware of this and deep down inside they kind of believe it too. So they strive to become so good that they are accepted as true photographic artists. If there is any veracity to the thoughts expressed, then it behooves us to make clear definitions of the various parts of our craft-profession.

As an example, let's follow a photograph through its inception and to the birth:

A person thinks he'd like to take a photograph of a still life. So, inception is a thought. He decides on vegetables, wine and bread, or perhaps a fish. So far, this is mental creativity.

Now, he places them on a table and starts to arrange them into some sort of composition. Ah ha! He's an artist! No, not yet. He's an arranger, perhaps a decorator. After his arrangement is set and it pleases him, he attempts to light it. Ah ha! A photographic artist. No, not necessarily. He's still a decorator or an arranger. His arrangement might very well be "artistic" whatever that means. But there is no photography involved.

Now let's add the camera on a tripod. The person selects a lens, a film, a point of view, an "f." stop, a shutter speed, a filter, and a working distance. The photographer now has made some choices that might or might not have been made by someone else. Is this enough to say that the photographer is an artist? I doubt it since any photographic technician could and would make similar selections of the items above. The choices are not varied enough to show the difference in people dictated by talent or technique. Could two separate people be involved? One to set up or arrange and the other to "take" the photograph? Could be. How about the laboratory technician who processes the negative and makes a 16×20 color print? There are numerous options there. I often use a screen, or solarize, or tone separate or in some way alter the print. So, does the person who does the enlargement become the artist — or is he a technician? The print is dried and then spotted or retouched. That person is an artist, but he can't be given total credit. Suppose that one person does all of the above jobs from start to finish. Would you call him a Photographic Artist? No, not necessarily. It could be a perfectly lousy photograph. Ah ha! Who made *that* judgment? He thinks it's great as does his wife, and he might very well sell it, so that's usually a way to tell if something is artistic. True? No! Most emphatically, not. Paintings by monkeys have out sold paintings by humans proportionately.

Many photographers are revered by the establishment and yet their prints are nothing more than grainy, black & white prints with blocked shadows and washed-out highlights. Everyone Ooohs and Aaahs, and they're hung in galleries all over the country. By what criteria are they judged? Content?

Intellectual statement? That's what the critics say is art.

But let's get back to the vegetable, wine and fish photograph for a moment. I have a theory that is not accepted yet, and may never be; nevertheless, this is what I use to determine whether or not a photographer should be considered a Photographic Artist if this is the epitome of photographic excellence and desired. That if the Arranger, the Lighter, the Technician, the Processor and the Printer, are all one and the same person, the resulting photograph is technically perfect in technique, the photographic execution is flawless, and the content is pleasing to a majority of viewers trained and untrained — then he is a photographer.

I feel that photography as an art is a *total* process involving the maker from start to finish. This isn't to say that photography as a profession can't be enjoyed by those who use laboratories or split the responsibilities as many do in large studios. The PPofA awards Merit points towards Master of Photography Degrees to photographers whose prints were made by laboratories. True, one is supposed to be able to have made the print, but nobody really follows through and checks.

Perhaps I am setting too high a sight for myself. Yet, experience tells me that many of my best photographs have been made in the darkroom. I consider the darkroom easily as important as the cameraroom. What we are talking about here is not just professional photography, but the point at which we acknowledge a person as a photographic artist. The fact that I write this as an enigma should make all of us realize that the question is still here.

I question those photographers that allow them-

selves to become complacent or pompous, who embellish their stationery, their yellow page ads and their price lists with titles and other forms of puffery, unless it is deserved. If we believe what our clients think and say about us, we become self-satisfied and complacent. Deep within ourselves we are not so confident and we should be striving to improve.

We like to call ourselves artists or photographic artists, but are we? By definition, Random House Dictionary unabridged defines the artist as:

1. One who produces works in any of the arts that are primarily subject to aesthetic criteria.
2. A person who practices one of the fine arts, especially a painter or sculptor.
3. One who's trade or profession requires a knowledge of design, drawing, painting, etc. — *a commercial artist.*
4. A person who works in one of the performing arts, as an actor, musician, or singer; a public performer; *a mime artist; an artist of the dance.*
5. One who exhibits exceptional skill in his work.
6. One who is expert at trickery or deceit: *He's an artist with cards.*
7. An artisan.

So the dictionary gives us lots of room. Perhaps the problem is a tempest in a teapot. Perhaps it's really not that important what we're called. Most photographers are photographers because they love the work. I know most are ambitious, will work like a dog, at all hours of the night or day, have a constant love affair with equipment, and never tire of talking about photography. Who cares if the lab made the print, isn't it a joy to behold? Don't you often wonder

at the magic of it all? Isn't it most important to all that we be happy doing what we want to do more than anything else in the world? Who needs labels anyhow?

Aren't all photographers kindred spirits? Photographers are the same the world over. A few years ago, I spoke in Brussels to the FEDERATION NATIONALE DE LA PHOTOGRAPHIE PROFESSIONELLE. I was so apprehensive that they wouldn't understand my Americanese. The photographs that I brought with me and the love of the profession broke through all barriers of language; I was well received. I still correspond with some and they made me a MEMBER D'HONNEUR, I treasure that.

13 The Photographer and the Art Director

Assuming the art director has already hired you and you are both in the studio, now is the time to really communicate. Make no mistake, this is the most important period in the production of an illustration or an advertisement. So many photographers make mistakes during this period that end in disasters and strained relationships.

The art director is the purchaser and you're the seller, regardless of how famous or how large your studio is. He comes to you because supposedly you have talent, technical ability, facilities and the price he wants to pay. He is also expecting a blockbuster of a photograph. You should have the attitude that you're going to make a blockbuster.

I find that I must question him and the layout of the ad or brochure, especially if the ad contains "clipped art." This is a layout that is already "comped." (Made into a comprehensive layout.) Should the client have seen that layout, I find that I must come close to it in my illustration. In talking it over with the art director I try to subtly find out that fact. So many of the younger and newer art directors are "clippers" rather than coming up with their own ideas. If the clipped art contains expensive models or props, you can't come near it unless you have at least the same budget.

If this is what the client wants you must point out the fact that you need a comparable budget. There is a difference between the average home grown variety of model and the professional. (See chapter 31 Models & Fashion Photography.) Props such as expensive locations, limousines, animals, furs and whatever, are unobtainable or priced out of practical use. The photographer who accepts this assignment without a clear understanding is looking for a planned disaster. This is the time to show and tell. Show him exactly what you have in the way of props and models, the type of photographs that you can do and be sure to tell him exactly what you expect his costs to be. Try to give him a choice of something so that he has to make a decision.

In a studio situation the photographer has the ultimate responsibility for the photograph so technical decisions should be his. If he finds that optically, he can't produce the photograph the way it is drawn, he has to notify the art director on the spot. Some art directors can draw a wide angle foreground, a normal midrange, and a telephoto background all in the same layout. They haven't invented that lens

yet. If he wants to look through the ground glass, let him. Nine out of ten times, it looks like a dark hole to him with everything indistinct. Looking through your camera a few times will suggest to him that he leave you alone with your focussing cloth.

Giving the model instructions is also a responsibility of the photographer, so ask the art director as well as the client to forward instructions for the model through you. If she has to listen to two or three people, she will understandably become confused and the photograph will show the strain.

Stop any art director dead in his tracks who takes out his pet 35mm camera and says, "I'm just taking a few for the record." Tell him in no uncertain terms to put it away and suggest that if he wants some slides taken during the shooting session, you will take them and charge for them. Remember, you have an expensive investment in equipment and facilities, and his taking photographs with his camera is using your facilities. A quality art director won't do that, so that ought to tell you something too.

On location, where light is a problem, make sure the photograph is taken in the light you wish and at the time you want. Should the art director stall and you loose your light, make sure he knows that he blew the shot. Light changes color and filters are not always the answer. This has happened to me and I lost the account since I had planned to take the photograph while the sun was out and I had pinpointed the time since the shot included light streaming in from a window. By the time the art director fussed with the food, I had lost my light and the shot was poor; he didn't want to pay the bill even when I pointed out that he had caused the delay.

The selection of models is also the photographer's responsibility but on some accounts with big agencies this is a coordinated decision and with the concurrence of the art director, but rarely with the client. Of course this is relative; I used to work on the Smirnoff account and the art director was as well versed as I was in the selection of a model, we always coordinated. Except for once where the Brand Manager, suggested using some friends of his. Although they were lovely young ladies, they were totally unsuited for the layout. The art director and I sweated through that one and came through but it could have been a disaster. Fortunately, he saw what our problems were and never did that again.

I usually suggest a few names and send the composites to the art director or client if I am working direct. Wherever possible I use the best model available as she can easily make or break the photograph regardless of your ability as a photographer. Remember this: *Technical ability can't compensate for a poor model.*

Perhaps the best way to avoid problems in studio photography is the Polaroid print. The cost is negligible in view of the total expense and it gives the client the exact feeling and especially so with color photography. The art director's approval of a Polaroid is my go-ahead signal.

Where you are working with a Home Economist, she is the person who will tell you if the food is properly prepared. Food photography is a specialty and needs the home economist. I have done enough in my life and am ever wary when I accept the assignment. I follow the instructions of one other specialist too; the Stylist. She knows the clothes, the hair and the makeup. It's true, I do have expertise

in most of these matters by sheer weight of years of experience. But I usually follow the suggestions of other professionals. Although once in awhile you hire someone who isn't as knowledgeable as you—then, well, do your own thing.

Most models know makeup well, but again be wary, they love to experiment and this you don't need on the job. Their biggest fault is that they like to make up for how they look in the mirror. The film doesn't see the same image as the mirror. This is true with new brands of makeup. Before I let a model use makeup I am not familiar with, I make a test, but never on the job.

Choice of backgrounds, props, clothes and the relationship of them to the product, belongs in the realm of the art director, again, with the concurrence of the photographer.

These problems point up the reason why I use either of two pricing systems. Either a single high price for the photograph or the hourly studio fee plus photographer's fee. Which ever you use, it should be high enough to cover any emergencies, as they always appear. All studio photographs are billed, fee plus expenses such as models, props, travel and meals. An assistant too if you use one.

So far, I have been on assignment where the art director is on the scene. The situation changes should the assignment be one over the phone or in the mail. The responsibility for everything is yours to produce the photograph but the art director must pay for whatever you do with one provision; you must make a technically good, well exposed photograph paying strict attention to the instructions that come by phone or mail. I always try to get him to send me a letter with all his thoughts and instructions.

I never begin if there is a gray area or a chance for a misunderstanding. Telephone or write but don't guess. And save all the notes. I notice that some large studios are taping the phone calls when work comes in that way. More disasters are produced by this "over the phone or written order" than any other way.

For one thing, you can't make a change in judgment while the photograph is in progress and the art director is not present. The responsibility for models, props, etc. is all yours and he is honor-bound to accept what you do. Naturally, you try to make the best photograph you can else he will go to a photographer in his locality.

I insist on Purchase Orders with everything I can think of written on them. If you ever have to go to court over a bill, you must have the Purchase Order or you will default the case. Misunderstandings can be straightened out before they take place. Be especially careful to note tax or non-taxable and list each expense individually when you bill. I include a Xerox of the vouchers with my bills.

If the art director gets your photograph and bill and has a complaint, or for any reason refuses the photograph, you have a problem. Every photographer has had this happen to him. First you have to determine where the basic fault lies. Usually it is your fault because you assumed more than the instructions, or it's his fault since he didn't give you full instructions. I can't make the decision in this book because there are too many ramifications to the problem for some pat answer. A do-over is expensive for everyone. For some reason all art directors need the job immediately, but they do find time for the do-over. As to price? Even if the fault is clearly the art director's and this is your important client, you can

and should do the job over for nothing. Else you'll never see that client or art director again. So make your prices high enough to cover the problems that might arise.

If the client is a one-shotter and not important and the fault is clearly his, then 50% of the original fee plus expenses is the custom. But here again, I doubt if you'll ever see the client again. You just didn't communicate.

Anybody can second guess a photograph and improve it the second time around. And sometimes the art director likes the mailed assignment, but the boss changes his mind or nit-picks and forces the art director to send it back, or ask for a do-over. Either way, the profit is gone. After awhile, you'll learn to sense those that have problems. As long as we make a product that cannot be seen before the purchase, we will have the problem that the art director has one impression and you, the photographer, have another.

Art Directors come in all sizes, shapes and types, with the highest type giving you little direction but drawing your creative juices out and inspiring you to do your best. This is the type we all want to work for. But you have to be good enough for him to give you that much leeway. These art directors are the tops in their profession and they can hire whomever they please. I try to break my back for this type. Some others are downright poor as art directors and come to you to pull them out of a hole. I take pity on them and I teach them all I can in the hopes that I will make a lifelong friend. I have a few of these, too. You can tell them easily; they want to learn and are willing to listen. Here again, you have to be good enough to teach them.

Then there is the bastard; he jumps from pho-

tographer to photographer, and he's usually the one that pulls out his 35mm for a few shots — the one who goes through the magazines and clips other art directors' work. With this type you have to lock up every avenue of escape. Write everything down twice.

The art director is your alter ego; a good one is the best friend you have. My best ideas have come from the interplay with a good art director. He can make you the greatest photographer living if he's good himself. If the art director is above you in pecking order, listen, and listen well.

14 The Photographer As a Writer

Photography as a craft, an art, a profession, has been changing ever since it was invented. More important, photographers have been changing. Most changes come about through need. All one has to do is to look back to see the changes that have already been wrought by need. An outstanding example is space photography. Without the space program and NASA, many technological advances would not have been made. Specialist photographers permeate all industry and government, where thirty or forty years ago, these areas were barren or lightly covered.

What does the future hold for photographers? What new advances in photographs shall we see in the year 2,000, only a short quarter century away?

Space, medicine, and industry have all taken a giant
step forward. Yet, changes are usually small and
gradual. Perhaps if we are to perceive change in
photography, we must look to small changes first.
One of those that I foresee on the horizon is a new
specialist, one that any practicing photographer can
enter directly from his present position. For lack of
an exotic name, I'd call him the Photographer-Writer.

The *Photographer-Writer* is not to be confused
with the *Photojournalist* or the *Writer-Photog-
rapher*. This is not a game of semantics, but one of
determining philosophies. For identification pur-
poses, I consider the Photojournalist one who is a
working press photographer on salary employed by
a newspaper, magazine or press association. His pri-
mary responsibility is photographic with secondary
requirements in getting captions or captions and
additional pertinent details of an event for publica-
tion. Perhaps this may seem an over-simplification,
but the key word here is "primary." Although many
photojournalists do write and quite successfully,
the bulk of their income is derived from photography
and the writing requirement is rudimentary.

The *Writer-Photographer* on the other hand, is
primarily a writer who needs to illustrate his writing.
He could be a free-lance writer and earn his living
with the written word. The price of hiring profes-
sional photographers being what it is, this specialty
came into being because writers simply couldn't
afford the fees charged by the average commercial
photographer. So most learned the fundamentals
of photography and now illustrate their own articles.
This isn't always possible since so much of photog-
raphy requires special equipment, techniques and
processes that the average writer would find more

expensive to try himself than to hire the professional. The difficulty is that one can read an article or fiction piece and determine the quality or lack thereof, but one can't see an untaken photograph. Where a writer in most cases other than on assignment, must submit a finished piece to a magazine on speculation, if he hires a photographer he is expected to pay him regardless of the quality of the content of the photograph. I'm assuming of course, that the photograph is well exposed, sharp, and of the subject the writer wishes.

Another point is relative time. By relative time I mean that the writer might and probably does spend an enormous amount of time preparing a piece for a magazine for a relatively small amount of money compared to the time a photographer takes to take a photograph and process it. As an example, a writer trying to sell an article on tropical fish and needing a photographer to illustrate salient points, would have to spend at least $100 for two or three hours of a commercial photographer's time to photograph a fish tank in color. In most cases, this might very well be as much as the writer would get from the Tropical Fish Journal which might pay three cents a word for a 3,000 word article and ten dollars each for color transparencies. Ninety dollars for the article doesn't draw as well as the combination which might use three or four slides for 3,000 words or about thirty or forty extra dollars. The writer would have to pay the difference between the forty dollars received for photography and the photographer's charges.

The *Photographer-Writer* is probably a professional photographer looking for ways to increase his earnings; perhaps one who is already successful at his work. Just as the *Writer-Photographer* would

have to learn a new trade; photography, in order to increase his earnings, so the *Photographer-Writer* has to learn something about writing in order to sell his work. But again, just as the photographs are a supplement to the writing for the W-P, the writing is a supplement to the photographs for the P-W. You might think that there's no difference between the two. Which comes first, the chicken or the egg? But, there is a difference and quite a large one at that. It has to do with the previous custom of selling and the markets sold to. Illustrative photographers without writing, get at least $250 for one, perhaps two photographs in their regular photographic markets. That is, magazines that he regularly sells to. The addition of the written word is designed to make the photographs more salable. It is not an attempt to sell writing. Again, you may argue; semantics. But maybe an example or two would help clarify the thinking.

A few years ago during the writing of one of my books on motorcycles, I needed a small animal in one of the photographs as a graphic warning to cyclists who ride at night to be ever wary of this type of obstacle. I looked up the local taxidermist and while visiting him, I was fascinated by the way in which he worked and achieved realism. The animals he was working on were for an exhibit for a museum and his poses were natural and astonishingly life-like. With his permission, I borrowed a number of them and photographed them in their own environment. The resultant transparencies had a natural quality with all of the good points of unhurried photography and none of the problems of catching the animal off guard. The problem was, what to do with them? I had decided that any editor would have the same problem. I knew nothing of taxidermy so I de-

cided to search the Encyclopedia Brittanica. In so doing, I wrote, or rather rewrote, many of the paragraphs until I had an original draft on taxidermy. I went back to the taxidermist and in talking with him I found other points. By combining all my written matter and condensing it to 1500 words, I felt I had a salable piece of property. My slant was "Strange Professions." I carefully selected a magazine where I was already known as a photographic illustrator and the editor bought it. I was handsomely paid.

What really made the package salable was that it *was* a package; a complete article well illustrated. Flushed with success, I went over my transparency files with renewed interest. Was there gold in those files I had overlooked? There certainly was. Since then, I keep in mind the above example each time I am analyzing my slides for stock. Many slides have been sold since, by searching the Encyclopedia.

I am certain that alone, many otherwise good transparencies have little meaning outside of their specific purpose, but the expanded photographs-article have a much broader possible use. As an example, I was teaching the process I use in researching for an article to my creative photography class. To make the process difficult I suggest that I'd write about one of their slides. One student produced an ordinary but good slide of a helicopter. All of the following was gleaned from the Encyclopedia Brittanica.

I first looked up the work in the Micropedia IV pp. 1000, and discovered that Leonardo da Vinci was not the inventor. It seems the Chinese made helicopter toys long before Leonardo's time. This column was filled with useful facts that I transcribed, plus no less than nineteen references to various articles that included something about helicopters, with a

major reference in book 1:380g. By reading further and following the references I was led to 2:1032g. Under the subject of Bionics, I found that the helicopter was copied from nature. The Chinese are thought to have seen mapletree fruit pollen falling. Watching the winged-membrane spin about its axis as it fell, they made whirly-gig toys. I won't bore my reader with all the details, but there was enough material to write ten articles on helicopters. Much material is dull and boring and much excerpting and rewriting is necessary. A slant or theme must be found. By taking the slant from toy to useful tool for man, I was able to write a short concise article that sold to a children's text book.

There are a number of advantages for the photographer who explores this means to additional revenue. Besides the obvious one of increasing your own storehouse of knowledge and lining your pockets, I began to understand the needs of editors and writing materially helped me in my illustration photography. It is true that writing is difficult to learn. Writing is an art, a craft and a skill and not easily learned. There are no quick ways to learn, but your needs are not that great in the beginning. I would suggest creative writing courses at your local colleges and high schools as well as adult education courses; most are quite inexpensive. These courses will expose you to "craft" books on writing. Buy a copy or two of Writer's Digest and The Writer. These magazines contain many advertisements of the "how-to" type of books. Correspondence courses are available from Writer's Digest.

On the subject of selling this new combination of photography and words, I find the Writer's Market Book perhaps the most useful tool, since sending a

single photograph to a magazine is like looking for a needle in a haystack. The chances of selling a single or even a series of captioned photographs are limited. The same series of photographs accompanied by a well written article of some 1200 to 3500 words makes it a publishable package. This might not result in an instant sale, but it certainly will result in more than a cursory examination and may very well lead to an assignment. Should it sell, the combined price would be worth more than either the photography or the written article. In looking up Field & Stream for instance, the pay for an article is listed as eighteen cents per word or about $450 for a 2500 word article. They buy color illustrations and pay $150 for the use of one photo. This doesn't mean, however, that your combination is worth $600. The chances are that the editor would offer you some price in between should your article include perhaps a half dozen photographs in color. Your chances of a sale are increased with the inclusion of the written word. This same magazine buys "fillers" of 500 to 1,000 words for a flat $250 not illustrated. Again the illustration increases the chance of a sale.

My suggestions for teaching yourself: pick a slide that has a well-defined object that can be labeled in one word. Look up the subject in the encyclopedia and write out all the paragraphs that interest you. Rewrite those paragraphs into your own words and in some sort of chronological order. Don't attempt to correct punctuation or spelling during this first draft. Rewrite by speaking your article out loud; correct awkward spots, punctuation, spelling, and grammar. By the third rewrite it should flow with clear prose. Type it on single sheets and double space with the title and your name on each page.

15 Photographer As a Contractor

One of the skills a photographer needs if he is to be in business is the ability to see a photographic problem through to the finish, even those sections that would not ordinarily be accomplished by him. I have often beaten out another studio because I was able to visualize the total job and either quote prices for photographic work other than that done in my studio, or contract work for the client and deliver a total job.

No photographer likes to be in the position of quoting or contracting for work he doesn't perform or have direct control over. Yet, there are many situations in commercial photography where the client does not have the knowledge or know the breakdown

of the job and how to get it done. Naturally, he will go to the photographer who can understand which is the best path to take — which way the client should go.

As an example, a large manufacturer of compressors has decided that he needs a photograph of an assortment of the various sized products in one photograph. He intends to use this as a double spread in a sales brochure and perhaps as the heading for a calendar. He approaches you by phone and tells you that some of these weigh as much as 1,000 kilograms (approximately one ton) and suggests that you bring your camera and some twelve-foot no-seam paper to his warehouse.

At this point, should you follow his instructions, you will be participating in what I call a "planned disaster." Even if you do question him as to the room and find there is plenty, and there is plenty of help to move things around, you still need to do much planning. At this point you should suggest that you go to the plant and see what has to be done. It might cost some for you to leave the studio, but it is cheaper than failing the job and doing it over.

During your visit you see that everything is exactly as he said it was, but you realize that you can't deliver what is in his mind. You know he is expecting a transparency of his products all lit beautifully and arranged tastefully on a smooth light blue paper; all with no marks on the paper and the shiny painted tanks and compressors with smooth textures, the photograph set for the trip to the printer. Or is it?

You'd be lucky if he knew the difference between a color print and a transparency, assuming he asked for one, and this struck a responsive cord in your memory, because you know that engravers like to

work from transparencies. Well, you'd be wrong here, because this job calls for a very different procedure.

First, when you see the tanks you find you'd have to run the no-seam sideways since the back horizontal distance is 32 feet. That means two runs, one for the foreground and one for the background. Next, you realize that the fork lifts would raise havoc with the paper in placing the compressors in position. Next, the shiny paint is going to reflect hot spots all over the products and the labels (which are made of metal foil). Obviously a lot of retouching is called for. What to do? Suggest the name of a good transparency retoucher? Not really.

Plan the photography from the end backwards. With all the retouching that is necessary, from large compressors right down to items of accessory nature that are no larger than six inches, you should recommend a dye transfer print large enough to enable the retoucher to work comfortably on the smallest object and to correct lighting problems on the foil labels.

Retouching a 16″ × 20″ or dye transfer print might cost as low as $100 or as high as $700. In this case you estimate $300 from your experience memory bank and a telephone call to the lab outlining what you are planning. The cost of the dye is $200. In order to give the dye the best chance, you elect to use the 8 × 10 camera. Your fee at the time is $400 plus expenses.

The planning is simple, you arrange to eliminate the paper altogether as a futile exercise. As it turns out, you are lucky that you are going the way you are; you have to shift those compressors inch by inch, composing on the ground glass. (Another reason for the 8 × 10.) You estimate that you will need four 1000w Quartz lamps with umbrellas to soften the lighting on the shiny objects.

The client is informed of the planning at this preliminary meeting. You also tell him the cost estimates and assure him that approximately $1000 will be his total cost, not all billed by you since all you would do would be to act as the photographer. You will send him to the right lab and show him what to ask for. Billing will be direct. If he elects not to follow your recommendation, you will have to say the hardest thing in the world for a photographer to say: No, you will not take the job.

He sees the logic in your reasoning and he has confidence in your ability to know *which way to go*. You agree to work at night so as not to interfere with manufacturing. Within a few days you come to the plant and set up the shot on the 8 × 10 camera.

You spend about three hours arranging the products according to the ground glass. Your assistant sprays the shiny areas since you want some detail in the highlights for the retoucher to see. No matter where you place the softened lights, there are numerous reflections.

You process the transparencies and send them to him with instructions to send them to the lab. You even give him instructions on how to write his order since he can see things in the transparency that needed retouching. He orders the dye transfer and orders the retouching. Which, by the way, included blowing in a complete background. You want a seamless background but the client elects to have the junction of the floor to the wall show.

The retouched dye came back to him and is approved and goes to the printer. Another satisfied customer.

The photographer has to know *before* he shoots what the client intends. Another type of job might require going to a color negative due to excessive

mercury vapor lighting and then to a print film. (See Chapter 41 on Color Printing on Films.)

Still another job might be to bring a photograph up in stages. For an aerial shot on $2\frac{1}{4} \times 2\frac{3}{4}$ transparency material, have an 8×10 internegative made and then to a mural print 4×6 feet.

Supposing you needed a fine dye transfer print 30×40 for a client's executive offices and the original was a $2\frac{1}{4} \times 2\frac{3}{4}$ transparency, would you order a dye transfer 30×40 without further instructions? No, you should order the size dye all right, but you should preface your order with a request for "enlarged separations" since the enlarged separations enable you to bring the quality up by bringing the number of diameter enlargements down.

Do you know enough to ask for masking? Do you know when you need a highlight mask? or a contrast reducing mask? The best way to order such things is to suggest to a good lab that they make enlarged seps and mask where necessary. If you are dealing with a high class laboratory they might suggest these things. Then again they might not. You have to know, if you're going to play the game.

I have often done multiple assemblages for whisky companies that require a generous amount of retouching and air brushing with the price going to $750 per print. I doubt if I would suggest that for all clients, but you have to be in the position of knowing which way to go.

Some of my best portraits of executives were 35mm Kodachrome slides, made into enlarged separations and then into dye transfer prints 16×20. You'd have a hard time determining the size of the original after seeing the prints—but then I had customers who could afford that kind of work.

Whenever you're called by the client the tendency is to grab the 35mm system. It's the lightest and easiest to carry and to use. (See Chapter 17 on Choosing a Camera System.) But, if it's not the best suited for the requirement, you are remiss in your responsibility to the client. Not every job can be or should be done on a 35mm or an 8 × 10 either for that matter.

Even when the art director from the advertising agency or the client is in the studio and suggests a certain system, you have to make an independent judgment. Of course you explain your reasons.

Contracting includes hiring models, stylists and the buying of the props. Most clients hate that kind of work. They'd rather pay you to do it all. Recently, a client wanted a wall built in the studio. Their regular photographer had a studio large enough but he quoted high thinking that they would come to him anyway. They happened to call me and I devised a three-room-wall in the shape of a "T" that would let us photograph three rooms out of one wall structure. This affected an enormous savings over the quote from the other photographer and I got the job. I painted the walls after I built them and, incidently, learned new carpentry skills. I furnished the area with their help and hired the models. The job was successful and led to many others. I find many photographers are lazy and just as many take advantage of the client.

Bidding on jobs is something I have never done. That is, I won't alter my prices. I have found that art services often ask for bids and then use my bid to come in underneath with their own. So now I don't bid on anything. This isn't to say that some commercial studios shouldn't bid. If they have reprint

facilities and mass-production photographic services, there is much work in black & white photography including reprints, that would utilize those services and facilities. My type of operation is interested in original photography only.

The question that always comes up is do you go to transparency or negative? You can't answer that by saying you need a print; therefore, go negative, because many advertising agencies use dye transfer prints that are best made directly from transparency. Where reproduction is the purpose of the photography it's best to go to transparencies. Transparencies are more difficult to take since most corrective measures must be taken before exposure. Little can be done by the average photographer to correct transparency errors except reduction in Colorbrite. (See Chapter 37 on film processing.)

Transparency retouching is an art and you should soon find out where the best person in the locality works. I have had many expensive photographic assignments saved by the two or three people that I know. They can change a product color, combine two transparencies, bleach any color to a hue, shorten skirts, draw in objects; the list is endless. The work is expensive; most work starts at $100. The price might be considered inexpensive if models are involved.

The more skills you learn regarding contracting the overall photographic assignment, the more you will be used. I have touched lightly on the subject only to tease the newer commercial photographers. I have left out the obvious such as the selection of models, clothes, the stylist, locations, assistants, carpenters and grip people, yet all of these come into play in a big assignment.

I've rented yachts, mansions, limousines and aircraft; travelled all over the world on assignments to build a storehouse of knowledge about my craft, all of which stands me in good stead.

16 Organizations, Exhibitions & Awards

Of course you must belong to trade organizations, but which ones? It depends on you and the type of social person you are. If you're a joiner and you like people, join them all. If you're a loner and join for gain of information or contact with other photographers to learn, join those that have something to offer you.

Every profession has little nuances of inside information that can only be gained by being "in." Reading the trade journal of the association is not just informative chit-chat regarding other photographers; it has vital, factual articles that are privy to the members, information that can be turned into either profit or a warning against a loss. Many of the

articles are of the "how-to" variety and teach a way of doing business or who not to do business with. In all honesty, I would not give up certain memberships no matter how bad business ever became. And some of the associations I belong to have been so useful that if I paid dues for the rest of my life, I would never equal the value I have received.

For the beginner, I recommend joining those organizations that have private newsletters or bulletins, but subscribe only to the magazine of those associations that have separate magazines and membership plans. Read the magazines for about a year and then see if joining is worthwhile.

Some associations are not open to anyone but the successful, such as the American Society of Magazine Photographers. Others such as the Professional Photographers of America, although having a magazine that you can subscribe to, are worth joining when you are engaged in photography as a full time business.

Photography as a business or hobby is world wide and some of the most prestigious photographic groups are in the British Isles and Europe. The best known of these is the Royal Photographic Society of Great Britain. Although it's not a professional group, many professionals are members. They have a system of graduated degrees from Ordinary member to Associate and Fellow—each more difficult than the previous.

The professional society of Great Britain is the former British Society now called the Institute of Incorporated Photographers. The word "Incorporated" is similar to our word "Professional" and they have a series of degrees starting at Licentate, Associate, and finally, the Fellow. This association

might be considered similar to the Professional Photographers of America in the United States whose degree system follows with Member, Craftsman, Master and what I call the Super Master—the Master-Craftsman.

Other societies are the eminent Photographic Society of America, mostly made up of amateurs, although many professionals are members. In almost every country of Europe and every other continent there are photographic societies: Japan, Australia, many countries in South America, India, Africa and Europe. Europe has one association also that purports to represent all factions; it is Europhot. There is no degree system, but membership is divided into classes such as individuals and corporations.

What do these mean to the professional photographer? Quite a lot really. Ordinary membership in most will give you an overall view of photography and if you are a participant, the attendance at the sponsored lectures and demonstrations should materially improve your ability. Submission to the contests will soon tell you if you're as good as you think you are, and if you are selected to receive a merit, you are on your way to a degree.

What good are degrees? They're very important until you have all of them and then suddenly they're not important at all. But, until you get there, they do boost your ego, give you the respect of your fellow photographers and to a point they are impressive to your clients and help your income. This is especially true of the general portrait and commercial studios all over the country.

They are not important at all to the big illustrator or the photojournalist who is probably more interested in the National Press Photographers As-

sociation, another respected group with similar steps and contests or exhibitions. Almost all newspaper and many magazine photographers belong to this group.

The freelancer and the illustrator are a breed that crosses lines of all associations, and I suppose that at one time or another they have belonged to one or the other as their needs dictate. I see no need other than a consuming interest in all facets of photography to join all you can. As to trying for the degrees, etc., again, if you're in a studio and can turn the awards to public relations value and impress your clients, then, by all means do work toward them. Remember that all of us like to be recognized and this is one way that recognition comes from your profession and is accepted by the general public. Actually, the general public places more respect on some of these degrees than they're worth.

The tendency is to identify the degree in photography with something comparable in another profession such as medicine or law. Personally, I am ambivalent about the value of the degrees. I think that at certain stages of a career, they're important, while at others, they really have little meaning. You can certainly be quite successful without them as many a famous photographer will tell you. But I do think they serve a purpose for the beginner.

By all means join a local group or at least visit with them. You should gain insight into the competition and some of the lectures are worthwhile although by and large there are few very good speakers at any one convention. When you consider the cost and time, I question the worth.

For the journalist and the illustrator, the group that is important is the ASMP mentioned previously.

The Bulletin they publish is more than worthwhile and the ability to hobnob with the greats of your profession is worth the price of admission. However, you have to have demonstrated published credits before you're sponsored and the sponsors have to be members. Once a member, it's a shame not to attend meetings and contribute. Of course, this is true of any organization you join.

Exhibitions are a horse of another color. The type I refer to is a one-man show of your work. I think they're vitally important to your career and when you're asked, exhibit. It will prove costly since there is no fee or other renumeration. If the exhibition is local the publicity will more than pay for the effort. Many banks, hospitals, schools and colleges are available for exhibitions.

In most cases, you should wait to be asked, but there's nothing wrong in letting people know you're available. The problem is that many pushy type photographers do get exhibited since they go right after this type of show. Most people get turned off by those who ask. My thoughts are that you know when you're good enough for a show, so ask; but try to be subtle and in good taste.

Exhibitions add to your track record and overall general public image. They are vital if you are in business, especially so if you have a studio. An exhibition is a form of advertising and because it isn't blatant, it carries more weight. Perhaps its appeal is snobbish. The general public thinks of exhibitions of crafts as artistic and intellectual, rather than commercial. This is another reason for your participation.

Exhibitions for photography are held all over the world and having a photograph exhibited in the National Gallery of Poobah under the auspices of the

Socialist Republic of Arts & Sciences sounds awfully prestigious, and yet might be nothing more than just another exhibition looking for stateside exhibitors. A press release or a notice to the editor of your local paper might result in a free plug in the news columns. Whether or not these are worth the trouble depends on your needs for publicity and prestige. The fact that the exhibition is abroad appeals to the intellectual snobbery of most readers. Similarly, your photograph from the "States" improves the Republic of Poobah's exhibition.

For all the value of these exhibitions, the general marketplace is usually the best "exhibition" of your work. Many photographers who have sold to the editorial or advertising side of national magazines use these tear sheets as proof positive of their "exhibition." There is a distinct advantage of being published in Life, Look and Playboy—an instant recognition and prestige, as well as that staff of life, money. The funny thing about the photographs that appear as ads or supplements to editorial or article writing, is that they rarely appeal as a visual entity. That is to say that they rarely are considered good photography when viewed without the written piece. This is the best way to judge the value of a good editorial photograph; it complements the written piece and yet is supplemental to it. If it is more powerful than the words it has failed as an illustration in this sense. I sincerely doubt that the best magazine illustrations would be awarded points in contests; yet, they command the highest fees in photography. Conversely, I doubt that many prints awarded points would be useful as illustrations. Which came first—the chicken or the egg?

What has been said above applies to awards, too.

The awards can be written on your stationery or following your name. A string of titles is impressive. We have all overdone this at one time or another. No getting away from it, being a Fellow of this and a Master of that and being able to enumerate those degrees is what the academician lives with and you may have to join the crowd if you wish the prestige and wish your circle of influence to increase. People who tell you it's unimportant are envious, jealous or vicious. The problem once again is taste. Exactly what is good taste? The image of the modest recipient of a degree, standing there bashfully, endures; yet, practice assures that he worked hard to achieve it. The difference is between unpretentiousness and obtrusiveness. Yet, a certain amount of aggressiveness is necessary if you are to achieve success.

Awards are good publicity and more so if accompanied by a photograph. Editors are looking for news items about people. You'd stand a better chance of getting noticed if you're a steady advertiser, too. Those who are illustrators, of course, don't advertise locally, if at all, so the problem of getting coverage exists. Then, too, they rarely need notice locally. The type of publicity that would be useful would be an award at the local Art Director's Show or some national award such as a grant from the National Endowment for the Arts or a Guggenheim Fellowship or perhaps the granddaddy of them all, the Pulitzer Prize for Journalism. Awards at this level are much more difficult to obtain.

Many of the greatest photographers receive honors from abroad. Soliciting these is most difficult, and there's almost no way one can go after them. They're something that come to you with age and experience and after many lesser honors.

As to the effect of your Fellowships, Exhibitions and Awards on art directors, clients, and other photographers, yes, they do impress. After all, these are the accouterments of the successful photographer and are known as such. They may gain you attention and entrance to the inner sanctums of the creative types. Still, the burden of proving yourself remains. As an art director once said to me: "Robin, you're only as good as your last photograph."

17 Choosing a Camera System

When a photographer receives an assignment, he has to make a choice as to what size camera and lens he is to use (I'm assuming that the photographer has a full studio.) Under a given set of circumstances, there is a specific camera and lens for each job. Which way to go is a question that plagues many an art director as well as the photographer.

One misconception is that the main difference between camera systems is size alone. The thought being that if you choose a comparable lens for a given size the angle of view and the depth of sharp focus will be the same for the comparable camera and lens. A quick example will make you aware of this problem; a 35mm camera with a 135 mm tele-

photo lens is not uncommon. And the effect of that lens is known to thousands. The isolation of the image, the quality of the background in a photograph exposed at say f2.8, and the total impression, is common.

To achieve the same effect with an 8 × 10, to go to the other extreme, would require a 650mm lens. That's just the focal length. To get the same isolation feeling that the f2.8 has, you'd need a f2.8 650mm lens. The diameter of the lens barrel would be at least one foot! *There simply isn't any way of duplicating the effect of one camera with another.*

A 4 × 5 camera would require a 500mm lens to match the 35mm in photographic imagery. Even this lens barrel would have a diameter of 8 or 9 inches. There are no lenses of a comparable nature.

Conversely, the 8 × 10 camera and lens can do things that the 35mm can't do. For one thing, the shadows and highlights will have much more visible detail. For another, lighting can be more contrasty since sheer size allows you to see into the shadows and the lighting need not be quite so carefully controlled. A contrasty lighting in 35mm will block up the shadows quicker than with the 8 × 10 camera.

Because of size, most large format camera lenses rarely have an aperture wider than f5.6. This automatically eliminates the isolation mentioned before; but, conversely, the aperture stops down to f64 and some to f128 for super depth of focus.

So those are some deliberations in the choice of a camera system for a given job. There are many others such as the one major consideration—sheet film or roll? Sheet film outdoor has an ASA of 50, roll film can go to ASA 160. The same comparison can be drawn with tungsten film; indoor ASA 32 for

sheet and ASA 125 for the roll. This consideration becomes important if live models are to be used in an outdoor setting. The roll film has the advantage of being able to stop the motion, since a higher ASA allows the photographer to use a higher shutter speed.

Strobe in the studio can be used with either size without regard to the ASA, but then another limitation arises — portability. A view camera must be tied to a tripod whereas a roll film camera, say a 120 size can be portable. This is a must with fashion photography. There are some cameras such as the Gowlandflex and the Linhof and Horseman, and some of the Plaubels that are portable 4 × 5 cameras, but I know of no 8 × 10 portables.

The viewing system is also a consideration. Most view cameras are viewed through a ground glass. The cameras mentioned above have reflex viewing for portability, but again, not an 8 × 10.

The quality of the image in so far as grain is concerned will control the choice of systems. Certain subjects need a grainless super sharp feeling. I would say almost all catalogue photographs of products need the smooth, clean, clear feeling of the large format. Although mood can be achieved in the 8 × 10 and even false grain, the 35mm camera might be more selective and moody than the large format.

Another determination: what is the quantity of exposures needed? Fashion shooting usually requires a large number of proofs from which to select *the* one. The use of models requires a choice because of movement, expression, feeling and composition. A photographer shooting with an 8 × 10 rarely shoots more than 12 photographic plates; a photographer shooting a moving model will expose two or three

rolls of 36 exposure film. An 8 × 10 of a food ad needs only one good transparency. It might, and often does take all day to prepare food with a home economist or a stylist, the shooting taking place late in the day. A half dozen sheets are exposed only to bracket the exposure and one transparency is what is needed.

Optical lens attachments rarely come in anything over Series VII in size, so if special effects are desired then the 35mm camera is chosen. Special filters, multi-image lenses and distortive attachments such as the fish-eye, are all made in sizes too small to fit the larger cameras. Even the 6 × 7 size has less lens attachments available than the 35mm camera.

Special lighting usually means the large format where the lighting can be viewed on the ground glass. Foods, liquors and other still lifes lend themselves to the view camera.

Some nature photographers use the view camera for the quality of the detail, the sharpness that is inherent in the larger size camera. The nature documentist has enormous problems with wind because he needs to stop down for depth and use a slow shutter speed since the film is so slow.

There are many obvious applications for the smaller camera such as sports photography where action dictates the need for features such as portability, light weight, and the ease of operation.

Weight has become a problem. Many wedding photographers have gone to the new 6 × 7 cameras and although they are happy with the new images, the effect of carrying one of those all day is enough to make a strong man blanch. The new wide camera straps help, but the weight is still there. I don't feel sorry for them because I carried a Speed Graphic

with a wet cell battery pack for years. Nothing in photography since has ever felt so heavy to me.

Portrait photography started out with 8 × 10 cameras and few dared to use anything less for years. Today there are some new changes in feeling. The new VPS films have much superior grain structure (finer) and the newer computer designed lenses are so superior in optical performance, enough to make fine portraits on 35mm film. The quality seems to be equal to the 4 × 5. That's a broad statement, but I have some astonishing 35mm portraits I have made on location for annual reports.

So far, I have drawn the comparisons using the 35mm and the 8 × 10 view camera without regard to the cameras in between, such as the 4 × 5 and the $2\frac{1}{4}$ square and the 6 × 7 cameras (ideal format) so that the differences are noticeable. The cameras in between have their characteristics, too, and comparisons can be drawn in one broad area — in between the lense shutters and focal plane. The advantage of the between-the-lens shutter is that you can synch for flash at any shutter speed. One other minor advantage is the ability to purposely double expose. (Cocking the shutter doesn't wind the film.)

The advantages of the focal plane shutters are more numerous: high shutter speeds are possible, larger openings are possible since the size of the lens isn't restricted to the size of the shutter, less cost, no duplication of shutters, less weight for a given size lens and opening, and longer focal lengths.

What all this means in choosing which system for the client's job depends on requirements. For all around uses I opt for the focal plane shutter cameras.

Often the art director has some knowledge of photography and might suggest a camera size. This

request is from the position of ignorance and the photographer would do well to explain all the reasons why he chose this or that system. But, above all, the ultimate responsibility rests with the photographer; he should choose that system that is best for the job. Of course, this implies that he has at the least three systems: a 35mm with most lenses and all attachments, a $2\frac{1}{4} \times 2\frac{1}{4}$ or a 6×7 camera system with most of the lenses, a 4×5 view camera and at least three lenses, a wide angle, a normal and long focus lens.

Anyone with a commercial studio must have an 8×10. One large advantage is that many art directors select the photographer who has the best facilities, especially if his requirement calls for large format photography.

18 Cameras; Buying, Selling & Servicing

There was a time when in changing camera systems, all the photographer did was to take the lens out and buy a new box such as the Speed Graphic. All his lenses and accessories fit the new camera. Even those of us who used either 35mm or $2^{1}/_{4} \times 2^{1}/_{4}$ cameras such as the Rolliflex or Rollicord had little invested that could not be used with the new camera. Even the 35mm camera had interchangeable lenses that fit the newer models from year to year. A professional photographer could be in business with as little as a thousand dollars worth of cameras and lenses.

All of that is past now, and not just because of inflation or the high original cost of equipment as much as the fact that cameras for the professionals

are rarely sold as a one item purchase. Today one buys the "system" which means that the photographer needs a full complement of lenses, filters and other front matter, extension tubes, and an enormous amount of smaller accessories that I would call minor except for the prices.

So today's cameras are truly systems, and it behooves a photographer purchasing any new equipment to be darned careful what he does. He no longer has the liberty to purchase a camera, and if it's a mistake stick it on the shelf and buy another one, with the loss being the investment in that camera. The camera is only the beginning, and it's a foolish photographer who doesn't realize this fact. Not only that, your monetary investment is easily ten to twenty times what you used to pay for a single camera. Buying a Hasselblad, Pentax or Mamiya medium format camera today will cost you ten times the cost of the camera for the accessories. One can't get away with just the old fashioned three lens outfit of a wide angle, normal and telephoto.

The 35mm systems have grown to fantastic proportions. Just pick up any photographic magazine and look at the full page color ads by Nikon, Pentax, Cannon, Minolta, Olympus and others. All of these companies show as many as twenty lenses and even more, not to consider the accessories. Today everything is modular. The professional's view cameras come in modular pieces, the theory being that he can choose those components best for his type of work. The problem is, it is a rare photographer who can get away with needing a bare, plain camera. Photographers are finding that they actually need the many accessories. And each of the small items are expensive. Care should be exercised in buying es-

pecially if you think the day might come when you will want to sell that system. You will want to sell the small items too. Usually these wind up as give-aways, expensive ones at that.

Anybody good at solving jig-saw puzzles ought to be good at selecting a camera system. The inter-relation between all of the filters, adapters, lenses and other components requires great thought and much planning. The otherwise simple selection of a lens might very well mean scrapping all your filters to change to a new size. I have some eighty filters for three camera systems; glass and gelatine. Fortunately the gelatine will fit all cameras. The glass filters that are in series can be adapted, but the filters fitted to lenses must have a separate adapter ring. After a year or two a professional is carrying all sorts of rings and tubes and paraphernalia in a case that reminds one of a woman's handbag.

Many of the new lens accessories such as the Spiratone lens attachments are made in various sizes. It would pay to buy the largest or series VII or VIII since reducing adapter rings enable you to fit it to smaller lens diameters. However, the effect is different. Not always, but enough to make you think twice which size to buy. Many of these attachments cannot be used on the telephoto lenses and some can't be used with the new 6 × 7 cameras, beyond the 200mm size. This means separate attachments for tele lenses. When I get into that kind of bag, I use a tele-extender and the smaller lens that enables me to use the attachments and filters I want.

The camera case problem is another costly venture for the unwary. I used to buy fitted cases made by the manufacturer of the camera. These were always over $150. They are velvet lined or red plush

with dividers for specific lenses and other items. Then you sell the camera system and the case goes for little. Now, I use the FibreBilt and make my own compartments. So much for buying.

Selling is another story. Here too the increase in the cost of the system and the small expensive related items have just about made selling impossible. Where just a camera would move quickly or could be traded easily, the system with all the extras raises the cost to the point where few can afford to buy even if they know how to get in touch with you.

The local camera shop really can't help the professional move a system; an isolated piece yes, but rarely a full system. Other professionals can be reached through the trade magazines, but I find this "chancy"; a hit or miss situation and expensive to boot. By far the best place to advertise used equipment is in SHUTTERBUG ADS, Box #730, Titusville, Florida 32780. This newspaper is growing by leaps and bounds and eventually will be the spokesman for everyone in photography who wishes to sell, buy or swap. The ads are inexpensive and the subscription reasonable. If you contemplate buying a system this might very well be the place to start looking. Excellent used equipment is much less expensive and bargains can be found. If you are selling, this is definitely the place to advertise. A word of advice; the subscription may be sent to you 3rd class mail or 1st class. I suggest 1st class. Good items are snapped up by phone when the issue arrives.

Selling equipment brings up the problem of price. In general photographic items are worth about 50% of the list price if they are in good condition and are common items. Antiques and rare valuable lenses can go for the original list without any trouble and

some items have increased in value. Selling too quickly can cause you to lose money. Twenty years ago, I sold a fine Speed Graphic for $125. Today it is still worth the same. I remember selling an Omega D2 Enlarger with lens for $100. Today it is worth more. Inflationary prices mean that your used equipment is worth more than you think.

Try for a discount when buying new equipment. Most stores advertise new equipment at a reduced price. Take advantage of these prices. This is another reason for selling used through another source. If you trade used in on new you lose both ways. You won't get enough for the used and neither will you get enough of a discount. Sometimes you can get enormous discounts on new cameras and accessories if you're willing to take last year's model. This could or could not be worthwhile; in the more expensive models like the Hasselblad, this is worthwhile as there is little or no planned obsolescence. Every few years there are major changes, try to get in on them the first year. Many photographers try to wait a year so that the bugs are ironed out of a new model. I am the opposite. I like the new invention.

Servicing is another horse. Years ago, you wouldn't think of not sending your latest back to the factory. Today that is simply not the best way. Except of course, if you are still under guarantee. If not, there are many excellent repair shops with many fine craftsmen perfectly capable of handling the most intricate and difficult repairs, often at reduced prices. I would suggest establishing a relationship with one in your area and send your cameras in on a regular basis.

Most problems other than the obvious; sand, water etc. are related to the fact that the cameras

are not used at a variety of shutter speeds nor are they used enough. I run my cameras on the motor drives through each shutter speed at least ten times, once a month and move all the working parts as much as I can. Blow the dust out as often as you can, especially if you are using your equipment constantly. I rotate my cameras; changing the motor drive to the spare once a week and keep using each camera equally.

Servicing the camera means repairs. Nobody wants repairs. The way to avoid them is to have them checked regularly. I have my repair man put a press-apply label in each camera with the date of the last check; I find preventive maintenance easily less expensive than waiting until trouble develops.

19 Lenses; Wide, Normal & Tele

There was a time when a photographer bought a wide angle lens so he could photograph in close; a group or a building or for whatever. Most of those early photographs showed the wide angle used for "flat" images; everything spread out. It was the architectural photographer who first used the wide angle to "draw" perspective; showing the dramatic effect of diminishing perspective and the use of near and far objects in sharp focus.

The wide angle soon became one of the most popular of all lenses. They are made today in all focal lengths for all cameras from a 35mm to an 8 × 10 view camera. The same effects are possible with all

systems, with the possible exception of a fisheye on the 8 × 10. Yet I often find them misused.

Generally, I believe that wide angles should be used stopped down to that aperture where every part of the view is sharp. Wide angles that have blurred, out-of-focus areas are failures as photographs. Couple this rule with another; that every wide angle photograph should contain a near and far object and you almost can't fail to have a good photograph. Look at it this way; sharpness is one of the original criteria for the judging of a photograph. The sharper the better was the rule years ago. In wide angles the addition of looming foreground objects, diminishing lines of perspective and tacky sharpness throughout, make this type of photograph.

When using the wide angle look for a near object, look for strong lines that can be used for perspective, and look for a far dynamic object to tie in with the first two. Set your aperture so that the near and the far are sharp.

Remember, a good wide angle has no linear distortion so don't buy it if when you aim the camera up the straight lines curve. There is no need for that kind of lens anymore. However, the fisheyes do curve, but that is their virtue. A good wide angle should sharpen from two feet to infinity by f16 or thereabouts. Preferably they should be multi-coated. All of the above applies to 35mm camera lenses to the 8 × 10 View Camera lenses.

The wide angles and normal lenses on a view camera can do astonishing perspective tricks. One that comes to mind is the famous Scheimpflug rule trick that places all objects sharp from about six inches to infinity when the film plane, the lens plane and the subject converge at the subject plane.

If you are buying for a 35mm camera you will want more than one focal length. My favorite is the 21mm, but I like the 28mm for some effects and I call the 35mm wide angle a "wide normal." When you go to the 2¼ square or the 6 × 7 camera or "Ideal format" camera, the 90mm becomes the "wide normal" and the 75mm a wide angle and the 50mm about the widest without distortion. When you arrive at 4 × 5 wide angle lenses there is another consideration: displacement. Swings and tilts require adjustments. If your wide angle just covers the plate diameter such as a 65mm wide angle, you have no room for adjustment. The 90mm is the most popular and common. When you arrive at the 8 × 10 camera, the 121mm is the widest with full coverage and no vignetting. More popular is the 165mm lens and some like a 200mm for a "wide-normal." (300mm is considered normal).

Because of an optical consideration — very little depth with large view cameras used in the studio — it pays to use the widest lens possible. Depth of focus is an enormous problem, especially in such things as product photography. (see chapter 32).

Wide angles are not too good in portraiture; they have a tendency to widen the face making the nose broad with the eyes spaced out. Even a normal lens is not considered a good lens for head portraiture for the same reason. However, where grotesque effects are desired, a wide angle is the way to go.

Fisheye, Birdseye and ultra wide angle lenses make interesting but highly distorted perspective photographs. When used without thought, the photographs are poor in content, when good use of the distortion characteristics is made of these lenses, successful pictures result. Just as when the regular wide

angle is used to compensate for lack of creativity, it sometimes shows; the photograph has a contrived look about it. Fisheyes and Birdseyes fall into this category. It's difficult for the photographer not to resort to the strange effects of a fisheye when he suffers from a lack of imagination or he's exhausted his ideas.

The wide angle lens is also best when used in closeup photography, not necessarily macro but where the near object is perhaps six inches away. An example that comes to mind is a vertical view of a crab on a beach close and people walking along the water's edge in the distance, both subjects tacky sharp. Such photographs are striking. Add a polarizing filter, a slight underexposure and you have a winner and more important, a salable shot. I know. I did this one.

I often shoot blades of grass, flowers with a bee or butterfly and a tied-in background; these have a ready market.

Normal lenses quickly fall into disuse when you become adept with the wide angle and the tele. My normal lens is used for low-light-level photographs only because of the f 1.4 opening.

I also use the normal lens when I imitate snapshots for nostalgic assignments. Sometimes the normal is used for documentary type photographs, but again just where the light levels are too low for slower lenses. The normal lens is not as popular with the 35mm cameras as it is with the 4 × 5 and 8 × 10 view cameras. Where the normal can be, and often is, eliminated when purchasing a 35mm camera, they are a must with view cameras. There are so many uses of the normal lens in the studio that one simply can't do without one. They're used for copying, small

object photography, all types of catalogue, architectural and general commercial photography. The normal lens is almost indispensable, yet I see little need for one with the 35mm camera. Most photographers in recent years buy bodies and separate lenses. For something approximating a normal, they use the 35mm focal length. This has been brought about by the increased ability of such companies as Kodak and Polaroid to produce cameras with normal focal length lenses that will take a photograph, albeit a snapshot, that is almost a duplicate of what the professional takes with the normal lens. The further away a professional can get from duplicating the amateur snapshooter's photographs the better. Of course this is an over-simplification in stating the case, but a viable consideration nonetheless.

If you contemplate buying a 35mm camera with a normal lens, buy the main feature, the large stop or aperture. True, it is not as sharp as the same focal length with a lesser stop, but only at the edges not the center. Sometimes this is reversed, so read the test reports before buying. You should read all test reports on all lenses before buying.

The teles are something else again. I shoot teles wide open, very rarely stopped down at all. Originally, the telephoto was used to "bring something up close," perhaps something that was inaccessible. As with the wide angle, the creative photographer has found other creative uses. One of the most common is the "isolation effect." It is characteristic of the tele that the depth of field is extremely narrow at any aperture and especially so wide open. This can be turned to good use. Visualize a crowded street with either cars or people. The tele of, say, 400mm held wide open will isolate one or two people or one or two

cars placing emphasis on the subject while at the same time the optical effect of the out-of-focus surrounding area becomes artistic with balls of colored light mimicking the full-open aperture. A blur or out-of-focus area in a telephoto has the character of an abstract painting; the same blurring in a wide angle lens is "mushy."

Real long teles such as a 400 with a tele-extender to 800mm or a straight lens of 800mm, shows considerable compression that improves the pictorial quality of the photograph. When aimed at a highway as an example, the highway climbs straight up and out of the photograph. Should there be a curve or so, the highway becomes a twisting ribbon climbing up the photograph. Fifty cars normally spaced as on a freeway look as if they are stacked one on another.

The fashion photographer would be lost without the tele for the candid effect of sharp isolation. The model is usually told to walk up the street smiling at people, swinging her bag and swishing her skirt. The finished photograph has all the elements for pleasing the client—a sharp, well defined product in an unobtrusive, yet attractive background. If the photograph is in color, the specular reflections make balls of vari-colored lights. Should the photograph be back-lit as well, the effect is astonishing.

Teles for the 4 × 5 and the 8 × 10 are almost non-existent. There are a few for the 4 × 5 and almost none for the 8 × 10. What lenses are available are highly priced for the limited use. The most popular, and therefore the most reasonable, are the lenses for the 35mm camera and perhaps the 6 × 7 cameras. Even these are not inexpensive. I would recommend buying tele-extenders to save money. The price of a 600mm lens might be around $1500 for a high qual-

ity camera. A 300mm lens might cost $300 and a tele-extender certainly not more than $50. True, the optical quality is not quite the same and there is a loss of two stops effective exposure, but all the optical feeling is the same as with the longer telephoto.

Another consideration is that the tele-extender is useful on all the lenses, but is rarely used with wide angle lenses. It doubles the power of whatever lens it is used with.

Teles are used with another gadget: extension tubes. These give different effects than the straight tele or the tele and the extender. This effect is a creative tool for the working pro. I use the effect in the studio for fashion. Use a short tele, say, a 150mm on a 35mm camera or a 250mm on a $2\frac{1}{4}$ square or 6×7 and focus on the model. Everything else becomes highly distorted and out of focus. Now, focus ten feet inside her or closer to the camera, place her so that she has backlighting and expose for the shadow side of her. She will become abstracted. I call this "defocusing." It's a separate effect from just out-of-focus. There are almost two figures in the photograph, one a shadow of the other. I have used and sold this effect many times. (A must when you have a product and wish a model in the background out of focus.) Ordinary out-of-focus looks mushy; this type of shot, the defocused, has character and drawing which gives style to an otherwise mundane photograph.

I am a believer in buying cameras with a focal plane shutters. This is especially important in considering larger than 35mm cameras. My reasons have a lot to do with the image quality. As an example:

Shutters between the lenses weigh more and be-

cause the size opening in the shutter governs the largest aperture, most between-the-lenses apertures are one or two stops slower for a given focal length. This is usually apparent in the telephoto lenses. The cost is more for between-the-lens shutters and focal plane shutter cameras have a higher shutter speed, such as 1/1000 instead of the 1/500th that is prevalent in the between-the-lens cameras. So aperture, shutter speed, cost and even weight are important considerations. On the down side, the focal plane shutters don't synch at every shutter speed, usually around 1/30 or 1/60th of a second. So far this hasn't bothered me, either in the studio or on location. Some photographers suspect that I suffer from ambient light creeping in. Frankly, I find this an advantage; it takes away the "flashy" look to a strobed photograph. One last consideration: shutters that are not used in one month are off speed. If you own six lenses with between-the-lens shutters, test each of the shutter speeds on each lens. They will vary all over the lot. A focal plane shutter admittedly is more reliable. When it does break down, you have lost the use of the camera. A plus for the between-the-lens shutter is the fact that one may make double exposure more easily — a doubtful advantage.

Fisheye lenses are an aberration of the wide angle and most started as attachments to the prime lens. I have, and regularly use, one made by Spiratone. It is most efficient and attaches to any prime lens up to around 55mm in diameter. This means that it can be used on view camera lenses such as the 150mm Caltar or Symmar. Thus, fisheye effects are possible on view cameras.

Manufacturers of cameras are all making prime fisheye lenses. Most are well made and most incor-

porate filters. A real good one will have no linear distortion when held perfectly parallel with the earth plane. Some of my best pictorials are made with these lenses held parallel and then the center cut out. The effect is super wide and arrow-straight lines. Live models must be carefully placed to prevent grotesque distortion.

Filtration has become a problem with the large wide angle and the large telephoto lenses. The price of the individual glass filters makes owning a full set prohibitive, especially so for the professional owning two or three systems. Most professionals have resorted to the gelatin filters with the filter rings; a practical and inexpensive consideration, especially for the filter-freaks such as myself.

20 Fine Tuning with Filters

There are many popular misconceptions about photography and of all of them, the idea that there are many photographic situations where filters are not necessary, is the most untrue. So little is taught regarding the use of filters that they have become unimportant accessories to some or bothersome and needless hindrances to spontaneity to others. Yet, the difference between the real professional and the beginner is in the fine-tuning of a photograph – the use of filters.

Understanding filters is really not that difficult. Breaking down all filters into easily digestible portions is the first order. The first and most important group is the *Light Balancing Filters*, next come the

147

Color Compensating Filters, then the *Color Conversion Filters* and finally the *Special Effect Filters*.

Light Balancing Filters are used to change the color quality of the exposing light to achieve proper color balance with artificial light films, and warming or cooling with daylight films.

They come in coded series and are known as 81 and 82. Memorize the fact that the 81s are all yellowish and warm the photograph; the 82s are in varying shades of blue and are cooling filters.

Use common sense. If you are outside and the sun goes in or the day is grayish, a medium 81 Wratten series would add yellow to your otherwise blue day and warm it up a bit. Conversely, dawn and sunset are times of day when the light is yellowish. So the use of an 82 series filter would correct the light and add a touch of cooling to otherwise yellowish photographs. If my reader has never used either of these, he's missing something, probably money, since the client doesn't know what is wrong with the photographs, but he knows something is wrong.

Many camera manufacturers sell filters for their cameras and drop the series numbers and name the filters. For instance, the 82 filter is listed as "Morning & Evening" filter, quite appropriately, since it's bluish. The 81 filter is listed as "Cloudy Day" filter, again appropriate since its color is yellowish.

The 81 and 82 Wratten filters come in a variety of codes: A, B & C in the 82 and A, B, C, D, E, & F in the 81. Each letter progresses one step in density from the preceding one. All are used by the big professional with a studio. He measures the Color Temperature (see Chapter 27) and selects the proper filter to balance his lighting. For most purposes even the rankest hobbyist should carry at least an 81A and an 82B.

Light Balancing Filters also come in three other 80 series filters but these are few. 80A is used to balance tungsten lamps to daylight films and are seldom used professionally. 80B balances photoflood bulbs for use with daylight films. 80C & D balance flashbulbs for use with daylight films.

But there are two other filters that are most important. The first of these is the 1A or Skylight. It is a warmish yellow-magenta or red (yellow and magenta mixed make red). When in doubt use this filter. It's main purpose is to reduce the bluishness in outdoor photographs, yet it is useful if you forget your 81A and 82B.

The last of the Light Balancers is the 85 and 85B. The 85 balances outdoor light to Type A and L films. This is seldom used. The 85B on the other hand is a must. It balances daylight to indoor or type B films. Many professionals don't use or buy much daylight film; they buy Type B or indoor film and use this filter. It is less contrasty, much warmer and pleasing to the eye. This is especially so with the High Speed Ektachrome films.

Color Compensating filters are used to make changes in the over-all color balance of the photographic results obtained with color films and to compensate for deficiencies in the quality of light used to exposed films. They can be used over camera or enlarger lenses and they come in six colors; yellow, magenta, cyan, red, green and blue. They come in arithmetic values like .05, or .10, .20, .30, .40, & .50. Their value is usually written as: CC10Y or CC10M. They can be used arithmetically since a CC10Y and a CC10M make CC10R.

Almost every professional has some of these filters in the gelatin style rather than the glass. Not only because of the expense of having or perhaps

needing all 42, but because they are used in multiples over the lens and too many glass surfaces over a lens degrade the image. If you are thinking of buying some, you'll most likely need the yellow and magenta and some red. The green, blue, and cyan are colors we have been trying to stay away from, but are needed from time to time.

Fluorescent lights as an example, need a CC5OR and CC10Y. This can be divided up to read CC50M + CC50Y + CC10Y.

The use of filters slows down the photograph and often one has to stop and clean the filter since the pouch or something else is dirty. Another problem is the variance in the filter sizes of your lenses. You buy one size filter and find you need another for the telephoto. Most professionals get around this by using gelatin filters and buying a large size, say, a 3-inch square and Gelatin Filter Frame or holder with adapter rings to fit all or most of his lenses. There is going to be some overlap. Wide angle lenses on larger cameras such as the 6 × 7 or "Ideal" cameras present problems because the glass is so big. The filter frame is the best way to go regardless of the problems.

If my reader hasn't done much with filters, may I suggest the barest minimum of the following filters:

1A skylite, 81A yellowish-red, 82B bluish, 85B orange, a CC10M magenta, and the last a CC10R, plus a polarizer.

Depending on your experience, you'll hear about UV or Ultra Violet filters. If used indiscriminately, the UV will turn all your transparencies a sickly yellow. There are a few special places that the filter is useful and only in these situations: beach scenes, water scenes, snow scenes, aerial scenes, and moun-

tain scenes. The key to its use is that the majority of the scene in the viewfinder is made up of highly reflective blue from the sand, water, snow, or haze. It is sometimes used under strobe lighting in a studio. If your studio strobe is older than five years, the flash tube just might emit ultra violet.

I've left to last the favorite of many professionals, the Polarizer or polarizing filter. It is one of the most difficult to use, but at the same time one of the most rewarding in terms of fine looking photographs. To over-simplify the case, all matter is photographed by reflection. That means that light is falling on the subject and most times the light forms light specular highlights that dilute the color. They're not visible to the naked eye, but the film picks them up. The Polarizer very effectively diverts those specular highlights from bouncing back into the lens and increases the color saturation. The effect is astonishing. A blue sky becomes a gorgeous velvet backdrop of royal blue, clothing snaps out, even faces are improved. Outdoor photographs change overnight from mediocre bald sky slides to artistic pastoral scenes. The effect is partially visible, for by rotating the filter in front of your eye, you will see some of the effect, especially so in the area of shiny or highly reflective objects such as automobiles, buildings and beach scenes.

All filters slow the film speed and must be compensated for. Every filter has a "factor," a figure by which the exposure must be increased. In the case of the "CC" filters, exposure increases are negligible at least in the filters you would normally use. But filters such as the Polarizer and some of the special effect filters require as much as two-stop increases in exposure. This must be lived with and the smart

photographer who is a "filter freak" (most real professionals are), uses high speed films in order to have room for the filter during exposure.

Special Effect Filters are either filters made by photographers or items like the Mistmaker (Spiratone). This is not to be confused with an ordinary diffuser. The effect of this on the lens is to create a work of art out of an ordinary snapshot. TriColor filters (Spiratone) are filters with vivid colors used for creative purposes and special assignments where a mood needs to be incorporated into the photograph. The TriColors come in aqua, purple and blue. Other filters are half-filters where the top or bottom is one color and other clear, or sometimes both have different colors, top and bottom.

Of course, there are hundreds of filters for a variety of purposes. Scientific and industrial uses are the most common, but for all practical purposes the filters identified and isolated in this chapter are those that are the most common to professional photography. It should be noted that I personally do not have in mind any situation where no filter at all is on the camera. The only two places that other professionals would question, would be in the area of strobes and quartz bulbs since both of these lights are constant and at one temperature. This is true, but the vagaries of processing, the physical temperature of the film before and after exposure, all contribute to slight changes in the finished transparencies. In my case as an example, my processing yields a slightly magenta-bluish cast to transparencies shot under quartz lights even though the meter calls for no filters. So I use a CC10Y and a CC05G over the lens when I am using quartz to copy something on 35mm EHB. On other films I don't have the problem, but

once I see the problem, I correct the next time. I have a chart that shows me exactly how each of my films and lightings perform. My studio strobes are slightly blue so I use a CC10Y with them.

Filtration is the fine tuning of a photograph and the difference is visible. Try shooting pairs of photographs, one with the correct filter and one without. Prove it to yourself.

Harrison & Harrison, Optical Engineers, make a series of filters for professional cinematographers that still photographers should be aware of. One of these is a gradual density filter that can be used to even out contrast in black & white and color photography. They think of this as "prefogging" and their theory is interesting but expensive since they make five filters with various degrees of "prefogging." Another of their products is the Opticolor filters, or "attenuators" as they call them. These are two-color filters in rotating rings so that the colors can be blended into each other. In practice, these are placed over the lens and the effect is visible. Some quite astonishing results are obtained on color films. A bald sky type photograph would be improved with the use of Blue/Coral or Blue/Yellow Opticolor Attenuator.

Spiratone, Inc. has a new filter of a similar nature called the "Colorflow" filter. As an example, one of the filters runs from yellow, through a green, and to a blue. It's made up of two separate filters each in a gradual density; one yellow, one blue, and each with a clear area so the photographer has a choice simply by dialing in the color he wishes. Additionally the filters polarize light.

There are two different sets of Colorflow filters; Type I uses a single color on one half and a polarizer on the other; Type II filters are made up of two dif-

ferent variable density polarizing filters. The effects obtained with these are astonishing.

Rotating either part of the filter increases the density or hue from a clear at "0" to full attenuation at "10." But that's just the color density. While you are dialing the hue, amazing things happen to the image; first it polarizes, or the reflections disappear depending on the angle of the camera to the subject just as you would expect from a normal polarizer. The added effect here is that the color of the reflection changes as you dial a hue. In some cases the hue intensifies and color is placed where none existed! A puddle of water, heretofor a troublesome spot on an otherwise excellent transparency now becomes a dash of color from an artist's palette! A red light sign over a restaurant now glows with an almost fluorescent brilliance. The tail-lights of a car in an evening scene become high intensity spotlights, improving your photograph beyond normal visual expectations.

The Type I filters are made in four colors, one color each in yellow, orange, red and green. Remember, these are single color filters. The Type II filters use two different colors in pairs of red-blue, red-green, red-yellow and yellow-blue. I hardly know what to recommend buying but I do know that the single Type I red is a must for the portrait and wedding photographer as a substitute for the CC10R used in environmental or outdoor portraiture.

Photographs taken under diffuse light such as under trees, out in the garden and other soft-light outdoor locations where the shadows are usually, blue or green, or cyan, need correction. The Type I red, Type I orange or even the Type II red-yellow adds the desired correction and necessary warmth. These

same filters are excellent substitutes for a Skylite 1A and when used on Ektachrome High Speed film which always develops out bluish, these filters create an effect similar to that had you used Kodachrome.

The Type II yellow-blue yields some of the most remarkable sunrises and sunsets I have ever seen! It's like having a whole series of 81s (yellow) and 82s (blue) for correcting morning and afternoon yellow and cloudy day blue photography.

Daylight can be made to appear as if taken at night and shooting the sun with full attenuation with some of the filters makes the most gorgeous moonlight scenes you can imagine. And, all of this while reducing contrast and compressing brightness ratios due to the polarizing of the scene. Greater color saturation is another benefit of polarization.

Ordinary bare grass scenes with a corresponding bald sky can now be improved with the Type II yellow-blue filter. Not only does the sky improve with the polarization, but it gets an added shot of color from the filter set midway and tending toward the green. The green then improves the foreground. The effects of these filters must be viewed to be appreciated. And not all colors are as they seem. The gradient density of two colors plus polarization alters the scene in such a way as to create a new color in the reflections.

These are truly innovative, creative tools for the working pro.

21 Special Effects Attachments

These are optical attachments placed onto the prime lens either directly or with adapter rings. Almost all are needed by the photographer at one time or another. They alter the image on the film in such a way as to create a feeling such as movement. Most of them are made in smaller sizes, rarely going above the series VIII filter size which precludes their use on most telephotos and ultra-wide angle lenses for medium and large format cameras.

Defining the specific uses of these attachments is difficult since it is a matter of opinion, but in general, too much reliance on gadgetry is detrimental to the creative juices, acting as a crutch rather than an accessory tool to be used when specifically needed.

Some of them are more popular than others and new ones are being invented daily. Since there are many and varied uses of each, I have had to obtain all of them. The one manufacturer that seems to have everything is Spiratone, Inc. of 135–06 Northern Blvd. New York and so all the optical attachments mentioned came from them.

The *Mistmaker* is by far the most important to the creative photographer. It is an optical cap in a ring with a fine spray of dots that diffuse the image when used on the camera. Most photographers have used diffusion filters or lenses. This is not even remotely similar to the effect obtained with them. This Mistmaker is a unique effect that seems to diffuse so subtly that it is not noticeable. One of its really great advantages is that it eliminates the need for retouching in outdoor group and single portrait photographs.

Perhaps more important is the use of the Mistmaker under the color enlarger head. Again, the effect is such that one would think the photograph was made with a soft filter and the negative retouched. Used either on the camera or the enlarger, the Mistmaker improves the image. A note of caution: in color printing this attachment acts as if it were a CP10G, probably due to the glass used. Be sure to compensate for this. The attachment can be used with other filters also.

The *Repeater* looks like five straight cuts on optical glass. One half of the lens is blank and the other half is clear glass. Its best use seems to be in fashion photographs where the model is in movement. The effect is to give a clear view of the model in motion on one side and then five repeats of her on the other half of the photograph.

The Repeater makes an interesting effect in almost any sports photograph: auto races, motorcycles, skaters, skiers, swimmers and so on — wherever the motion is dramatic.

Studio photographs using the Repeater should have a dark background with the subject wearing lighter clothes. With strong, simple, single subjects outside, the background blends behind the figure.

Multi-Image Prisms. This group of attachments is characterized by the segmented areas of cut optical glass. The three-segment prism has three pie-shaped areas, the five segmented prism has the same type of cut but repeats the image five times in a penta-prism grouping. The three and five parallel prisms fall into this category, too. They are made with parallel cuts which repeat the image either three or five times. This effect is different from the Repeater in that no one segment has a full image; they are all partial, whereas the Repeater has one full image and five repeats.

The *Multi-Image Prisms* are useful in making design patterns. One of my uses is the photography of balloons; another is a half-dozen fish, head on, and close to the camera. It is best to use the smallest aperture possible with these for clear definition. Although they can be used wide open, the edges of the subject become indistinct. Focusing should be quite accurate as an out-of-focus image is distasteful.

The *Crosstar,* single and double, is another optical glass filter etched with a cross-hatch pattern on the glass. When used to photograph an image with highly reflective highlights, the highlights tend to split off into four points of streaks. In black & white the effect is that of photographing street lights at night; in color the four streaks usually break up into

shades of red, green and blue colors. With an image of multiple highlights, the resultant photograph is a plethora of colorful streaks.

The *Doublecrosstar* has two single crosstar filters in a rotating ring and the effect is one of giving each highlight eight shafts of colorful light. With the possible exception of a specific need this is almost too much streaking.

The *Vignetar* is another of my favorites. It is a ground glass surrounding a clear optical glass spot. Used with either black & white or color this attachment has the effect of softening into a haze all but the center of the image. It has an adjustable collar with three degrees of effect. I use this with flowers, insects, and in any type of photograph where I wish to isolate the central image with sharp center focus and a soft out-of-focus hue of the same color surrounding it. (Excellent for portraiture and of course all of these attachments or most, can be used under the enlarger lens.)

The *Centerspot* is an optical filter with a highly magnified outer area surrounding a clear center spot. In use, you focus with and through the center. The magnified area around the spot will cause that part of the image to shoot into straight out-of-focus bursts of color, (easily another favorite), especially so with insects, flowers and pretty heads in portraiture or mood photographs for greeting cards.

The *Proxifars* are attachments with half air and half a lens blank. By focusing through the clear or "air" part of the lens, the highly magnified half section of the lens causes you to have a sharp focused foreground. Since the edge of the "cut" lens is in the area of in between, it doesn't show. By carefully composing your photographs so that you select subjects

with a plain middleground, you can photograph something in the foreground, a foot away, and still retain a subject at infinity.

These Proxifars (near-far) come in two powers, 1+ and 2+ and can be rotated to either vertical or horizontal images.

Spiratone makes other variations of the prisms; one is the Sixshooter which has six pie-shaped optical wedges and is an improvement over some of the earlier prisms. I find that with a lens stopped to f 16 the Sixshooter will record six clear clean images almost like the kaleidoscope effect.

Hollywood long ago found out the usefulness of the *Matte Box*. This attachment looking like a solid black lens shade has a slot in it for placing either filters or various cut-out masks to allow double exposures or multiple images. A young photographer has made a very successful plastic molded duplicate for all cameras called the *Lindahl Montager*. This is a sort of snoot attached to the prime lens with a series filter ring making it adjustable for most cameras. It can also be ordered with specific millimeter sized rings for most cameras. It looks like a square lens shade, flared out to about one and a half times the focal length of the lens. A slot in the far end takes any one of an assortment of masks. In use, you expose the frame with a mask in place, remove the mask and without winding the film forward but recocking the shutter, take another exposure on the same frame creating a double exposure. The effect is a nicely blended double exposure all on one frame.

The assorted masks, clear, translucent and solid, permit a wide range of creative effects. As an example, the clear and translucent masks can be colored with Magic Markers for wild, colorful images. Any

kind of light can be used for the exposure – even mixing doesn't spoil the effect.

Should you be unable to double expose with your camera, take two negatives or positives from the same spot. Under expose if you are using negative material and slightly over expose if you use transparency material so you can sandwich print the negatives or copy the transparencies.

Silhouetting is easy with the Montager and an appropriate mask. Even mixing black and white and color films improves some otherwise uninteresting photographs. Other effects are possible since this is a Matte Box and can be used for a variety of purposes. Many of the techniques are included with the instruction sheet.

Perhaps my favorite of all images created with attachments is the least expensive. I purchased two *magnifying glasses* at the dime store carefully selecting them so that one fits a series 7 filter ring and one a series 8. I demounted the magnifier from the frame and handle and inserted it in an adapter ring with a lens hood as the retaining ring. I mounted the adapter into a camera body cap with the center cut out. This was then attached to a bellows matched to the camera system. At this point, I had a camera body with bellows attached, and instead of a lens, I had a magnifier.

The stop opening for all magnifiers is f2. Don't trust your meter to give you an accurate reading; the flare is enormous. With Ektachrome HS daylite I was shooting at 1/1000 at f2.

The effects are delightful soft focus, with the tricolor dot structure of the film broken down so that the red, green and blue are visible to the naked eye. All lines are softened and muted.

Transparencies or prints yield exquisite colors, but the subjects should be simple and graphic without busy interplays and subtleties.

Portraits, nudes, and colorful children at play make breathtaking artistic photographs. Many of the greeting cards I have sold are made with either this or the Mistmaker or the Centerspot.

All of these attachments should be means to a creative end, rather than the end itself. My complaint with most photographers is that there is little creative thought, little attempt at pinpointing the uses of these attachments. True, they are a crutch and may get you out of an otherwise blah situation, yet to use them for their own sake is to by-pass creativity. Experimentation is necessary to determine for yourself the creative abilities of these tools. Once learned, they should be committed to memory and put away to be used for that occasion when they will enhance an otherwise dull situation.

Camera lenses and accessories should always be considered tools of the creative photographer. The photographer's mind is still the greatest attachment to a camera ever invented.

22 Flare & Reflection

Easily one of the least understood problems in photography pertains to flares and reflections. Perhaps the reason is that they're not visible except to the highly trained eye. Everything we see is the reflection of the actual object. If we take away the light and are in total darkness we see nothing, yet the object is still there. So we see by reflection.

Understanding the action of filters where the color of the filter is the clue to what segment of light is absorbed and what is reflected, is necessary to the overall understanding of reflection.

Let's talk about a "red" filter. White light, consisting of a mixture of blue, green and red falls on the filter. The filter appears red because it lets through

only the red light and absorbs (subtracts) the blue and green light.

A piece of red paper is red because it reflects red and absorbs the blue and green light, subtracting them from the white light that falls on it. So anything that absorbs blue and green light will look red. If you see something that is green you know the object is absorbing or subtracting blue and red; see something blue and the object is absorbing the green and red.

So the key to understanding photographic filters is to say that they always subtract some of the light reflected from the scene before it reaches the film in the camera. This is easy to understand when thinking about black and white photography but somewhat different in color since you don't use pure filters with color film.

Reflections are usually white light hitting the subject at the exact angle that you are to the subject, following the old rule that the *Angle of Reflection is equal to the Angle of Incidence.*

The first way to avoid a reflection that is degrading the saturation of color is to change the angle. If the camera angle is fixed, change the light. If you are outside and the angle of light cannot be changed, then change your position, and if that can't be done then use a polarizer. (see chapter 20 on Filters)

Surprisingly, few photographers are aware of the reflection problem when setting up the camera and picking an angle. I have seen countless examples of reflection that could have been foreseen had the photographer the curiosity so necessary to being a photographer; the curiosity that would have made him carry, as I do, a polarizer on a cord around the neck. One quick check through this identifies that area of heaviest reflection.

Lens hoods made by the camera manufacturers are close to being useless, primarily because they are too small and hence inadequate. As an example, the other day I made two exposures of the same scene, one with a camera lens hood and one using the Lindahl Montager. (see chapter 21 on Lens Attachments) The camera did look odd to say the least, but it was an improvement over the lens hood.

The studio photographer is brought up on compendium shades and has long ago noticed the usefulness of these which look like a mini-bellows attached to the front of the camera. All view camera photographers are aware of flare and reflection since so much of that type of photography requires a compendium shade.

The way the camera is made has much to do with the amount of flare inherent in the design. Flare can come from the inside of the lens mount depending on the quality and placement of the baffles. The interior of the camera has much to do with how much flare you will have to put up with.

For the moment, the test reports in magazines aren't testing for lens flare, or camera baffling. Occasionally, a test report mentions the problem but I have seen no guidelines or ways of measuring and comparing either flare or reflection. The optical bench can and does show the degree of flare but these tests haven't found a way into the test reports.

In the view camera area, flare can be controlled by the photographer, first with the compendium shade and by checking inside his camera. Areas such as the back of lens boards and the rear element of the lens often show shiny marks where the paint has worn off. The inside of the bellows is one of the common areas for dampening reflection. If you have an 8 × 10 view camera, try sticking your head inside the

bellows and seal the cracks with the focusing cloth; fire the shutter and look at the inside of the bellows and notice the light traveling along each bellows fold. Try looking at the back of the lens board too. Of course your face is a reflector and the test isn't accurate but it will acquaint you with some of the problem areas.

The pressure plate on small cameras and the back of the cut film holder used in view cameras are two of the worst places for flare. In some cameras these are worn shiny. Why they aren't replaced is beyond me. Flare can and does come from behind.

Would you believe the film itself creates reflections? Well it does, but there's not much you can do about that. Reflections in a view camera bounce back and forth between the back of the lens, the folds of the bellows, and the surface of the film and even behind the film on the pressure plate.

As a practicing photographer there are many things you can do to enhance the quality of the image in so far as flare is concerned. One of the first is to constantly clean the lens. A dirty lens is going to dilute the color saturation and increase flare. Photographers who smoke are aware of the nicotine coating in the darkroom and in the studio. Just look at the insides of the windscreens of their automobiles for the coating.

Careful cleaning is done daily on all lenses that are used. When 35mm lenses are used, put them away with a back and front lens cap and in their own case or compartment.

Whenever chipping or flaking is noticed use some Kodak Camera Flat Black Dressing on those shiny points. I have a bottle of this for touching up in the studio.

Once in awhile blow out the bellows of the studio cameras and inspect for fading of color. While you're at it, check the back of all lens boards and the back and front standards of your camera.

Much has been said about multi-coating versus single coating. First, single coating doesn't mean what it says. All lenses since 1950 have been coated on both front and rear elements and often on the front and rear elements of internal groups. Nobody ever mentioned this; it was just one of those improvements that lens and camera manufacturers were aware of for years and whenever possible they coated. Coating has been said to improve light transmission by 5% per coated surface. Each of your lenses has about four coatings anyway if they were made in the last twenty years.

On 35mm cameras all sorts of flare and reflections can and often does come in from the viewing eyepiece. May I suggest that you keep the sun out of the back of the camera when using a single lens reflex.

Museums and professional laboratories doing a large amount of copying have long ago determined the need for polarizing of the copy lights in the copying of paintings, drawings and art objects. Anyone who intends to do any serious copy or reproduction work should consider purchasing Kodak's Polarizing Lamp reflectors. These are an advantage over the polarizing camera filter in that the light is polarized *before* arriving at the lens. In some cases it is necessary to polarize the light once more at the camera. This can be seen by looking through a filter at the painting or object.

I was privileged to copy Andrew Wyeth's water colors and also Maxfield Parrish's paintings for two

different books. I like to think I was selected because I knew how to record on film all the nuances of their paintings.

The studio photographer lives with reflection. Everything in a still life is reflecting. The problem is; how much is acceptable? How much is really necessary to the proper rendition of the scene? Sometimes, wiping out all reflections takes the life out of the photograph. When I build a scene, I keep a viewing filter handy and as each light is placed, I check the reflection and the saturation of the color. After all the lights are placed, I check to see if a polarizing filter over the lens improves the photograph; invariably it does. Sometimes a correction has to be made in the placement of one light or so. The discipline gained in the studio proves invaluable on location. Photographers who train themselves to think in terms of flares and reflections which affect saturation, always make better technical photographs.

Flare and reflection effect your meter readings too. They have a tendency to read high and cause you to under expose. More often than not you blame the poor meter and all it did was to tell you that you are reading flare. This can be proved by metering an 8 × 10 gray card and leaving the meter in one position. Move the card by tilting and turning always in the same position. You will notice about a half stop difference in reading when the sun hits the card and reflects into the meter, both at the same angle. True, you can't angle the house but . . .

Now let's take a white building, a plant or architectural structure. If the sunlight is striking it at the same angle as you are photographing it, the meter reading will be high and you will underexpose. Check

it by reading a small gray card with your spot meter, making sure that the card is not reflecting the sun. Use that reading for your exposure.

Fashion photographers who have to work in the sun should always use a polarizing filter else the color of the client's clothes desaturate. Sometimes I shoot with a huge translucent shade to hold the sun off the model. Even then, I find the saturation better with the polarizer.

23 Compressing the Contrast Ratio

Photographing interiors presents many problems to the unwary photographer. Because the lighting is generally overhead the floor shadows become deep and muddy. Where table or floor lamps appear, the glare of the bulbs casts shadows below and high-lighted, washed out areas above, raising the devil with the overall lighting balance. This imbalance cannot be photographed successfully on transparency material without corrective measures, as the contrast ratio, or the difference between the highlights and the shadows, is too great to record on the film.

The eye is quite able to see into the shadows and highlights, recording all the detail it needs. However, the eye is using a variable aperture; the camera uses

a fixed aperture for any one exposure. The eye suggests that the ratio is recorded because the through-the-lens-viewer says so, but the photographer, looking through the viewer is still not aware that he is adjusting his pupil when he checks the shadows and highlights.

The film itself presents a problem because of its narrow contrast ratio. The photographer must previsualize the effect of the lighting on the film and make adjustments in the lighting to achieve the desired effect. It is not enough to fill in the shadows, one must tone down the highlights as well.

First, take meter readings with a spot meter of all the areas and chart them. Pick the median level and set this as the goal to reach. Let's assume that this level was such that it could be photographed at f 16 and that this was desirable. The fill lighting for the shadows has to be brought to within a $\frac{1}{2}$ stop of this aperture or f 11$\frac{1}{2}$. This may be done with any number of systems, but the best is the waving light technique since it fills evenly. If this can't be used for some reason, then a soft umbrella broad fill is next best. This is used where there is a live subject such as a model, ruling out time exposures. Any other type of lighting has the tendency to be visible, creating a false look to the photograph.

Second, the highlights have to be dropped to about a half stop above the normal exposure to around f 16$\frac{1}{2}$. This can be done in many ways, the easiest being to remove the bulbs and drop their wattage down to your meter reading. Another way is to wash the highlights by building up the lighting to match the highlights. This means that the average and the shadows must be brought up too. Now check all parts of the scene and make sure that no im-

portant part is outside of the $f11\frac{1}{2}$-$f16\frac{1}{2}$ spread of the lighting.

Compressing contrast is most important in copying, even though there are films such as the new Ektachrome Duplicating Film 6120 and the 35mm Ektachrome Slide Duplicating film, that have a low contrast feature. This is accomplished by reduction of the time in the first developer. Not all color films retain their balance when the first developer is reduced, hence the new film.

Contrast compression is necessary in existing light conditions also. So often photographers are prone to photograph in offices or plants and ignore the fact that almost all of the light they are using comes from the ceiling. Here again the eye fools one as does the through-the-lens viewer. Most professionals fill with a "kicker" usually something like a #3300 Mole-Quartz lamp a 3200K quartz bare bulb fixture that works well with either black and white or color. Although I use the word "fill," the quartz light will become the "main" in this situation. This is why it can be used with either tungsten color film or black and white, but not daylite film. The fixture is usually placed so that the bare bulb is close to mid point between the ceiling and the floor. This is most important for an unobtrusive lighting. The effect is almost shadowless and of course, the shadow and highlight areas fall within the latitude of the film.

In the 1930s photographers who photographed rooms in black and white used to overexpose and underdevelop. This effectively compressed the ratio; shadows developed early and contrast which usually comes soon after the mid point in the development cycle was stopped. This same philosophy still pre-

vails with some of the modern color duplicating films mentioned earlier.

Some transparencies improperly exposed in regard to the contrast ratio show a great range of values that cannot be reproduced on the printed page. Separation through screens drops tones quickly, usually in the highlights that become washed out and in the shadows that block. Very few art directors or clients think to blame the photographer; after all the transparency has all the tone one would want, and I can see it with my eye can't I? Here again, the eye is greater than the engraver's camera lens. The way around this problem if you can't get the photographer to shoot it over correctly, is to mask.

Masking is much easier than one would imagine. A mask is a silver or black and white film of low contrast, such as Pan Masking Film, exposed in contact with the transparency. The density determines what kind of a mask it will be. A small exposure will result in a "thin" negative that masks the highlights; more exposure will result in a full scale, flat, negative that we call a "contrast reducing mask." A heavily exposed mask, which is quite dense tends to flatten out the tones more and is a shadow mask. For all intents and purposes the median mask serves the purpose here.

I expose the Pan Masking Film in a print frame with both emulsions facing away from each other to soften the edges; this makes registration easier later. I tape two pieces of matte acetate, the kind used in transparency sleeves, to the outside of the print frame to serve as a diffuser. The print frame is then placed under the enlarger with the standard raised

to about a 11 × 14 image on the baseboard. The exposure is 18 seconds at $\frac{1}{2}$ candlepower. If you don't have a Gossen Lux Meter, use f 8 for 18 seconds with this film.

Develop in a tray for 2 minutes at 70 degrees. Use D-72 or Heico's OS. Be sure to use a short stop, not plain water. Then fix in any fixer you have. The dillution of the developer must be 1 part stock solution to 10 parts of water.

Wash and dry and you have a mask. I usually buy 8 × 10 Pan Masking Film and do a whole roll of 20 35mm slides at once. Registration is easy since the 8 or 9 sprocket holes are easy to line up. When printing or copying, register the mask to the transparency with tape. When focusing in either the enlarger or camera or Illumitran, focus on the image of the color transparency and you will never know that there was a mask attached.

You take one giant step forward when you give the art director a mask with his transparency. It is so rarely done. Whenever I do this, I find I get more assignments from that agency. The engraver will recommend you to other clients, too. After all, you are making his job that much easier.

Contrast can be controlled easier with negative color film than almost any other type. If you don't want to make a mask for the negative and you haven't developed the negative purposely for softening of contrast (overexpose and underdevelop), then you can work by dodging on the print, burning in the highlights, and dodging out the shadows. The danger is controlling the color shifts since longer exposures change the color on the print and dodging sometimes makes for muddy shadows. But it can be done.

One quick help is to make a straight print through a Spiratone Mistmaker Filter. Usually used over the lens in photography, it makes a very fine diffuser without cutting sharpness. It does change the color about CC 05 G, so compensate by adding CC 05M to the print. Remember this is done by subtracting magenta filtration at the color head.

24 Copying and Duplicating Techniques

Most of the big illustration photographers keep the originals they shoot and send art directors and advertising managers duplicates. For those who use multiple images in their illustration this is understandable; you can't send pieces of film taped together with instructions on how to reproduce and what filtration to add to achieve the effect you want. No, you have to send one piece of film with everything you want the art director to have on that piece of film.

These same photographers don't usually have only one avenue of revenue; they just don't take one specific type of photograph. Most dabble in stock photographs. They have to; their representatives are

often asked for a specific photograph that is already made and "just fits our ad." Stock is a way of life and many fine photographers have thousands of stock slides on file. Some maintain duplicate files in more than one agency. So, duping is another way of life. I would hate to give up the income from my stock files and I'm sure my brethren feel the same way. This would be a good place to show how we solve the enormous problems in copying and duping.

As any professional knows, as soon as one copies an original transparency, one increases the contrast. But this word "contrast" is misleading. What really happens is that you lose the detail in the highlights and shadows. (This is touched on in Chapter 23 on Contrast Control.) In order to hold that detail and keep the contrast in reproduceable limits, engravers have been "masking," that is, making all kinds of masks called "highlight mask, shadow mask and contrast reducing mask." These are the three basic names, but masking can be done selectively within certain colors. This gets to be quite sophisticated and almost limited to the high priced engraver or separator. About the best the photographer can do is to make masks (see Chapter 23 on Contrast Control) and use films for duping such as the Ektachrome Duplicating film 6120 and its 35mm counterpart, Ektachrome Slide Duplicating #5038.

There are a few things the photographer can do to help the situation, assuming he has high contrast originals. One of the easiest and best is to make *enlarged* dupes. I have found that when I make a 3 × 5 dupe on Ektachrome Duplicating Film 6120 from a 35mm I find that the contrast is lowered by the enlarging. It is quite apparent when going from 35mm to 8 × 10 as I often do.

Another way to drop the contrast is to see if you have a small additional slide that you can combine with the first to make a multiple image, especially so if you just add a color gel which gives tone to the highlights when copying. Because I say "multiple image," doesn't mean that you have to design a new photograph to go with the original; sometimes a texture slide will add much to the original. Just photograph a book of wallpapers. Copy them and extend the exposure so that the transparency is light but full bodied; mask this with the original and you have not only improved the original but you have cut the contrast. Had you added still another for tone, perhaps a cloud or a deep sunset, you'd find the shoe on the other foot. Then the contrast would be too soft and instead of copying on 6120 you'd have to copy on regular Kodachrome 25 in the Illumitran or whatever. You'd need to build contrast to prevent the three pieces of film becoming "mushy." There are other techniques:

"Flashing" or "pre-flashing" as it is sometimes called is not as difficult as it would seem. Ask any engraver for a piece of exposed film with a density of 1.00, or if you wish, expose your normal sheet film to light and develop it fully. After fixing, washing and drying, hold it up to the light. You should be able to see through it with a powerful light bulb, but not so easily that you could read anything through it. Needless to say, the exposed film should have no visible grain. After all, you don't want to transfer the grain to the copy film. Now this film is placed in the Illumitran or Kingdon Copier or Repronar and using perhaps Kodachrome 25 for the purposes of example, shoot the whole roll at the same exposure that would copy the film; in my case f11 at 1/60 with flash

in the Illumitran. Mark the film when you load it in the camera opposite the sprocket holes so when you rewind and reload for the actual copying, you will match the frames. Now copy normally and you will find that you have retained the detail in the highlights and kept the shadows open. If the slides are flat and mushy, then the exposure used for the flashing was too much; if the copies are too contrasty, then the flashed film was not dense enough. That's why I gave you the exact formula of density 1.00. This should give you perfect slides. Thus, flashing is another technique used to cut contrast.

Copying slides on 6120 is quite easy. I use my enlarger and any enlarger will do. Use a 4 × 5 Cut Film Holder or 8 × 10 if you like and place a piece of white paper on one side, making sure it lies flat in the channels. Place a piece of 6120 in the other—in the dark, of course. Using your present easel, compose the image onto the white paper in the Cut Film Holder; make sure the holder is up against the easel firmly. Focus on the image you wish the sharpest. In multiple imaging, only one should have the greatest crispness; the other will fall into focus but at slightly different stops. Once the image is focused, cut the lens down to whatever your test transparency showed was the proper balance. This balance, incidentally, is something that is constant regardless of the original. There is only one balance for one box of film for all originals. The 6120 uses a constant exposure of ten seconds and the filters given by Kodak are accurate for the type of lamp they suggest. The only judgment you make is any change in exposure controlled by the aperture rather than the timer. A dense assemblage needs more light and a single transparency would need less. Remember to feed in

the color of a glass negative stage (opposite color) if you use one rather than a glassless carrier.

Processing of 6120 requires a slight alteration in the first developing time regardless of whether you use E-3 or Unichrome. As an example, the normal time in the first developer for either E-3 or Unichrome used at 75 degrees is 10 minutes. With the 6120, the time is 6 minutes. Length of time in the developer is the determining factor in the control of contrast.

Duping on 35mm film is the most common way that a photographer solves the problem of multiple submissions. The most sophisticated machines for studio use are the Illumitran, Repronar, and the Kingdon Copier. Then you drop to the bellows attachment with a slide copier and macro lens. Any of these will do an excellent job, the difference between them being the degree of convenience. Both the Illumitran and Repronar are made to copy any size from 110 to 4 × 5, using the internal strobe or the viewing light. The strobe doesn't have to be balanced with filtration for daylight films, but the viewing light must be brought to 3200K if you wish to use tungsten films. Ektachrome Slide Duplicating Film #5038 may be used in any of the above machines or may be used with quartz lamps. The starting filtration for the viewing light to bring it up to 3200K and balance for tungsten film is done with an 82B filter.

The three copiers mentioned are capable of copying multiple assemblages and still give a meter reading on the strobe section, whereas the bellows-macro lens attachments can be used with strobe but without a metering capability. In order to get enough light for an exposure using a single quartz lamp, the lamp must be placed so close as to cause excessive heat.

The filters will warp and so will the slides. Individual frames must be mounted, although the copier will take unmounted strips. Conversely, the three copiers will accept single unmounted frames in sizes from 35mm, $2\frac{1}{4}$ square, $2\frac{1}{4} \times 2\frac{3}{4}$ (ideal format) and all can be metered. Incidentally, the meter readings are surprisingly accurate.

Each copier has scale provisions for adjusting exposure for different magnification, so you can see, with the features of the copiers the photographer can quickly, accurately, and with little fuss make duplicates, masked or flashed for sending to the client.

The bellows-macro lens is a poor substitute for the professional copiers, but they can be used. Spiratone makes a tube-like attachment that mounts directly on the camera (35mm) in place of your lens and incorporates a single element lens for magnification to 2X. This attachment is easier to use than the bellows-macro lens. I notice little or no difference in the quality. But this is limited to copying 35mm originals only. Also, filtration means cutting up gelatins to fit. So if you ever plan to copy $2\frac{1}{4}$ or 4×5 or any other size, or need a quantity, you may be forced to buy one of the professional copiers mentioned.

Some slides present immediate problems; those with large areas of sky, snow, water or sand. Without masking you never will get a satisfactory duplicate regardless of what the film makers say about duplicating films. Delicate details in highlight areas are devilish to retain. Masking is simple and most effective. Yet, even masking won't retain all the detail. I am ever wary of scenes with large expanses of highlight areas.

Reducing large transparencies, perhaps a 4×5

to 35mm doesn't present as much of a problem as enlarging a 35mm to 4 × 5. The copiers have provisions for copying 4 × 5 with accurate exposure measurements using the built-in probes. The 35mm to 4 × 5 is best done in the enlarger outlined at the beginning of this chapter.

The title of this chapter is somewhat misleading in that so far I haven't mentioned copying original art. Usually this is a capability of most photographers, not needing further explanation. For those who haven't done much copying of art, let me explain my procedure:

Copying flat art has a specified technique that requires polarized lights and a polarizer on the camera lens, else the art will reflect and flare the highlights.

Much of the paper or canvas fluoresces and should be checked with a "black light," a bulb or tube that can be purchased in any electrical supply store. If it does fluoresce you must use a UV (ultra Violet) filter over the lens. While the item to be copied is under the black light, check the crayons, markers or paint for fluorescence and if there is any, show it to the client. If the marker or color is in a highlight area, the result might be a bit blue and washed out. Reds go to the magenta, blue goes deeper and green goes to the cyan.

The center of any lens other than an apochromatic (flat field) tends to have less apparent sharpness unless it is closed down. The density in the center is greater also. If you are using a straight camera lens, keep your exposure down to cover the edges. Harrison & Harrison makes a special filter with a density in the center to compensate for this problem;

a worthwhile purchase for anyone doing an extensive amount of copying.

Large sheets of polarizing filter material are available from some camera supply houses. I use about a foot square piece, one over each lamp, rotated until polarization is visible in the camera lens. This cuts the light down about ten stops to a point I consider unusably without an apochromatic lens, since the exposure must be made with the lens almost wide open.

The effect of the UV filter is not visible as are most others. Your only check is with the black light bulb used in the darkened room.

25 Tricks, Props & Style

Every craft has little known techniques that are enormously useful to the artist, yet are difficult to discover. The most common way to learn is that a photographer try to become an assistant in a studio and learn by watching. But for those who haven't had the advantage of an assistantship, the tricks are hard to find.

The studio photographer has to accept many assignments that require this knowledge, yet, without it, he will struggle with that assignment and very definitely fail. The photography of a person pouring a glass of beer against a black velvet background is an example. As simple as this might sound, the problems are tremendous, and without the skills the illustration will be a failure.

Beer won't photograph as beer; it comes out a too muddy beige. The suds will collapse and drip down the side of the glass. The cold glass will sweat and the moisture will run down the sides and dampen the material the glass sits on. A total mess; a planned disaster. This is how the pro would do the same job:

First he'd throw the beer out—or drink it and replace it with either *tea* diluted to the proper consistancy and color or *vegetable dye* to the proper color. Next he'd make suds out of Joy or any other *dish washing detergent* (they hold their shape and won't run). He would have sprayed the back of the glass first with a *matte dulling spray.* Since the spray would hit the sides, he'd have made a cardboard cut-out of the shape of the glass and held that over it while spraying. This can be done before or after making the "beer," but before the suds.

The front of the glass would have the cold look by virtue of the matte spray on the back of the glass and back strobe lighting also coming through the back of the glass and white cardboard reflectors in front to fill the shadows. For accent, he'd use *Q-tips* dipped in *glycerine* and drawn down the face of the glass in wrigglely lines. The hand with the bottle pouring, would have been made up and the bottle arranged so that the label would show. (In pouring photographs real beer would be poured since he'd want the bubbles to show.

The matte spray with the back lighting would prevent the black velvet background from showing through the glass as well as outlining the rim of the hand, bottle and glass.

All in all it sounds quite simple doesn't it? This type of exercise should be taught in schools.

Where a glass of another type drink is to be

photographed, and the glass should look clearer, the photographer tapes a piece of *white paper* to the back of the glass. This won't look so "matte" as does the spray.

The *ice cubes* used in these drinks are made of *Lucite* and are sculptured by just a few professionals. A good set of four will cost about $250. Believe me they're worth it. Ice melts fast and sometimes it crazes or even clouds up. Lucite cubes are worth their weight in gold.

Any professional photographer knows how to tent for silver, but how do you photograph highly polished chromium surfaces on silver? If you tent, it will not be representative of that pattern.

I use *makeup liner* from Max Factor or Elizabeth Arden Stage and Screen Make-up #12. This should be brushed on with a camel's hair brush and smoothed out with a lintless cloth. Then you can use any kind of lighting to give more reflection. This stuff works on plastic, glass and leathers. Sometimes I use it on metal objects such as medals, cups and plaques. It must be smoothed out however as the brushing alone won't be even.

Incidentally, if you find the letters on cups, plaques and medals disappears in the camera; fill them in with *black shoe polish,* carefully rubbed into the grooves. This will bring the lettering out in contrast to the metal surface of the plaque or cup.

Whiskey is best made of *tea,* sometimes *vegetable dye.* The same dyes can be used to make medicines if your test transparency shows that the color won't reproduce for some reason. These dyes will not fluoresce.

Cloth background, especially velvet attracts lint from static electricity and photographs like static.

I find that almost all lint can be removed after the props are set in place by simply making a loop around your palm with one inch *masking tape*. Run your palm gently across the area, sticky side out, of course. This "pick-up" works on all cloths and some card stocks.

The home economist will cook a meat for a short time to avoid shrinking, but this doesn't give you a realistic brown crust, so paint *Kitchen Bouquet* on the meat with a pastry brush. Sometimes I brush the cut surface of the meat with *salad oil* for that shiny moist look. Salad oil, incidentally, is the perfect touch for vegetables and fruits. Rub it on fruits and brush on leafy vegetables. Sometimes I spray them with water droplets after the application of the salad oil.

Ice cream is one of the most difficult subjects to photograph. It melts under the lights — even strobes. It's best to slide a sliver of *dry ice* into the ball of ice cream from underneath. Some ice cream should be molded over dry ice and put in the refrigerator until the photography set is ready then placed in a predetermined position and smoothed with a *hot knife*. If the ice cream is to have the marks of the scoop, I place a sliver of dry ice into the ice cream while it is still in the scoop and then release it into the dish. It'll stay hard longer.

If cakes aren't photographed quickly, they tend to "fall" when cut, and the soft texture flattens. Use the *tines* of a *fork* and "rake" the cut area with them. I use a small *vacuum* to pick up the cake "lint."

Dry ice is sometimes used as a substitute for steam emerging from hot foods. Just insert a sliver into the food. This won't work with hot coffee, however. Most big food photographers have a cup with a hole drilled through the bottom and through the

saucer. They attach a thin rubber hose to this and *blow smoke* from a cigarette through the coffee. This is crude but it does work. The only other way is to retouch the steam into the transparency or onto a dye transfer print. Incidentally, coffee often requires a light ring of bubbles around the edge of the cup to show that it is freshly poured. Sometimes the time taken to set up and expose causes the bubbles to fade away. These can be replaced by blowing air through a *straw* placed in the coffee cup.

Have you ever seen those terrific ice-covered windows in some ads and wondered how they were made? Melt down a block of *camphor* with alcohol and water until it has the consistency of paint and brush it on the pane, then blow hot air with a hair dryer around the pane until it dries. The effect is astonishingly realistic.

Powdered snow is made of *Styrofoam flakes.* Studio Specialties in Chicago sells most of the supplies for studio photographers and this is one of their products. The flakes are light and can be filtered down on a set from a ladder and a big tub sieve. The trick in making it snow in a still photograph is to get the flakes spread out so that they look even. Distance is the answer; get as far up as you can get and shake the sieve. It won't cover more than an area two feet wide. If you need to cover a wider area, I suggest throwing large handfuls up into the air, they should scatter as they come down. Shoot a few polaroids to check your throw.

Smoke or fog is made with a special machine by Mole-Richardson of California. They make a special effects *Moleffect Fog-maker* using kerosene which is messy in the studio. This outfit makes all kinds of goodies for the movie industry. You won't have much

use for them, but how about a *"Cobweb spinner kit"* or a *"WindHowler Kit"*? Just the thing for that Count Dracula photograph you were going to make. Add those to a *"Molefact Blood Kit"* and some *"Breakaway bottles"* and you'd have most of the ingredients for a western saloon fight.

Someday you might have to photograph a stew or a clam chowder. Perhaps you'll wonder how you keep the meat and vegetables in the stew from sinking to the bottom? Easy, you put a bunch of *glass marbles* in the bottom and the goodies rest on top just peeking out of the broth. I know, you're going to say that a lot of this is illegal; yes it is, if you imply that the entire bowl is loaded with meat and vegetables, but if what you show is actually in the can then you have the right to photograph it. Where you get into trouble is when you add something that isn't in the can. In many of these cases the agency has to place a phrase in the ad that says "Suggested serving." This complies with the law. This is especially true when, say, you might photograph a TV dinner and you add a dessert that doesn't come with the purchase price of the dinner.

Incidentally, many photographers buy *fake foods* made out of plastic. They can't be used for the product photography, but if used out of focus in the background they'll save you a bunch of dollars for real food stay fresher longer, too. Of course, if you don't do a lot of this type photography it wouldn't pay you to buy the plastic food.

Sometimes you'll see a real fizz drink; looks highly carbonated against a black background. When you go to pour the client's Super Pop, it fizzles all right; you get a really flat photograph. My suggestion is to pick a low camera angle and hide a small glass

with a couple of Alka-Seltzer wafers in it with some water. Backlight and you'll get all the fizz you need.

This chapter just scratches the surface of the tricks learned the hard way by working with studio pros. If anything, these ideas prove that given an assignment, the photographer will find a way to solve the unsolvable.

26 Meters & Metering Techniques

Almost all professional photographers know all there is to know about metering so in a way this chapter is an exercise in futility. Yet, over the years techniques are refined and slight nuances developed that just might make it easier to determine the most difficult of all problems in photography: the correct exposure. I know of no other facet of photography that has caused so much constant attention.

I use two broad classifications—the spot meter and the incident meter. Perhaps a better word for the spot meter would be "reflection" meter, with the word "spot" being a type of reflection meter. In general, the reflection meters are used in the studio and

191

on interior locations; the incident meters are used outside on location.

The incident light meter, like all meters, requires a subjective judgment after taking a reading. It is in the subjective judgment that all photographers have their problems. As an example, you have as the assignment the photography of sailing boats for a catalogue. You are the photographer on a power boat cruising around among the boats taking shots. An incident light reading for, say, a film with an ASA of 160 should read 1/1000 sec at f5.6. The meter is set for an "average" scene of an 18% gray card. So why not read a gray card? Take a small gray card and with a spot meter read the same ASA and you should arrive at the same 1/1000 @ f5.6. If they don't match one of your meters is off. The incident meter was aimed at the sun, the same sun shone on the 18% gray card, and the meter (spot) was aimed at the card slightly at an angle since you don't want to measure the glare or flare. Try your 35mm camera. Set that at 160 and that had better read the same.

Let's assume that the spot meter, the incident meter, and the camera meter all read the same. Is this the correct exposure? Not necessarily. We have to make that subjective judgment. Is the boat you are photographing lighter or darker than the 18% gray card? Quite obviously, it is lighter by about a half stop. So we should cut the exposure by a half stop to between f5.6 and f8, else the photograph will appear somewhat washed out. The water, the light boat, and the white sails are all highly reflective. The general scene is on the light side; we must compensate for it.

Suppose you filter (you should). You put a Skylight 1A on the camera. Do you make any adjustment?

No, but if you decide to use a polarizing filter, you make two adjustments. One is the obvious; you must compensate for the density of the polarizer by two stops probably in the shutter speed and go to 1/250. But, you must alter your subjective adjustment of the light scene and go back to f5.6 because the glare, flare, and highly reflective light that caused you to make the subjective adjustment to between f5.6 & f8 has now been taken away by the polarizer.

Suppose the time of day is late afternoon. A color temperature meter or a Color Dataguide book will suggest an 82A, a bluish filter that has a factor of $\frac{1}{3}$ of a stop. Just the use of this filter negates the subjective analysis you originally made. You must go back to f5.6 and then go a third of a stop beyond to compensate for the filter. Incidentally, a $\frac{1}{2}$ or $\frac{1}{3}$ stop is not $\frac{1}{2}$ or $\frac{1}{3}$ of the distance on the scale between stops. The movement of the aperture lever is logarithmic. Most professionals have the manufacturer give them a set of cardboard markings which they transpose to the aperture of certain lenses.

The point is that the meter's only use is to get you to the ballpark; once there you have to make all kinds of judgments and the quality of those judgments determines the quality of the photograph. Some scenes such as the boat scene above have little tolerance, others are more forgiving.

Had you determined to get underneath the boat on the "lee" side and have the sun backlight the boat, you would have had to made a subjective judgment again. Go back to f5.6 and the scene would be a reasonably light scene—kind of blah. But the aperture to, say, f8 and you will have added drama to the scene with the slight underexposure.

It pays to meter correctly with an incident light

meter. Should you have the spot meter only, take a reading of a gray card, not your hand. Readings of your hand will cause you to underexpose your boating scenes.

Snow scenes, sand scenes, mountain scenes all need the subjective analysis that would cause you to cut the aperture. There are scenes such as a black cat in a coal yard that would cause you to make an analysis to open the aperture from what the incident meter says.

Crosslighting, sidelighting and backlighting all call for a change from the recommended reading on outside photography.

Inside the studio or inside a location, I prefer the spot meter for a number of reasons. The first is that I usually have more than one source of light. Each light must be metered and more important, each reflection on the scene must be metered to control the contrast. If I am doing an illustration for an ad or magazine, I carefully light the scene with the spot meter making sure that each light never varies from a difference of one stop from another light. This is the absolute limit if you wish to keep the contrast down. It is true that the camera and the film will record a greater variance – one that will be visible in the transparency; but the engraver or separator will have trouble holding his dots in the highlights and keeping the shadows open.

I usually cut an 8 × 10 gray card into four pieces, each 4 × 5. These can be slipped into a still life or a small scene and readings are easy to get. Stand back at the camera with a good spot meter and read each point in the scene. I often have as many as six of these miniature gray cards in the scene at the same

time. I have left them in the scene, too, so remember to take them out when you're ready to expose.

It is dangerous to read color with a spot meter. The chart below is reasonably accurate. The gray card reading is: $\frac{1}{4}$ @ f8$\frac{1}{2}$

RED	$\frac{1}{4}$ @ f16	
GREEN	$\frac{1}{4}$ @ f11	
BLUE	$\frac{1}{4}$ @ f8$\frac{1}{2}$	GRAY $\frac{1}{4}$ @ f8$\frac{1}{2}$
YELLOW	$\frac{1}{4}$ @ f22	
MAGENTA	$\frac{1}{4}$ @ f16$\frac{1}{4}$	(All are
CYAN	$\frac{1}{4}$ @ f11$\frac{1}{4}$	process colors)

The nearest to the gray card is process blue. All the rest will create errors in the readings, so don't measure the color. For that matter, don't read skin either—especially since everyone's skin reflects differently.

Another reason for the use of the spot meter is that you can measure the filter factor directly through the filter by placing it over the meter opening and reading the factor directly.

Highlights and shadows should be read. You expect the shadow to be dark, but how dark? Do you wish to see into the shadow? Should it be opaque? How light should a highlight be? You can't use your eye to determine this since your eye will close the iris when looking at the highlight and open the iris when looking into the shadow. The camera can't do that. It has a fixed aperture, so any adjustments must be made in the lighting. If you carefully keep the contrast ratio within one stop, experience will soon tell you if you are correct in your judgment.

Flash meters are not as popular as either of the

two above. The reasons are twofold, one, a strobe generator is constant for a given distance and the manufacturer gives you the guide numbers when you buy the unit. The second is that most photographers use umbrellas, the light is spread, and once read by a meter remains constant. These reasons are plausible and reasonable for general purpose photography, but for the professional studio photographer the proper type of flash meter is a must.

I use a *spot* flash meter regardless of using umbrellas or the square hooded reflector or ordinary reflectors. The strobe meter of this type has a small (10 degree) circle in the center and by aiming this at parts of the scene, I can check the balance of light just as I would with quartz lights and a spot meter. It is a characteristic of light that it falls off with the square of the distance and that the spread from the center or hot spot to the edge could be as much as a stop difference. This difference is meaningful only if you either underexpose or overexpose in which case the edge of your light will go out of allowable contrast ratios i.e. if the center of your flash umbrella light is underexposed, the edges would not record. If the edges of your flash umbrella light is overexposed, the center where the light is greater would not be recorded.

The flash meter is important to the proper control of exposure. Many food photographers who ordinarily would be expected to use quartz lighting since there is the need to see exactly what the light is doing, have learned to use a series of small reflectors in chrome satin and sometimes a bare bulb. (Use direct light for such subjects as ice cream, all kinds of liquor photographs and food shots.) Strobe gives a more crisp looking photograph and has

numerous advantages, not the least being the fact that you eliminate reciprocity – the biggest bugaboo in professional studio photography. Used with a polaroid and a good spot flash meter, the system can't be faulted.

The biggest drawback is that in order to work at apertures around f45 and f64, the photographer needs an enormous amount of light, at least two 2400 Watt Second units for each of three or four lamps. This is especially apparent when using either umbrellas or large muslin square box reflectors. One way to overcome this is to use multiple exposure with still lifes. Two flashes at f64 are twice the exposure of one. This is also why some studio photographers buy their lenses in self-cocking shutters . . . to avoid recocking the shutter. Once a photographer masters strobe, it's hard to get him to change.

27 The Tricolor Temperature Meter

How many times have other photographers visited me and opened the trunk of their car to show me one or two beautiful fitted cases of Hasselblads, Mamiya RBs, Nikons, Canons or the latest what-have-you with every accessory lens the manufacturer makes, and yet I never see the most important photographic instrument next to a basic camera: the 3-Color Temperature Meter.

In some forty years of professional photography, I have yet to find a situation where absolutely no filter is required to improve the photograph. I honestly know of no situation where an unfiltered lens has been used in my photography during the last twelve years. I believe this came about because I grew up in

the studio type of photography where filter training was a must; an indispensable adjunct to the photographer's lenses.

My suggestion to any serious photographer intending to go into any type of photography that includes the reproduction of color such as sales brochures, annual reports, record album covers, greeting cards, posters, portraiture and wedding photography, is that he consider the purchase of a 3-color Temperature Meter on his list of needed accessories. True, they're expensive, but then so are most lenses and I think you'll find the improvement in your photography a financial asset. More important, a CTM teaches you an understanding of light, the most necessary ingredient in any kind of photography.

Just so you won't confuse a 2-color meter with a 3-color meter, a small explanation is in order:

When a 2-color meter is used to measure a scene, its reading is expressed in terms of a single number, such as *"degrees Kelvin"* and gives you an indication of the *warmth* or *coolness* of the light indicated by the single *blue-to-red* measurement. Normally, this type of measurement is adequate for a "black radiator" source of light, such as a filament or incandescent type of bulb. However, it will not measure the *green-to-red* ratio in light sources such as daylight, fluorescent, arc, mercury vapor and some filament types where lighting is mixed with any of the above. This is why the new Spectra Model FB Tri-Color Temperature Meter has two distinct meters in one housing. The left side measures the Blue/Red and the right measures the Green/Red simultaneously. Looking at the meter while reading, it is instantly apparent that there are two different

temperatures to be read from any one light source giving a condition report of the red, blue and green in the light. To measure with one reading for the condition of two colors without consideration of the third and the fact that film has three layers: red, green and blue and further, that the meter must match the characteristics of the film, is to invite off-color results.

It is entirely possible to meter a daylight condition where the Blue/Red measures 4500K and the Green/Red measures 6500K. Obviously, if the daylight reading shows 4500K of Blue energy, and the film is exposed without correction, the blue layer will be underexposed since daylight film is balanced for approximately 5500K (Kodak). Using the same reading but the right hand meter, the Green/Red measurement of 6500K means that the green layer of the film will be slightly overexposed. The result on your transparency will be a yellowish-green tint.

Minor variations in color temperature are visually acceptable, but the major corrections can be determined only with a Tricolor Temperature Meter. The use of one usually means the difference between a knowledgeable pro and a commercial hack.

You cannot depend on all the individual light sources being constant and in balance with present day films. Daylight type films are balanced to 5500K but that is usually on a bright sunny day, sometime between 11 A.M. and 2 P.M. in the Northern Hemisphere. Even then, weather conditions will alter the color temperature as much as four or five hundred Kelvin.

Of all the incandescent type lamps commonly in use in professional photography, the quartz is the

most stable, but I have found variations in temperature with them. I always meter a commercial scene just before I expose, . . . and I always wind up with a correction filter or two.

The biggest single problem is with fluorescent lights and although there are FL-D and FL-B filters they're simply not good enough for most situations. I find many variations in tubes; I find mixed tubes, and what's worse, sometimes I have to work in mixed lighting. The use of the Spectra TriColor Temperature Meter takes all of the guess work out of the problem. The meter readings taken from the subject pinpoint the correction. This is vital should you have a product with a trademark color.

The meter comes with two plastic adjustable dial computers — one for Light Balancing Filters such as the 80 series by Kodak and one for Color Correction Filters (the CC- series). Almost every photographer has some of each. The readings are read from the subject facing the camera. The Light Sensor assembly gathers the light through an integrating diffuser before being read by the three filters, one for each color, covering the photo-detector cells. The information is then recorded by pulling the trigger. A number of actions take place at this time. Each meter needle automatically goes to the proper position on the scale and stops. Releasing the trigger locks the needle position. The left needle points to a number to be used with the computer to read the Blue/Red value. The right hand needle records information to determine the Green/Red values and they are almost always different.

Transposing the left hand number to the computer and matching the number to the type of film used shows the filter needed and an exposure correc-

tion for the use of that filter all in a window cutout. Holding the matching dials in position, move the bottom dial and match the needle position shown on the meter to the film used and read the Green/Red correction, and its corresponding exposure compensation.

All filters may be added together to lessen the number of glass or gelatin surfaces. Two CC05 Magentas can be combined into one filter of CC10 Magenta as one example. In some cases, especially in the use of fluorescent lights, the filters can and should be combined. CC35 Yellow and CC40 Magenta can be made up of many filters, but CC35 Yellow and CC35 Magenta are equal to CC35 Red. Wherever possible in all photography, the least number of individual filters should be used.

The front trigger that actuates the readings combined with the check switch, gives two instantaneous pieces of information; a battery condition check, read on the lower part of the left meter, and a light level check, read on the lower part of the right meter. Incidentally, this meter reads down to a level of five foot candles; levels below this give erroneous temperature readings. One suggestion to improve the ability to read in low light levels is to move closer to the source. This isn't always possible, especially in existing light conditions. Five candlepower is quite low and would require real long exposures.

Mixed lighting conditions are a dream with this meter. I found that in outdoor portraiture, where the sunlight is filtered through the leaves, the shaded area called for different readings on different days in the same spot. One day the call-out came to about CC10 Red (combined reading), another day, there

was more yellow light so I went to the called, Blue. In each case the photograph was superior to those taken with the bare lens. Shade is often blue, the meter showing a need for yellow . . . and it varies hour by hour. CC10 Red on VPS film correcting incident light falling on the subject is entirely different from CC10 Red added to a filter pack at the enlarger. Some photographers believe that all they have to worry about is the density and the laboratory will correct for deficiencies. That is sheer nonsense; the labs can't correct to match a properly balanced and exposed negative. (I have a laboratory and I teach this very subject of color temperature correction and have often made both types of negatives simultaneously and printed them separately for maximum color quality.) The properly filtered and exposed negative does show a difference. This is sometimes the difference between the professional and the not-so-professional.

The photographer using transparency materials for subjects, such as those I mentioned in the beginning of this chapter, doesn't have a chance to correct after the exposure is made. Short of copying, there isn't any way to correct for color deficiencies. This is why photographers who supply clients with material that is to be reproduced must make near-perfect transparencies.

Properly balanced projected slides are a joy to behold compared to bare lens photography with the washed out skies and off-color late afternoon photographs. The principles of Tricolor Temperature Meters apply to all sizes of film, 35mm to 11 × 14.

There are other variables that affect color balance such as different processing methods, the age of the film, how it was stored both before and

after it was exposed, what coatings are on the lenses used, film and filter tolerances at manufacture, not to speak of your own feelings.

As an example, you might like cooler or bluish snow scenes as opposed to a thoroughly corrected one. But wouldn't it be nice to have a choice? To be able to determine in advance what your feelings are as to the mood? You have that choice when your Spectra TriColor Meter reads the Blue/Red and the Green/Red and you interpret the scene to reflect your personal feelings and filter accordingly.

The Spectra TriColor Temperature Meter is made of light plastic, with solid state circuitry and comes with a padded plastic case and two computers, one for Light Balancing Filters and one for Color Correction Filters. The next time some proud photographer opens his car trunk to show me an array of sophisticated photographic equipment, I'd like to see a 3-Color Temperature Meter.

28 Something About Light

Before a photographer becomes professional about making photographs, he has to have some basic understanding of light. One can make photographs under sunlight and existing light conditions just so long before tackling artificial light. There are many rules and rules are made to be broken; some rules are worth understanding and the first of these is called the Inverse Ratio Law. It goes something like this; Light falls off or diminishes from a given source with the square of it's own distance or . . . more simply stated: you should open your aperture two stops when you double the distance. This rule is constant in its application to all types of artificial light: Strobes, photofloods, quartz and all types of

incandescent lamps. You can see this visibly on the exposure dial of any strobe unit regardless of power or style. At 5 feet set the dial at f22 and at 10 feet it will read f11; at 20 feet it will read f5.6. The exact exposure may vary but the formula will remain the same.

With quartz type lighting one can adjust the shutter speed instead of the aperture – or use a combination of both. The strobe dial mentioned above assumes that the shutter speed is fixed for the duration of the flash which wouldn't be true with any type of incandescent lamp.

The two areas where this problem doesn't come up are outdoor photographs using either sunlight or skylight and those interiors using existing light that usually comes from multiple sources and is spread evenly at most distances. Think of classrooms, gymnasiums, offices and even some homes.

The Inverse Ratio Law of lighting does apply. It just happens that these places mentioned have flat lighting by design. It pertains to outdoor lighting under the sun, too. The reason you don't have to worry about it is that the sun is 93,000,000 miles away. Since your point source, in this case the sun, is so far away, how can you double the distance? There isn't any fall-off. A light meter reading of two people standing ten feet apart under sunlight or overcast won't show any difference in the amount of light falling on them.

Manipulating lighting is one of the marks of the master photographer. Understanding some of the principles will make it that much easier to work successfully with light, most especially, indoor lighting. Each type of lamp; quartz, photoflood, spotlights, arc lights, and mercury vapor all follow

the law . . . but in dissimilar ways. Strobe, quartz and photofloods can be used with umbrellas, highly polished or satin reflectors, or bare; again, each follows the law, but the effect is different.

Light falls off to the point of being almost useless sideways. The usable portion is usually the width of the reflector or umbrella. So few photographers realize this. Proof of this is to try to photograph a blank wall in a studio from ten feet with any type lamp, but use a wide angle lens that will cover the wall and the fall-off becomes visible on the print or transparency. Why photographers attempt to photograph anything larger than the width of their umbrella or the shape of their reflector is a mystery.

The widest usable shape in photography is the bare bulb. Without the confining reflector the light spreads evenly. The antithesis is the spotlight with the highly polished and ray-directed reflector creating a sharp and well defined area of light.

We don't really see someone when we look at them, we see a reflection of them, else we would see them in a pitch dark room. The difference is the light that falls on them. It's the reflection of the person we see and that is what the camera photographs. We can control what the camera sees by altering the light. The most common alteration is the position of the lamp in relation to the subject. In general most people look best when the light comes from above and slightly to one side. The same thing applies to objects; light from above generally looks the best.

Besides direction, we can alter the quality of the light falling on objects or persons. Sharp, highly reflective light tends to dramatize, umbrellas and matte reflectors soften shadows and are usually considered more pleasing to the eye.

We can light with a number of lights rather than just one. The effects run from the dramatic to the ordinary. Special small lights are often used in fashion and portraiture to bring out certain features, to lighten shadows, create highlights in the hair or if the subject is a product, accent labels that need extra lighting.

Since we are photographing reflections, it is not always necessary to have an extra light. Anything that reflects serves as an extra light. Foil, white cardboard, mirrors, anything can be a reflector.

Intensity creates different effects by opening up shadows or the reverse, creating deep shadowed photographs.

In color photography, the color temperature of the light alters the effect quite dramatically. The warming or cooling can be achieved either with filters or changing the film.

These are all options and tools for the creative photographer and to be one, one must know how to handle each of the above.

Direction, quality, number, reflectors and intensity are just as useful outdoors as in the studio. The prime example of the use of all or most of these options is the Hollywood movie set. That is quite beyond the scope of the average photographer but it is interesting that the cinematographers should know the proper way to achieve the desired effect.

Besides the need to know much about light, the photographer must know the effect of light on film. Perhaps one of the first lessons a neophyte photographer learns is that what he sees through the viewfinder does not come out on the transparency in the same manner. This is caused by the fact that the aperture of the camera lens is fixed during the time of exposure where the iris of the human eye adjusts

constantly; if you look to the shadow area your pupil will dilate, as you glance at a highlight your pupil will contract. Your ability to see into dark areas and see detail and almost at the same time look at detail in a bright highlight gives you an ability beyond any lens or series of lenses. Because of the "fixed" aperture of your camera, what you see in the viewfinder through a single lens reflex is not even remotely connected to what is recorded on film. So, one of the first lessons that must be learned is to recognize when looking at a scene, exactly how it will record at different apertures, and the next lesson is what to do about it.

Suppose you're creating an indoor scene and you're pleased with the natural feeling and the softness of shadows. To create that on film requires that you over light the shadows and tone down or soften the highlights. It's easier to say than it is to do. Softening shadows means filling them in with light. Since the light is directional the fill creates a false look. Nobody has discovered a foolproof method of filling shadows selectively. Blending a highlight so it's not glary means to find the offending light and place some sort of diffuser over it. The total process is one of condensing light ratios; keeping the highlights and shadows within a 2-1 ratio. A generally flat-looking scene is going to photograph better than a contrasty one. There are products that will help previsualize a scene. They are called Viewing Filters and both Spectra and Tiffen make them. I find them so dense that I can't see the little nuances that I'd like to.

The spot meter is the best way to set lighting so that the recorded image is in balance. After awhile, experience will tell you that something is too contrasty or the shadows are blocked and the highlights

washed out. If you're aware of this phenomena, the relationship of the actual scene to how it will record, you are a giant step forward in your march toward professionalism and the understanding of light.

Another important characteristic of light is its color temperature. That is a subject in itself and certainly not basic. The use of light as a paint brush, so to speak, is part of the art of photography. I mention it here only to make the reader aware of some other perhaps unthought of facets of light. (See Chapter 27, Tricolor Temperature Meter.)

It takes about ten years of experience before the professional photographer understands anything about light other than what he has learned about placement and fall-off. Two other characteristics become more important as your experience increases; those are the *quality* and *amount* of *light*. Quality deserves an explanation. Quality is not the color temperature so much as light's specular characteristic, better defined with words like soft, harsh and intense. The last word is getting nearer to the point where quality and amount in reference to the light, collide. This means that the quality improves with the intensity and amount of light available. I have discovered that many photographs are improved when I work with a large volume of intense, highly specular quality light.

To get the gist of this idea and a quick understanding of the difference between light philosophies, pick up a small camera strobe unit and set it for ASA 160 at 10 feet; it recommends an exposure of f22. Expose a transparency and the result should be what some people would call a properly exposed transparency.

With the same camera and film move into a professional studio and on the set, photograph the

same subject, perhaps a fashion model, with the light intensity and amount built up with four 1200 watt second generators firing four strobes into translucent umbrellas. The exposure will still be f22 but the "quality" of the transparency will be vastly improved over the first unit. Why? Obviously, there is a vast difference in quality exclusive of type or arrangement of the lights. Yet, I rarely read of a discussion of how the gross amount of the light effects the quality. Usually, the amount of light is discussed as a need for depth of focus or to achieve a shorter exposure.

When it comes to buying lighting, most photographers buy strobe units with too little power. Portraiture needs very little output, but commercial subjects need an enormous amount of light in order to expose at small apertures. This is especially so when using umbrellas since they cut the light power in half.

Of all the units on the market, I find the Ascor and the Balcar the best in quality, reliability and usefulness. The Balcar sold by Tekno, Inc. of Chicago, New York and California is my personal choice since I need at least 2400 Watt Seconds per unit. Sometimes I use all this power from one lamp; sometimes I divide it up among three lamps since this unit has a "variable" feature. Heads may be switched on or off without unplugging and the quartz modeling lights are not only bright enough to see your modeling, but they can be used for small product photography as quartz illumination by switching off the strobe generator. The array of creative lighting accessories are all modular, well-designed and relatively inexpensive.

Tekno Inc. also sells a very superior line of quartz lighting units called "Hedler." The best I have ever seen.

29 More About Light

Studio photographers are often surprised by the fact that both black and white and color films exposed at the same f stop will be properly exposed; yet the black and white ASA is 400 and the color 160. How is this possible? One would expect the black and white to be a stop and a half overexposed; it is. The reason for the similarity is that most photographers habitually overexpose black and white to get a more printable negative; whereas, color must be properly exposed for a given density. Black and white film has enormous latitude and compensates for variations in exposure.

Under the conditions outlined above, the quality of both is similar because of the amount of light for

each is high. Had the volume been low, both would have suffered from lack of quality even though each would be properly exposed.

Small flash units expose small areas, usually flesh tones, and darken the surrounding areas. In essence, small flash units are grossly overrated; a whole generation of snapshot fans have grown up assuming that all photographs must look like well exposed faces and darkened surroundings. This has been carried over to the portrait field. Most portraits accepted by the large associations for competition were all dark except the face. The theory was that the highest key in a portrait should be the face — to draw attention to it. That may be, but many photographers missed some excellent opportunities to experiment with light.

I have discovered that in order to work best with light I must think of it as having a visible and physical shape. Mentally, I imagine light as a large hazy mass with some consistency — something I can hold in my hands — something soft and puffy like white clouds.

I realize this philosophy makes me a candidate for the loony bin, but I feel strongly that this attempt to understand and "feel" light gives me the advantage of better use of the medium.

"Always Fighting Light" was the motto of a director I once worked for. As the years of experience pile up, more and more I think back to what he taught me. His respect for light led to my understanding of light. For instance, all humans are programmed to feel that light should come from above, since everything we have ever looked at outdoors is lit by either the sun or the sky light. We have been conditioned that this is the best way to view anything.

So for this reason, when humans went indoors, they hung their makeshift first lights high in the cave, not on the floor. Through the evolution of artificial lights we have tried to emulate the sun. Our street lamps are high — why didn't we make them the same height as the fire plugs? The interior of all homes of every nation in every part of the world place the room lights in the ceiling. Even the table lamps are designed to *shine down* on the sitting person.

To give you an example of just how conditioned you are, think of the horror films; whenever Hollywood wants to frighten the movie-goer or the boob-tube watcher, they light the villian from *below*. Today, you wouldn't think of lighting from below, except maybe some products, but never a portrait or model. So let's assume that light should come from above.

Look at how conditioned you are to large volumes of bright light. A sunny day is considered better than a dark day by everyone everywhere. All ads that depict happiness are bright sunny ads. Gloom and sadness is darkness and if you look at what you read in the advertisements you will notice this dichotomy of bright and dark. Think of clothes for a moment. White denotes purity, cleanliness; nurses, doctors, waitresses etc. Black denotes violence, macabre, sinister, war, pestilence, etc. The list is endless. According to the National Association of Paint Manufacturers, white is far and away the most popular house color, regardless of climate.

If you wish acceptance for your photography, capitalize on some of humanity's conditioning. Make some of your photographs light, bright and airy with the light from above.

My idea of the best light available were I able

to package it, would be a bright, sunny, cloudless day heavily diffused with a controllable diffuser. This type of highly specular, yet diffused light from a *single source* is easily the most complimentary light for humans as well as products. Again, probably because I'm programmed too.

Since most photographers don't walk around with huge diffusers, they opt for a hazy bright day without sun. It's near, but not quite. In the studio, many great photographers have been building up the amount of light and concentrating it in one huge powerful generator with an umbrella. Even when they use two, three or more lights, they try for a visual effect of *single source*. Because of the fall-off (See Chapter 28 on Light), they use the extra lights to fill in what the sun doesn't need to do since it is a powerful point source. Almost all good ads (check all the issues of PhotoGraphis) give the impression of a single source.

Some practical examples of photographs that should show one light are the outdoor portrait often spoiled because the flash fill shows in the face, in a super bright area. Strange as it may seem, had the photographer taken the light off the camera and held it high so that the shadow was cast down, the same brightness wouldn't have been so objectionable. Again, the fault lies in the lack of height as much as the falseness of the visible fill.

I have a phrase that guides me in the handling of light in these circumstances; I call it "visual acceptance." When I judge my own or someone else's photograph, it must have "visual acceptance" just as it must have photographic excellence and if a portrait, it must be pleasing to the character depicted.

Visual acceptance is the guide to good lighting.

It follows the photographer in every type of photograph. A motel room or a room for a decorator must have lighting for the photograph that is concerned with exposure, but the lighting must also have "visual acceptance"; it must be unobtrusive, and above all it must look as if it weren't lit or that the lighting was natural for that room at that time.

I often light rooms and because the light comes from above, all the chairs, tables, couches and other furniture have dark underpinnings that must be lit and brought up to the contrast ratio. (See Chapter 23 on Contrast Ratio.) Most photographers tend to overfill. Then the room has a "plastic" or "gaudy" look. For natural photographs in rooms, I use what I call the 4 in 4 exposure. This is nothing more than a formula for almost any room. It works like this:

The camera is on a tripod, the film is ASA 125 Type B emulsion. The aperture is set at f 16 regardless of the room, excluding banquet halls, and the first part of the exposure is 4 seconds of time while waving a 650 watt Victor Quartz lamp around the room from behind the camera. The rest of the exposure is four seconds of time without the lamp using the existing illumination. This is the basic formula. Now for the qualifications:

Should the room have heavy globs of daylight coming in, still use the ASA 125 Type B without an 85B. Leave the time exposure at 4 seconds but increase the waving light to 6 seconds to compensate for the increased outdoor light coming in.

Should the room have more lamps and less light coming in from the windows, then reverse the above to read 6 seconds of time without any lights except the natural lamps in the room and 4 seconds with the waving light.

Exceptions to the above are very dark or very light rooms, but by and large, I use this formula since it preserves the natural and programmed feeling of what the room should look like without the falseness of overfill. Look through almost any magazine and you'll see falsely lit photographs created by inept photographers who do not know light; a shame, and totally unnecessary.

The test of many a good photographer is a rather simple photograph, the in-out combination, an enigma to so many photographers. Many systems are used, but the simplest I have found is to use Type B emulsion with an 85B filter. Exposure would obviously be for the outdoor scene. The interior must either be built up with quartz light exposed simultaneously or as a separate exposure. The dictate of naturalness would indicate that the interior should not be as bright as the outside so almost a stop less exposure is needed. Since the lighting calls for Type B emulsion without the filter, and the outdoor part of the total photograph calls for the filter, my suggestion is to leave it on with a simultaneous exposure since the overly warm condition caused by the 85B filter is acceptable for interiors, but the cold blue of an outdoor scene photographer on Type B emulsion is unacceptable.

It is axiomatic that product photography contains one strong overhead back light with a soft, broad frontal fill. But, again, the rule of "visual acceptance" still applies. As long as the photograph contains one central overhead light from the rear or side-rear, and the fill and accent lights are subtle and not at all obtrusive, then there will be visual acceptance.

Even in fashion photography, or perhaps I should

say, naturally in fashion photography, the rule would still apply since people photographs, almost more than any other kind, must be visually acceptable. Fashion photography goes through many fads; right now is the time of the blurred image. A year from now might be the makeup of the twenties. Last year it was the high overhead "butterfly" light. (With a sharp overhead light, the nose casts a butterfly image over the lips.) Each year the fashion photographer searches for a different way to present the latest from the salons of Paris. Yet no matter what gimmick or change, the light is always high or at least as high as the eyes, and the impression of the lighting is visually acceptable.

30 The Case for the 8 x 10 View Camera

It is often said that the 8 × 10 view camera will separate the men from the boys when it comes to high quality technical photography. I couldn't agree more. Without a doubt anyone who has learned to use the view camera in close-up and studio photography and mastered the swings and tilts and other problems, he has absorbed a discipline that will make him master of all photography. Would you believe that my 8 × 10 work helps my 35mm work? It certainly does.

Whenever a student or would-be assistant approaches me with his portfolio looking for a job, I gently ask him what his experience is with the view camera. Or sometimes I take him by the hand to the altar of photography; the 8 × 10 studio view camera

219

and take an orange, an apple, a loaf of bread, a bottle of wine and ask him to set these on a piece of black velvet and "set it up" for me. It is here that you can tell in an instant who has done his homework.

Were I ever to teach professional photography, regardless of what part of the profession the student would eventually specialize in, I would teach the 8 × 10 View Camera discipline. In my opinion the Photojournalist, the Portraitist, the Industrial Photographer, the Photographic Illustrator, each should be thoroughly familiar with the 8 × 10 camera and its techniques.

There is an enormous thrill to making a photograph in 8 × 10; a great sense of accomplishment comes over you. The quality alone is apt to make you fall in love with the 8 × 10. And you can be just as creative with 8 × 10 as you can with a 35mm. But boy, do you have to know your stuff! No getting away with a weird image, or smear and attach some phoney intellectual statement about your involvement, it's all there baby, it's all hanging out. Just look at the transparency; it doesn't lie. You either have it or you don't. For another thing, there isn't an art director in the world who doesn't admire a good 8 × 10.

I once picked out about thirty-five of my best 8 × 10s and placed them in an album with no other prints or tear sheets. I showed them to an art director at an agency where I had not previously done business. No slide show, no print presentation, just the 8 × 10s. He looked through them, showed them to his assistants and said a simple: "Wow!" Most art directors assume that if you can do 8 × 10s, you can do anything. They may be right.

Outdoor photography with an 8 × 10 is usually

not as worrisome as the studio work because you're working with longer distances between the camera and subject so you don't get into bellows draw problems and reciprocity, but you do have motion problems. The speed of the film and the need for depth are your two biggest enemies. Most photographers use Ektachrome Daylite ASA 50 or Agfachrome Sheet Film ASA 64. This means that your exposure is a 1/50th at f16 or thereabouts. If your outdoor photograph needs f45 or more for maximum depth, you cannot use these films. Reciprocity starts for Ektachrome Daylite at 1/10th of a second. So you will have to use Ektachrome Type B with an 85B filter, and an ASA of 25 with the filter. No reciprocity until 5 seconds.

The big problem here is motion since you must shoot on calm windless days on extremely rigid tripods since even a 1/50 of a second is not sufficient for the size of the camera in a wind.

But indoors is where the fun is. The lenses for these cameras are different from those for smaller cameras in many ways. A 300mm Telephoto lens for the 35mm, a 300mm telephoto for a 4 × 5 camera and a 300mm normal lens for an 8 × 10, all have the same image size for a given lens-to-subject distance and the same depth of focus for a given aperture and that's about all they have in common.

Shutter speeds and apertures are different with the fastest shutter speed rarely exceeding 1/150 of a second and the aperture just as rarely wider than f5.6, but it does go down to f64.

These restrictions are normal since the slow film makes anything more than 1/50 impossible; the cost and size of a lens that would have an f2.8 open-

ing would be eight or nine inches in diameter and the cost would be so prohibitive as to make them cost even more for few would buy them.

For starters, buy a 300mm lens and a wide angle of 165mm. Both of these lenses should cover most of the photography you'd ever run into. Each allows plenty of movement since they cover well. Buy a compendium hood, (See chapter 23 on Flare.) you'll need it not only to control reflections but as a place for your gelatin filters. (See chapter 20 on Filters.)

Studio photography is where these cameras really shine. Most work would be quite close and this is where most of the problems are, such as reciprocity (see chapter 32 on studio photography) and compensation for bellows draw.

It's axiomatic that anything less than a super sharp transparency from 8 × 10 is unacceptable because you're defeating the purpose of going to 8 × 10 in the first place. If grain and unsharpness are acceptable in your conception of the photograph why bother with all the extra troubles caused by 8 × 10? Not to speak of the expense. The beauty of 8 × 10 lies in the wealth of information or the content. An 8 × 10 is made to be *looked at* and *looked into*. 8 × 10s are not made for the emotional response although they can evoke all kinds of responses. They are known for their ability to *record detail*. Printers and engravers go ape over good transparencies and will often recommend you to their clients.

But super sharp means cutting the aperture way down to at least f64 and that means that your exposure is going to be long. And when that exposure gets beyond five seconds you're into the famous reciprocity syndrome and more than likely, you need to increase the exposure because of bellows draw.

(See chapter 19 on Lenses.) Couple those two problems together and you see why some people go bananas with 8 × 10 and assistants pick up the 35mm and "swing."

Filtration changes about every five seconds of exposure and (see Chapter 20 on Filters.) this means a knowledge of filtration is essential.

The exposure of color materials is critical, with little or no latitude, so bracketing or exposing at least three sheets is necessary to get one. This is insurance against processing problems too. But it's obviously, quite expensive: a 35mm slide has about one square inch of film, an 8 × 10 has 80 square inches, so you can see the reason for the cost.

Measuring exposure takes careful analysis, not like your SLR. Calculations must be made, figuring the bellows draw, the reciprocity of the long exposure, the exposure increase for the added filters and just getting a basic exposure. Rarely will two meters give you an accurate reading, and even when they do, the big lenses' shutter speeds are not accurate. If they're not used much they tend to react slowly or gum up. And the aperture blade system on big lenses causes slight over exposure. The mechanical figures of, say, $\frac{1}{2}$ second on a shutter for a 300mm View Camera lens is based or said to be a percentage of the exposure of the shutter were it open for the full time. This varies with the length of exposure time and at different apertures. It takes more time for the blades to uncover the lens and cover the lens at one aperture than another. This means that the center of the lens receives more exposure than the edges at small openings. The net result is overexposure at small apertures; especially with wide angles.

After a few experiments you will find that you know what your shutter is doing and when all the other variables are figured in, you will make consistently good transparencies.

Focusing with large format lenses must be absolutely accurate. Since you focus wide open, you must check the focus with a magnifier at the stop you wish to use since the focus usually shifts from wide open to stopped down. This is great since you can't see much at f64, you learn to use a small spot light from behind the camera to check focus.

The depth of focus is ridiculous. On a table top with food and an 18 or 24 inch bellows draw with a 300mm lens, at f64 you might have as much as 5 inches of sharp focus. Isn't that just dandy?

Lighting control must be super accurate; measurements with a spot meter are about the only way to get readings of the contrast ratio. (See chapter 23 on Contrast Control.) Lighting is often with the use of mirrors, bits of paper, miniature reflectors and small lamps. One inch one way or the other makes a big difference.

So far everything sounds quite negative, yet, that is not the case. This type of large format photography; an 8 × 10 or even with a 4 × 5 camera, (the results are not so pronounced with a 4 × 5) has enormous benefits as you learn more about photography in one session than you would in days and weeks with an SLR.

Let me enumerate some of the benefits:

It teaches you exposure control, the cost of materials, the atmosphere of working unhurriedly, working carefully with attention to details and is beneficial to your overall photographic expertise.

It teaches you the fine points of focusing, show-

ing you the shift that occurs in all lenses, but is more pronounced in view camera photography.

It teaches you a greater understanding of depth of focus, how to control it, how to measure its limits, how to increase it.

It greatly increases your ability to understand the reaction of filters and their needs, also teaches you filter factors and what they mean to the exposure.

It teaches you contrast control. A few blocked shadows or washed out highlights and you learn to watch for problems.

The one thing I haven't touched on since this chapter is not a lesson in large format photography as much as it is written to make you aware of the problems and the benefits, is swings and tilts.

This technique when understood is tremendously useful in all other types of photography. When you learn movement ability with the view camera to solve perspective problems, you learn to "see" what you can do with smaller cameras and you usually pick better angles and have greater control over the field of view.

To sum it up, my case for the 8 × 10 view camera makes you a better technician in any specialty of photography.

I've saved the granddaddy of all the benefits 'till last. A few transparencies entered in contests or for awards generally set you apart from other photographers. All knowledgeable photographers can see what you did in making an 8 × 10, much more so than with smaller sizes.

So can every art director. He knows that you know. You can't get much further ahead with a client than that.

The personal satisfaction is really great. You have approached a problem with multiple internal problems and you have solved them. You can and should be proud of your 8 × 10s.

And for those of you who need to make money, an 8 × 10 draws twice the money that a 4 × 5 draws. In many cases you can set a separate fee for 8 × 10s, and you should; a fee commensurate with your knowledge, your equipment and facilities, which in most cases is considerable.

31 Models & Fashion Photography

By far the most difficult photography in the studio is that type of photograph that contains a live model, yet more neophyte photographers aspire to become great fashion gurus. Apparently the glamour is akin to Hollywood movies and television. Perhaps it's voyeurism through the contact with the glamorous model, whatever it is, live model photography is most difficult.

The model adds another dimension to the photograph; the moving, living, breathing person whose very actions, expressions and mood control the very worth or sum and substance of the photograph. Because they have a personality, you the photographer have a tendency to become engaged with it. This is

probably one of the most detrimental features of photography with a live model. You need to retain your individuality and not become involved with her personality.

Yet on the other hand if you don't "turn her on" she won't be able to project for you. The expert with fashion has learned to have his cake and eat it too. The simile pertains to the fact that he must not be involved, yet give his model the impression that she is projecting. How this is done is quite intricate and not easily learned.

For the beginner who has never used a model, I suggest hiring a professional and telling her the truth, as much as it hurts. She can show you what she does for other photographers. These girls rarely "freeze" so you must be ready at all times with your concept of how the photograph should look. Start with black and white first since color is simply too hard in the beginning and too expensive.

Your technique, now firmly in your mind and your studio strobe set up the way you want it, find out the number of seconds to recycle your unit so that you don't fire faster than the unit can recharge as this will result in underexposed negatives. Depend on the model to pose at the correct timing. Give her the number of seconds for recharge. Prefocus your camera and be portable, at least enough so that she can move around in the area you assign to her.

As soon as you have shot a roll, no more, process and print and determine the quality. Next time you shoot you should have some ideas of how to improve your timing. A moving figure is a design in composition, the fashion photographer has an inborn sense that tells him when to fire to catch the model in the

best poses. Not everyone works this way with the model but this is good exercise for the beginner.

Many photographs have to be taken with the posed position because the props she carries or wears have to be handled in such a way that were she to move, the flared skirt would pull the weights or tape. This is much harder to photograph than the moving figure. Still, the photographer and the model can give the illusion of movement by coordinating their work. He gets set and tells her he's ready. Never say "Hold it!" This is a command that freezes the expression.

Get set, say "I'm ready Paulette" and then depend on her to search her expressions and try different things, different ways of holding her hands, tilting her head and the responsibility as to when to shoot is yours. This gives the photograph some feeling of spontaneity. Remember, she moves slightly in expression and whatever confinement of body she has and you fire when you see what you want. Run through it two or three times and fire the strobe without film. The dry run will train each of you when to fire.

In order to give you a head start may I suggest that you use a red filter on Tri-X film processed in your favorite developer?

The red filter will wipe her face clear and eliminate the skintone and blemishes. Ask her to over-makeup her lips with red lipstick. Most black and white photography of models has too little definition as it is with pan films without filters; the red filter will lighten it still further. This is a trick the big fashion boys use. You might also try a green filter, that will give you a slightly different effect.

While on the subject of makeup, the model

knows how to make herself up, but they often try to look good in the mirror; you aren't interested in how they look for the mirror since the film and filter alter the look. If your model is new at modeling, I suggest you send her to some of the makeup places in the big cities or take a course yourself (that's how I started with models). I have some makeup and can recognize a problem. I carry a combination brush and comb with a pick and a tube of Erase in my back pocket so I can make instant corrections as I see them. Looking through the SLR with the filter on and under a bright light will show you the effect of the filter and her lipstick.

Poise and grace are the two main things I look for in a model after determining she is attractive. Without these she is Susi Clutz. No matter how charming a personality, she must have poise and grace. I really don't think these can be learned in a charm school so I rarely suggest a model school to anyone interested in a photographic modeling career. These schools do help many people with self-confidence problems and people who have no knowledge whatsoever of modeling. These I don't want anyway.

A natural, goodlooking girl who can move, can model rings around a plastic beautiful face with affected motions. The overly graceful model school turnout turns me off.

Any girl is bound to be nervous the first time in front of the lights, so try to use her favorite music played in the studio. Have the lights set for strobe since posing is out of the question until she gains experience. When you start shooting, shoot with an empty camera for at least ten shots as a dry run and tell her so. This gives both of you time to limber up

and get in the mood. Tell her when you think you might have caught a good one. She is trying to please you so say so when she does. A person who is told she is beautiful IS BEAUTIFUL. While you are at it, get yourself in the mood, for unless you have an open mind and try hard with this girl, your photographs won't be successful. Soon the two of you will reach a point where you are excited, she is excited, and everything "clicks." It is this point that we look for. I call it "Non-involvement love." It is a meeting of personalities and until you can quickly establish this rapport with all models, you will never be a fashion photographer.

Fashion photography requires a model who is coordinated in every part of her body. She must be able to arrange her hands, arms, legs, head and torso so that they all combine into a pleasing composition. Models learn this in front of a mirror with a half dozen copies of Vogue and Harper's Bazaar in front of them. Incidentally, the best way to study poses for the photographer is to buy the same magazines.

It's easy to check a model. Just ask her to wave her hand in the air and hold it. It should form a graceful swanlike pose. Then try posing her whole body. If this too forms a graceful image, then never mind what she looks like; I tell you she's beautiful and she will photograph like a million dollars. Believe it or not, the best models are often passed on the street. They don't draw that much attention. A plain girl with beautiful bones, usually tall and thin with long legs, a graceful neck and arms, and a flat bust will make the best photographs.

It has been said that the camera adds ten pounds . . . it does in the look of weight in the photograph. Almost anyone heavy will appear much heavier so

when you select the girl, if you have a choice, go for the thinner type. Whatever you do, don't lie to a girl. If you think she won't make a model tell her so, but qualify it with stories of girls who have overcome many odds and become successful. You might also tell her that your judgment isn't infallible.

When the client picks the model, that's his responsibility, but yours is still to make the best possible photograph. Clients are often fooled by personality and miss heavy thighs and thick upper arms; he is impressed because he knows her. I don't know how to tell you, to tell him, she can't make it.

You're going to be disappointed with your photographs if you compare them with the fashion spreads you see in popular magazines. Better to understand than to be discouraged. Those fashion spreads are taken by top photographers using top models and with a stylist and maybe a hairstylist. More professional talent has been brought to bear on that spread than you could ever assemble. Be content if your work is clean, clear and shows a style. But practice and more practice if fashion is to be your choice in photography.

Probably your first experiences with models will be of the more commercial type of photograph where the model is the accessory to the product. If this is the case, select subdued clothes without glaring checks, spots or stripes and harmonize the colors of her apparel with that of the product. Try ever so desperately to avoid the dreary toothy smile with the sensuous and loving touch of her hands. Better to be frank and commonly happy if you can't show her in action with the product.

Where posing comes hard for both the beginner and the photographer, it is best to "lead" the model.

Try having her outside the set, and at a given signal walk on and to the predetermined action. You be ready to shoot as she reaches the peak. This often takes away the deadly frozen look to the photograph.

Some magazines stress the "big bust" type of model to sell their products. The idea being that the sexy cleavage draws attention, it certainly does, but I doubt that it sells. I'm not a prude by any stretch of the imagination, but the more the model looks like a lady the more desirable are the products. I can prove this theory:

A few years ago I was commissioned to make a life-size display of a model holding a tray on which the liquor store dealer would place bottles of Black Velvet whisky. I selected Lisa Sjoberg out of Wilhelmina Agency in New York. We worked on the look directly into the camera to establish "eyeball" contact. This display was a winner in the POPEI contest held by advertising people. This Point of Purchase display compelled people to identify with Lisa and buy a bottle from her tray. This is the name of the game for the photographer and the model. Because Lisa is a lady and she projects that way, she created a desire to be with her and customers wanted that identification. Powerful stuff. The price of the model evaporates when you can consistantly evoke that kind of feeling.

The handling of a model by the photographer is just not done by the best photographers. If you can't direct her and control the set, you aren't there yet. There is never any need to touch her or actually place hand or foot or touch the head for any reason whatsoever. Any great photographer is a master psychologist and has other skills as well. Such attributes as the ability to see a composition, to have

the taste to know and select clothes, to be aware of color harmony and above all to be a gentleman.

If it is at all possible and you are not located in the larger metropolitan areas may I suggest that you pay your models as they leave your office? I have found that this has enhanced my reputation with individual girls. Of course the agency will bill you for those that come through them. Many of the models I have used have been the world's greatest and I hope that most are still friendly with me. I find that they help my career as I suppose I help theirs.

Establish a rapport with a local clothing store or boutique. I find that more often than not I have to have a greater choice than the model brings with her, so I either rent or perhaps borrow clothes with the promise of a tear sheet of the ad or a print.

If you can afford a hair stylist and a makeup artist just for the assignment, you will find them worth the small cost. Invite your local hairdresser to assist, you'll find he's flattered and will come for very little. With specialists watching their areas of the photograph, you will have more time to your photography.

32 Small Product Photography

In an earlier chapter, I mentioned that the Illustrator commands the highest per photograph fee, however it is the Studio photographer doing small product or catalogue photography that makes the most money. Generally, he needs more equipment and facilities than any of the others of his profession. The larger the studio and the facilities, the more work he can take on and more important the more he isolates himself from his competitors.

His knowledge must keep pace with his equipment. He needs to know a great deal more about techniques than the Illustrator. He must be highly skilled in such subjects as exposure, swings and tilts, color temperature, filtration, all sorts of special

techniques in lighting, propping, styling, home economics, color processing, color printing and many others, peripheral to the job at hand. The greater his skill, the more clients will seek him out.

For the beginner trying to break in, there are a number of requisites; the first is a studio shooting room big enough to handle whatever jobs he can get. But I would say that 15×20 feet would be the minimum although every once in awhile you see an article about a talented commercial photographer who works out of a smaller space. Space is the main ingredient. The larger the space the easier it is to work and also the larger the product one can handle. If you're bothered by competition, build a bigger shooting room.

Recently I was hired to do a display photograph. The display was 16 feet long and had to be built in the studio. I got the job because I have a 50 foot studio. Many clients are forced to find a large studio because of the size of their product. Automobiles are specialized and handled by large studios as are furniture and other like items.

More important, or at least as important as the size of the studio is the height of the ceiling. Small products can be handled with a normal ceiling of 8 feet. But any product above a 4×4 foot subject is going to need a ceiling light and that must be at least 12 feet high. The furniture and automobile studios count 18 feet as the minimum and of course, many studios are 24 feet. Since ceilings are left open in the photography of furniture and large product photography so that the lights are out of the photograph, height is a must.

The point of view of the camera is another consideration. I have had to take the skydomes off the

roof and place the camera outside of the building in order to shoot one job, with a wide angle lens. So height is as important as the room dimensions.

Small products don't need quite the size studio discussed above, but they do need room for lighting and all the accessories.

Another consideration is the need for many outlets and different lines controlled by circuit breakers. I use the rule of two outlets per line or breaker and each breaker is capable of handling 30 amps. Obviously, the outlets should be of the three-wire type. Almost all photographic lamps sold today are of this type.

Any commercial studio should be painted white. White walls, ceilings, and if possible the floors should be tiled in white. The need for reflection is constant.

Numerous sturdy tables and boxes, all painted white are a great help. In a small studio, hinged tables are useful. Still, if you have a choice use free-floating tables so that you can place lights or reflectors or what have you around the table.

The minimum processing necessary is the ability to process 4×5 color transparencies and of course, roll films. Prints are not so much in demand with the catalogue studio since reproduction is better from the transparencies and is preferred by the separator. It isn't necessary to buy automated equipment in the beginning. A simple water-jacketed, one gallon, three tank processing set will process sheet film in hangers and will do it just as efficiently as the big units. The difference being that one is backbreaking hand labor and the other is mechanical freedom from drudgery. If and when you do go to more sophisticated equipment, don't go for the tube type of processor, go for the reel type. They use less chemistry

and are more efficient. The other disadvantage of the tanks is the fact that you must mix either one gallon or $3\frac{1}{2}$ at a time. This means that if business is slow, you must throw out the two developers in two weeks, whereas with the reel and tube systems you can mix what you need from liquid chemicals. Eventually all chemistry will be liquid and may be mixed in small batches. This would be most economical. So much for the facilities for the moment.

More important than the facilities is the equipment. I would consider the minimum a long bellows, 4×5 view camera, with a rotating back, capable of taking a polaroid back, with a bag bellows, recessed lens boards and a compendium shade with a gelatin filter holder. That's a mouthful, but every bit of it is important.

Next is a real sturdy tripod stand with the capability of going to ground level and a height of at least eight feet. This is the minimum, not the ideal. The ideal is either the cantilevered camera platform or the central post counter-weighted type of tripod. And these should be able to drop to a few inches off the floor and rise as high as ten feet and be rugged enough to handle a heavy 8×10 camera.

It's not the scope of this book to go into each piece of equipment necessary so I have eliminated many that seem obvious excerpting those that I think are important and pertain to this discussion. Everyone knows you need a meter in the studio but not everyone knows which and why. The which and why of meters is simple enough. The spot meter is indispensable. The why is that the small product photographer must measure all parts of the scene accurately for two reasons; one the need for accurate exposure and more important, the need for

accurate measurement of the extent of the ratio between the highlights and the shadows. (See Chapter 23 on Contrast Ratios).

Lighting is next with the need for two complete and competent systems: strobes and quartz. Again it's not the scope of this book to make specific product recommendations but whatever unit is purchased should have the following considerations or features: It must have at least three lamp heads with the attachments for them such as different reflectors, umbrellas, stands and cords. The generator or flash unit should be as powerful as you can afford, either in one or more units. Umbrella lighting is popular and will be for many years to come. Umbrellas cut the light power of the basic unit in half; most view camera product photography is shot at f45 or f64 for depth and more than one model in a photograph needs plenty of light, so buy big.

The quartz units should be at least three in number and also have their own stands, reflectors and barn door attachments. The power should be at least 1000 watts for the reasons above; umbrellas and f stops cut the light power.

The strobes are used whenever there is a live model or whenever the product will be affected by heat or slow exposure. The quarts lights will be used whenever great depth and intricate lighting is called for providing the product is stationary. Umbrellas are used with quartz by the professionals, more so than the reflector or bare bulb in the studio. Again the need is to keep the highlights and shadows under control. So many photographers try to make contrast in a photograph to suit their eye, when all that is needed is flat lighting to the eye as the color will make its own contrast on the film.

I've left to last the knowledge of the photographer. This is not to say that the equipment and the facilities are more important because they're not. Knowledge is far and away more important. The ability to conceive the photograph is the first requisite. The need to determine the background and arrangement of pieces of the product or the group of products is next, and most important, the ability to control the lighting.

For the sake of an example, let me state that the best way to begin if your experience is limited is to use the quartz lamps with the umbrellas and form a triangle of all three lights, completely surrounding the table and product. If the lights are equi-distant you will have an acceptable photograph. Should the product be shiny you will have to control the shine with either a polarizer filter (best way) or mask the light with black cards.

A tent is the commercial idiot's delight. Every studio has to have a tent for small products. These are usually four pieces or frames of 1 × 2 wood, 4 feet × 4 feet covered with translucent shower curtain plastic (white). Three of these should be hinged so as to form a square U, the fourth piece is for a top. The three piece unit surrounds the table which you have conveniently made slightly under four feet for this purpose. Use three quartz lights this time without umbrellas but with the reflectors; one from the back, one on each side and one on the top. I know that is four lights, so fudge either of the two sides and offset the back light to partially cover the side with the missing light.

Wherever possible expose at that lens stop that will give you depth throughout. With small products that means f45 at the minimum. And that means that

the exposure is going to be over 30 seconds and that means reciprocity. A word that has been frightening photographers for years . . . and it should. I can't explain reciprocity in detail here but a slight explanation is needed for the neophyte photographer.

Tungsten type color films are rated for an average exposure of from $\frac{1}{10}$th of a second to $\frac{1}{2}$ second. Beyond this $\frac{1}{2}$ second in time the film's sensitivity decreases as the time of exposure increases, creating a situation that means that the longer you need to expose, the longer the film must be exposed to compensate. This becomes a can of worms since you never know which is first, the chicken or the egg? The instruction sheets given with each box of film are quite clear, but in addition to the reciprocity problem the color also changes, usually toward the blue or green. So additional filters are needed to correct for this condition; and in turn the additional filters need more exposure compensations; and this means more reciprocity which means more exposure to compensate.

If you haven't gone batty with this problem you are well on your way to becoming a successful commercial photographer. These problems don't appear until you have approached the third worm in our can: bellows draw.

The normal lens on a 4 × 5 camera is considered around a 150mm. This is about $5\frac{3}{4}$ inches in focal length. When the camera is focused at infinity, the distance between the center of the lens and the film plane is the same as the focal length; $5\frac{3}{4}$ inches in this case. If you decide to make a photograph with this set-up in the studio and you choose a small product such as a clock-radio for instance, the distance between the subject and the camera lens will

be about 24 inches. And about twice the focal length of the lens or 11½ inches will be the distance between the lens and the film plane. This means that the exposure must be increased by two stops. Add that item to the reciprocity and filters and you can readily see why commercial product photographers get bald early in life.

All is not lost though. The way to approach this problem is with a Kodak Color Dataguide which contains a chart for the correction of the exposure to compensate for both the bellows draw and the reciprocity effect at the same time. This factor with the exposure from your meter and the compensation slip enclosed with the film should enable you to determine the correct exposure and the necessary filters. Bracket one on the high side and one on the low side and pray.

This is why I break photography into segments. The most knowledgeable photographers are those who have to work within four feet of the subject and need the most technical knowledge, and those working between four feet and fifty feet next, with the infinity photographer needing the least. Of course this is an over-simplification but the closer one gets to the subject the more the problems increase.

Swings and tilts are a separate subject and must be learned. The best book ever for the real professional is STROEBEL'S "VIEW CAMERA TECHNIQUE." However, I don't recommend everyone starting with that book. Calumet puts out a very fine booklet with their cameras that is more practical for the beginner to the professional, and Kodak has PHOTOGRAPHY WITH LARGE-FORMAT CAMERAS; both are excellent.

For a five minute course consider the following:

1. Set the camera base level and "zero" all adjustments.
2. Perspective is controlled by the back camera standard; in general you keep that vertically and horizontally level or perpendicular to the floor. To change this changes the shape of the subject.
3. You can tilt or swing the front camera standard to improve sharpness or preserve it.
4. Raising the front standard when perpendicular to the horizon and lowering the rear standard prevents "keystoning" of tall buildings or objects.
5. Offcentering either the front or rear standards, or both, gets YOU out of the reflection when photographing mirrorlike subjects.
6. For a high point of view, camera aiming down, bring everything to zero adjustment and improve sharpness with the front standard tilt forward or backward depending on the subject.

Suggestion: buy a camera with a rotating back rather than a fixed two-position type. Be sure to buy a compendium shade and a long bellows. Make sure that whatever lens you buy will cover all the adjustments you might want. I would say a 150mm on a 4 × 5 is the best all around lens for that size camera and a 300mm for an 8 × 10 camera.

33 Annual Report Photography

In just the past few years annual report photography has come into its own. Now there are specialized corporations who design and manufacture the report where just a decade ago, most of these were produced by the marketing department of the corporation. Essentially, the annual report is a glorified stockholder's report. The stockholder's report of yesteryear contained page after page of unrelenting columns of figures that few could understand, today's annual report is the showcase of corporate industry, with glamorous photographs depicting the products and the services with top models and the whole thing designed with no expense barred that would not seduce the investor.

The annual report is the sales brochure of the business side of American corporations. Today these are carefully conceived and executed. The photographer who gets this type of assignment is considered a top man and he is selected carefully.

Most photography of this type is done on 35mm and almost always in color. No "shotgun" photography here, just expert techniques. The requirements are stringent: color portraits of the executives, both formal and informal, and in two's, three's and groups; second echelon managers and executives behind desks working; department heads with their people singly and in groups.

When you cross the line into the plant, factory or whatever, you'll meet the foreman, or more likely the Superintendent in his more austere office with the manufacturing schedule on the wall. Now you are into Industrial Photography. (See Chapter 34 on Industrial Photography.)

This type of photography is priced by the day on the Day Rate, rarely any other way. This is especially so if the agency is running the show. Incidentally, good manners dictate that you never mention your Day Rate when in the company of the client. Some agencies mark up the rate or bury it and the less said the better. At this point in time, the going Day Rate for this type of photography is about $600 a day plus expenses. This is a low for any corporation listed in Fortune's 500. One reason for not mentioning the rate is people who work for salaries have little understanding or patience when they hear "$600 a day."

The first photographs are of the executives who have been warned with a notice from the photographer suggesting they wear nothing with dots,

checks, stripes or plaids and certainly not something that is suggestive of the season. Remember, they are waiting for you.

The pecking order demands the President or the Chairman be first in your view finder. I usually set up my 35mm SLR on a tripod about twelve feet away from him with a motor drive and a zoom lens. I carry two 3100 Molelite Quartz lights and shoot on type B film unless the light is existing light, then I use the same film with an 85B filter. I carry the trigger in my coat pocket and I engage the gentleman in conversation; I am sitting alongside his desk and out of range of the camera. With my hand in my pocket, I squeeze off a few shots.

If the light is fluorescent and you are shooting in color I suggest you use the Quartz lights and overcome the fluorescents. If the light is predominately daylight, I suggest the Type B film with the 85 B and a quartz fill. I know that sounds strange, but try it.

Strobe is used by some. I tend to go back and forth on the matter of strobe versus quartz. With quartz I can see what I am getting, with strobe I sense or know what's on the film. I must say that when I use strobe, I use three lights, two of which have slaves, and one, the one with the cord, on the camera for fill. The other two are on high power and are placed strategically around the office; the low power on the camera.

For the portraits of the executives, both formal and the informal, I do not touch the camera or aim at them. I place the camera on a tripod and using a 28mm lens for the groups around the conference table, I watch off to the side and look for "the moment." Believe me, there is a moment that is differ-

ent from all others. This moment can be programmed by you, by asking them to actually work on a project. Wait until they become absorbed, then shoot. It is difficult to set up three people without someone having a back to the camera, so I change the places often. I never leave the shot until I am satisfied that I have a good one.

On the photographs of the President or Chairman, I try to contact his personal secretary and with his knowledge, I have her call him from her office and "chat" with him. Most of these women are experts at handling their bosses and quickly put him at ease. Telephone shots without someone on the other end are deadly.

Your biggest problem with the executive is his shyness. Not all are shy, but for those that are, you must "lead" him into the photograph. If he is given things to do he feels in his element. I once spotted a Frieden Calculator of a special type and by asking the Comptroller what was the most difficult type problem the calculator could do, he quickly showed me and the increased interest gave me a good photograph.

When working in close, don't use a flash on the camera. The flash is anticipated when you are close and the expressions are false. I also try not to get in too close, preferring to use my f4 75-150mm Zoom; the subject is more relaxed that way. There are some interesting low level shots with the wide angle, but few are flattering, as the wide angle distorts the face. Where possible, I work with no less than a 75mm lens for portrait photography of this type. My favorite is about 100mm on the zoom lens.

Some Annual Report specialists use a wink light at the camera and have two small stands with strobes

placed to act as model or main light and general illumination. The wink light is to open the shadows.

Fluorescent illumination plays hob with portraits if used as is, even in black and white it muddies the faces. I don't suggest taking anything under fluorescents except perhaps the large expanse of offices in color properly balanced. Then you will have to warn everyone not to move or perhaps push the film to 500 ASA as I do. (125 ASA push twice: 250–500) Be sure to mark that roll—another reason why people carry three camera bodies. Be sure to filter.

Whenever you control the illumination, Quartz or strobe, there are few surprises when you get your slides processed. I am a firm believer in the photographer controlling all lighting situations. I have had my share of surprises.

I will skip the in-plant part of Annual Report Photography since the subject is covered in the chapter on Industrial Photography and, also skip the section pertaining to the use of models since that is covered in the chapter on Models.

Location photography for annual reports requires a much greater expertise in imaginative techniques than can be done by average photographers. Everything in your bag of tricks must be pulled out and sorted over. This is an area where lesser photographers fall on their faces. They try to cover with fisheye shots, or prism attachments, or the like.

Perhaps the way to approach location photography would be to take much time and explore all views with telephotos as well as with wide angles. A tank farm can be deadening as an example, or beautiful with perhaps a 28mm lens and an oversize polarizer shot from one leg of the tank. Or perhaps a stark, lone figure dwarfed by the expanse of white

and climbing the outside ladder on an oil tank; a composition of tanks added together by the compressing effects of a 400mm tele with a 2X extender so that the effect is like an 800mm lens, the real and the extra real, the real to the abstract. I can show you, but I can't tell you some of what your eye has to see. Most errors are caused by the photographer not spending enough time thinking and looking. The pressure of the people talking around you seems to say, "shoot, why aren't you taking photographs?" This is where the pro excels . . . he says nothing and he isn't panicked by people . . . he just does his own thing.

Night photography is a must with the annual report. So many locations are heavily industrialized and night hides so much. When I say "night" I really mean "dusk." An underexposed dusk shot passes for night. This is especially true where the photographer uses a polarizer. I try to hit that time when the sky is deepening toward dusk or night and yet there is separation in the roof line. I use Type B film even though the shot is outside. The color of the lights on in the building and the night sky are rendered a gorgeous blue.

There is much an annual report specialist must know; advance notice to the people to be photographed is important, especially the ladies; warnings about highly visible patterns in clothes are necessary; asking the Plant Manager to ask Maintenance to see that all tubes are replaced where missing in offices; seeing that all outside lights are replaced where needed. These are but a few of the more obvious details you should coordinate with the plant. Attempts to clean up the yard are welcome, but never really come off. If you place these on your check sheet sent

to the plant, at least you are covered should there be a kick back.

Equipment that you should bring is obvious, but there are a few items worth special attention; one of these is the use of the motor driven camera, used not for sequential photographs so much as to allow the photographer freedom from the camera, so necessary to a candid effect with people.

More and more photographers are buying Tricolor Temperature Meters. The increased use of Mercury Vapor and fluorescent lighting is pointing up this need.

Both strobe and quartz lighting should be carried. Of course, this is the optimum desired and is probably most impractical for those who have to travel to a location by plane.

The annual report photographer usually is paid better and makes more net profit than many of his brethren. All his expenses are paid; yet, it is a field for the super pro.

34 Industrial Photography

The commercial photographer with ambitions of being a well known Photographic Illustrator, will find his path winds through many by-passes. One of these is the industrial photograph. The beginning of industrial photography would be the plant photograph in and outside for the facilities brochure. This type of picture requires no great expertise or knowledge. Most of them are what I call "flat" photographs; the photographer stands back and picks a lens that will cover the area in question and fires away after due deliberation as to exposure.

These "focus and expose" photographs are available all over the country and they're easy to knock out if you have a little knowledge. About the

first clue that a commercial photographer has left the super sharp and "flat" photograph, is his choice of an angle that requires a judgment of a median focus point; an aperture selected because of its ability to cover the depth and a thought about composition.

This photographer isn't dangerous yet, but he's on his way, unless he stops at focus and expose photography. There's no shame in stopping there, and even the greatest of the industrial photographers are required to perform this ritual; but, most have gone on to what could loosely be termed: "creative industrial photography."

How many of us have gone to an assignment where the industrial plant is located in the "Industrial Park" . . . Park? This turns out to be nothing more than a collection of all-on-one-level windowless plants made out of either precast concrete, cinder block or brick boxes set in "imitation landscaping." It's easy to tell where the front is; that's the glass window area, usually a glass fronted oblong box attached to the cinder block, etc., etc.

If it weren't for the signs you couldn't tell one plant from another. Not one has any character, and as to being a photographable site? Ever try shooting one of these from the air? They are all covered with black tar and stone compositions and are easily seen, since any height above fifty feet you see acres and acres of this black composition relieved with puddles of water, and ventilator huts. The ecologists can say what they will about the old-fashioned industrial plant, but man, it had character!

The architects of the late 1800s had a hey-day with their designs; ornate steel fabrications, stone work copied from many European cathedrals, slate

roofs with gables, turrets and minarets, towers, and cupolas; all of this led to a distinctive, interesting plant. Today's sterile slab building may be efficient, but from the photographer's point of view, something pictorial is missing.

Faced with this problem the photographer is hard put to make dramatic individual looking photographs. Often he must resort to wide-angle views with either distortions ala the fisheye or he has to alter the color with a polarizer. He might have to make a solarized print for the front of the building or perhaps a montage of two views or an overprint of the product coupled with the building.

Outside views lend themselves to using a "cherrypicker" rather than the aerial photograph. The aerial is a poor choice of views with these buildings, whereas the cherrypicker is just the right height to favor the front of the building with some roof.

One of the big advantages of the old smokestack was that it added to the composition, and most of those old buildings had a small step up building just under the stack which further enhanced overall composition. The cherrypicker placed at one of the front corners and with a superwide angle makes a unique photograph and one to investigate. Another is at the dead center of the building still in the cherrypicker and shooting almost straight down with a good wide angle.

Still another is a ground shot with a wide angle. When I say ground, I mean just that; on the ground, one shooting level and another shooting up. During the latter, use the wide angle and have the roof line cut the corner of the transparency frame, a very dramatic shot.

Sometimes the glass front is such that a purposeful reflection is meaningful; check the reflections. A pond or perhaps a park or even white billowy clouds reflected in the glass of the front door with lettering on the door makes an interesting cover shot.

Often there is a flag, monument or sign with flowers in front of the building. Add these to the front with a telephoto lens so that the building isn't dwarfed by the wide angle.

I always look for shiny aluminum building edges or expanses of aluminum paneling outside. These make great reflecting areas. Remember that you should focus twice the distance for a sharp reflected image; one distance to the shiny reflector and one back to the object.

The insides of these plants don't vary that much either. Some have row upon row of dirty, messy machines with operators. If the plant is into electronics the areas are cleaner but the idea is the same; mass production or assembly line production. Most have been done and redone in the same type of photography year in and year out — camera on a tripod with a wide angle lens, but here color doesn't work that well with this type of photograph. They can't depend on the lighting. This accounts for the popularity of the FL-D and FL-B fluorescent filters. Until they came along, most photographers were lost. Even they are only good for Cool White fresh tubes. In all other cases you should use a Tricolor Meter. (See Chapter 27 on Temperature Meter.)

Again, this is still another "focus and expose" or very elementary photography. It shouldn't be. Most photographers have little understanding of inside industrial photography.

When you are inside one of these plants, divide your photography up into three areas and write each down. Start with the one mentioned above; a few overall views with the camera on the tripod; use either transparency or color negative film and balance the light with either the FL-B filter or take a reading with a Tricolor Temperature Meter, and balance with gelatin filters. Think of this type of photography as "distant" photography.

Your next group would be photographs that are closer in distance, say, five feet to fifteen feet. These photographs should be "people" photographs for two reasons; one, you can light this kind of distance with either strobe or quartz lighting, and second, you can capture movement with good color rendition and action.

The third area or group of photographs are those that are the most important and they are taken from five feet to five inches. These are the "hidden" images—those that aren't visible. You have to train yourself to be this kind of photographer. They are the most important because here is your chance to show yourself to the world with creative photographs.

Each small area in any kind of a plant has a specific action or function that is almost invisible to the eye at least it's not noticed, yet the function of the machine is aimed at this one action. It might be something under a microscope such as in many electronic plants; it might be a chip in a furnace as in a semi-conductor plant; it might be larger, puddling in a casting plant, but whatever it is, it is there. It has to be. The purpose of the plant, no matter what it is, is a small function and you had best find out what it

is. All of the other departments are subordinate to this function. (Refer to my book Creative Color Photography, Chapter on Industrial Photography.)

In many plants where there is a sequence of events or a continuity, such as an assembly-line or manufacturing procedure most of the departments and machinery are accessory to this one function or point. Look carefully, ignore whoever is taking you around, follow in your mind's eye the progress of the item, whatever it is.

When you find a series of small functions, such as welding in a sawblade plant or a chip in a semiconductor plant or a resistor in an electronic plant or something large; a car in an auto plant, whatever, this function should be the creative focus of your photography. This is how you do it.

For small items that can be moved, I place them on a white card in the conference room and back light them with two spotlights; one red, one blue. Use a small telephoto with extension tubes, which, depends on how small the item is. Place a number of them in rows and random shoot, wide open focusing on one row or one item; let the two lamps flare into the lens. This will create halos all over the photograph and emphasize the one focused upon. For larger items, larger than a bread box, reverse the procedure—light from the front but find one point for sharp focus. Let the rest blur out to colored balls of light.

Make some shots with the camera moving using slow shutter speeds; others with a zoom with same slow shutter speeds. All with a wide open lens.

For these creative type shots, make most of them vertical since they will wind up as covers or ads. If the composition is such that you must go horizontal,

fine, shoot it and then suggest that it be folded in the middle making a front and rear cover for the facilities brochure or whatever.

When the item can't be moved, say, the process of the chip in the furnace, then light it as best you can — use whatever lens seems to give a creative effect. (See Chapter 19 on Lenses, section re telephotos.) For instance, a telephoto is easily the best lens in an industrial plant, yet many of my assistants, before learning otherwise, tend to leave these home. Try a telephoto in the main part of the plant. You'd be astonished at what you can see. In most cases, use it wide open. This type of lens used with extension tubes to bring you to about six or eight feet will open a whole new world of creative color photography in the industrial plant.

So these three areas are to be treated individually and with different lightings. The last is easily the most startling in quality and in most cases winds up on the cover. As is the case in all types of photography, the photographer must be able to "see" or have an "eye." Experience with a few of these plants will give you this eye and you can get better and better at it after awhile.

It is important to realize that you simply can't light everything. Big plants have too much space. This means using existing light; if, however, existing light means mercury vapor, God help you! I find that for most mercury vapor rooms I am using 80 Red and 40 Blue; time exposures, too. Fluorescent is not so bad, running in the neighborhood of 50 Red and 10 Yellow. All of these are read with a color temperature meter.

This is how I divide up the plant into the three areas of photography: existing light, tripod, and time

exposure for the distant shots. Where I can overcome the problems, five to fifteen feet, I use strobe or quartz. I do the moving people in here. And then under five feet I do the highly creative color photography using all sorts of optical effects. (Read Chapter 21 on Special Effects Attachments.)

If an industrial photographer goes to a plant for this type of work and is not prepared for all that I have mentioned in this chapter, he is cheating the client. More important, he is cheating himself. If you do not know how, these chapters should guide you in the proper direction.

35 Illustration Photography

Illustration differs from other forms of photography in the way you receive the assignment. In almost any other form of photography, you have something or someone to photograph; in fashion, you have a model with specific clothes; in portraiture you have the person; in commercial photography you have the product, place or point of view. In each of these and others, you have something *visible* and *tangible* to start with. The illustrator starts with an *idea* from which he must make a visible photograph that illustrates the idea.

 Let's follow an assignment through. The art director of the magazine calls and says he needs an illustration for the June issue for an article on

"Fear." He needs it within a week and he has sent a copy of the article to you. That's about all you get on the phone.

Your job is to read the article or fiction piece, extract the juice and concoct the graphic photograph. You must recognize that the ultimate purpose of the photograph is to draw the reader's attention to the subject of the written piece, to pique his curiosity.

Sometimes I do this with a *shock technique,* another time I abstract the piece and *hint* at the content. Other times, I try to *complement* the piece, and still others, I make a *thematic* photograph. No matter what the method, the photograph is a supplement to, not a substitute for, the article. If I have done my job well, I know it and so does my art director. The proof is being asked to do another.

The second purpose of the photograph is to break up the pages of unrelenting type; to provide a balance for the overall design of the magazine. This is a subjective use of the photograph and the selection is often made with primarily this consideration in mind. Since I must, of necessity, submit a small selection when I complete the assignment, the art director has a choice sometimes dictated by the *color* almost without regard to *content.* This destroys my ego at times since I always label my own choices according to content and numbered 1, 2, 3, etc., in the hope that he will use my first choice. It's disappointing to learn that he might have to use a back-up photograph either because the editor thought that number one was too risque for their readers, or that the heavy magenta wouldn't balance previous articles or fiction pieces and their illustrations.

Then, too, the art director is buying expensive photography, sight unseen and in many ways un-

directed. He does this purposely, since he doesn't want to coerce the talent he hires, he'd rather they create on their own. This forces the illustrators to grope somewhat blindly, but the good ones will come through. The emphasis is on highly imaginative photo-illustration. It's not easy.

When you consider that there are as many as five different photographers working on each issue of, say, twenty top magazines, you can see the competition is enormous. All of the photographers are the best in the country since the art directors of these magazines are the highest paid themselves and they pay the highest fees for illustrations. This means the competition for space and color is just as immense. How big a play you get depends on the quality of your illustration, the content, color, weight and balance, not to mention the whim of the art director. Should other articles and fiction pieces already be plated when yours arrives, and they are, say, large in overall size, then yours might be made small to balance the issue.

Often a neophyte photographer will wonder why the art director of a big magazine won't give him a chance at an assignment. The answer is that he simply can't take the chance. The photographer might fail and he, the art director, has to answer to the editor. Why jeopardize his job, especially when he can hire anyone he wishes with his budget? Remember, the going rate for a photographic illustration for any one of the top twenty magazines is $500 plus normal expenses such as models, props and processing. There are some variations to this fee, but this is the pay scale at this time.

A constant flow of portfolios cross the desks of most of these art directors daily and from this group

come the newer illustrators. (See Chapter 3 on Portfolios and Chapters on Speculation.) When the art director sees consistent and demonstrated abilities, he will take a chance, but until then he uses those illustrators who have also demonstrated consistent skills in this field.

To illustrate an assignment is not easy. Certain philosophies must be understood first; such as, illustrations are made in the brain, not in the camera. The brain must read the article on "fear of falling" and make certain creative *images* that depict the fear of falling. Let's take this assignment through to the finished photograph. (Read my Theory of Creative Color Photography book.)

Reading the magazine article is the first step. From this reading you should have determined the author's thrust—the points he makes or the theme of the article or fiction piece. Write these points down in your notebook. They should suggest some images. Try to think of images without regard to cameras or how difficult the image might be to reproduce on film. Decide what you'd like to see in the image. As an example, in the above assignment I thought of a falling person; a woman, a young woman since eight million of my readers were to be women. At first I thought of falling off a building since I was born and brought up in New York City, but I found that most of the readers are from the suburbs and also, urban readers would certainly recognize country locations. So I thought of falling off a precipice, some sort of cliff. This was enough for me to start the process of my next stage of designing the photograph.

I decided on an assemblage of two transparencies; the first to be the figure of the girl falling, the second a cliff with crashing waves below. I decided

that I would use a $2\frac{1}{4} \times 2\frac{3}{4}$ or ideal format camera since I wanted to use a ground glass for matching. The first photograph would be the girl, so I decided what criteria I would use. She should be facing away from the camera. I wanted no identification with the viewer. I picked a dark-haired model since the blonde was too synonymous with glamour. I wanted a pants suit as I felt that a dress flying up would draw attention to her figure and detract from the emotions I wanted to show. Her arms and legs should be outstretched. Now I had enough to start shooting. The model was called and told what to wear. I wanted a light colored pants suit, makeup wasn't important, long hair, either her own or a wig or a fall—nails not important.

When the model arrived, I was ready with a single large umbrella strobe for soft lighting. She was to stand on one foot, other leg outstretched as were her arms, one bent at the elbow. The fan was behind her blowing her hair toward the camera, as it would were she really falling away from the camera. My background was a continuous tone white curve built into the studio so that there was no seam nor shadow showing.

I placed her in the center and then cocked the camera on the tripod so that the final photograph would show her falling asymmetrically, not "straight up." The exposure on EH Daylight was f22 to make an extended exposure that would yield a somewhat light transparency. (Her light pants suit and the background both showed almost clear on film.) The darkest object was her hair.

Photographs of her were taken in a dark outfit and with her facing the camera and all other positions. Since I was paying for the session, I wanted

to be covered and then I might come up with a variation that needed a different approach.

The films were processed and I picked one or two that seemed to fit my plans. I contacted those onto a piece of 3M Color Key not for any qualities in the 3M except that it is quick to do and would give me a piece of film to lay on the ground glass.

Finding a cliff was no problem; I live in New England on the shore. For a cliff, I needed a wide angle lens of 50mm on my $2\frac{1}{4} \times 2\frac{3}{4}$ camera and a few rocks no more than six feet high with waves. The unaware photographer would have searched for a cliff of normal size. This wouldn't have done the job as well as something less imposing, but with the wide angle lens on the average rocky beach, the effect would be much more realistic. The key is in the view finder. I made a number of exposures almost normally; that is, no extension of the exposure. I filtered for a colder color than I would under other circumstances and processed those films.

By matching the films of the model with the various ones of the "cliffs" I found the combination of the two that seemed to portray my feelings. I had shots of the model close and far away; I had shots of the cliffs that appeared to be high and some close. Using ten of each of the model and ten of the cliffs, I came up with a combination of two. Then I added "gels." These are colored pieces of gelatins placed over the assemblages on the light table until I found a color that gave me a "feeling." Incidentally, I always work in vertical format since most magazines are vertical. I find that if I give the art director horizontals, he has to make a smaller illustration in the magazine than he would if I give him verticals.

When the assemblage of the model in the studio

and the background of the cliff were wedded, the crashing water and the rocks came through the light parts of her pants suit and the clear transparency of her background, giving the assemblage a ghostlike feeling.

Then I had to either copy this on the same size film or on 6120 (see chapter 24 on Copying Techniques). I *never* submit taped transparencies, always a single size, copy transparency.

Variations are made with a shot of a building looking up and some looking down. My experience tells me that the building shots with the falling model figure look too gruesome and that is not the point of the article. In fact, it detracts from the article on acrophobia. Shooting up isn't indicative of falling, except that the figure of the girl comes down at you.

Variations could have been made with the enlarger using 6120 film. Raising or lowering the enlarger while copying for the required ten second exposure would have added a falling motion to the photograph. Another variation might be a copy under the enlarger and double print her into the photograph of the cliffs. (See Chapter 41 on Color Printing Techniques on Films.)

After finding some five or six variations, I sent the package to the art director. At this point, although I have an assignment, I am still speculating. If he, or the editor, doesn't like any of those I made, I feel I am honor-bound to make them over. And I have done them over. My average do-over in this type of magazine illustration is one in twenty.

In a way, all photographers are speculators in the sense that you intend to satisfy your client. To force photographs down their throats with purchase orders and legally signed letters may win you a court

case and lose you the entire magazine. There aren't enough that you can afford to lose one. Besides, these magazines pay the best; surely you can afford to pocket your pride and start over again.

The key to Illustration Photography is your ability to mentally create images and then translate those images onto film.

36 Aerial Photography for Profit

For some reason not quite clear to me the buying public is always interested in aerial photographs in color. I suppose I'm somewhat jaded since I have been flying all my life and have a Commercial Pilot's License and a Flight Instructors Rating. My own flying aside, the flying cameraman is a successful one. Any commercial photographer wishing to increase his income should take to the air.

Aerial oblique photography can be divided into two philosophies one being the camera designed for aerial obliques (angle as opposed to vertical maps) and photographed from a plane designed for the camera. The other would be the one that concerns us;

267

the camera being a suitable one in popular use and the rental of a plane common to most airports.

Let's talk about the camera first. Years ago, we used the ubiquitous Speed Graphic with film packs. The problem was the fluttering bellows. That was corrected by most with an aluminum shield over the bellows. I don't prescribe the use of this camera today since better results can be obtained with more modern equipment that have auxiliary uses. We went from the Speed Graphic to either the professional aerial oblique cameras such as the Linhof Aerial Camera, a fine but expensive piece of equipment with a singular use, to the Hasselblad with the 90 degree prism. This camera is still in use. I should say, both are. Still, neither solves the majority of problems. Both of them have slow (1/500thSec) shutter speeds, not quite enough for the bumpy days. Where the Speed Graphic did have the 1/1000 focal plane shutter it was awkward and clumsy to use.

Today there are so many improvements in the grain of the film that the smaller negative or transparency is often equal to yesterday's photograph taken with the 4×5 camera. The present Vericolor II films are astonishing in their capability to render detail. A grainless 16×20 is not uncommon from the Ideal Format camera. Many cameras are more than useful for the Aerialist-Photographer; Koni-Omega, Linhof 70, Mamiya RB 6×7, Pentax 6×7, Kowa Six with 90 degree prism, and the Hasselblad just to name a few. It is interesting to note that all of the above cameras have more than just this one use. Those that are of the Ideal Format (6×7) have the slight edge in that their film is a third larger than the $2\frac{1}{4}$ square cameras. Where cropping is necessary this could prove to be the difference between grain

and no grain showing. The other consideration with all of these is shutter speed. In fact, this is the most important consideration after selecting the size of the camera.

On a calm day, with no turbulence, a 1/500 of a second is more than satisfactory, but before I would consider accepting assignments for aerial work, I would have to have a 1/1000 of a second shutter and this would narrow the field somewhat . . . in fact right down to the Pentax 6 × 7. But whatever camera is picked, a viewing system is the next feature in importance. One can't look down into a reflex camera from a plane without contortions and aerial photography is hard enough without working in other problems. Most of the plane's side windows are small and awkward and one must twist as it is to get a comfortable clear view. The 90 degree prism or a sportsfinder is a must. Of the two, I like to see what I'm getting through the lens. A negative feature of prisms becomes a plus in aerial photography; the fact that they cut off some 15% of the visible image means you will get 15% more on film than you see.

The roll film configuration is another plus, you don't have to fool with packs, septums, holders or whatever. Just fire, cock the lever and you are ready for the next exposure. This means you could conceivably get your shot in one pass around the subject. I rarely shoot a whole roll of 10 shots on one subject.

Other than the photographic problems, one must consider the plane for a minute. Although photography can and is done from a low wing single engine plane it is far more difficult than with a high wing. You don't have to wait for the wing to get out of your sight for one thing. On the high-wingers the struts do pose a problem but not as much as the travelling

wing tip. The high wing plane usually has a window on the left side that will open. The plane's speed through the air will keep the window open or it can be hooked open. This window is a must on cold winter days. For this reason I like the Cessnas and the older Piper Tri-Pacers that are almost extinct by now.

There is a trick to flying a photographer and if the pilot is not familiar with the problem you can tell him . . . not how to fly, but how you want the site flown. If you sit on the left by the window, that is normally the pilot's seat; he has to sit on the right and fly blind in the sense that he cannot see what you are photographing. So it's best to give your pilot as much information as you can as to what the plant, estate, or home etc., looks like. He has to approach it with the idea of flying circles to the left around it to give you a clear view or shot. His minimum height is governed by the law; roughly 1000 feet over unpopulated areas so he can pick any altitude you want above that. Remember that as a rule the air is smoother the higher you fly. So maybe on a very rough day, you can put a longer lens on and up your shutter speed for shots from a higher altitude which is another reason for the 1/1000 second shutter.

Your pilot has to fly what is known as "Around Pylons" and "on pylons." The first expression means that he flies an equal distance away from the subject even though the wind blows him off course on the downwind side and over the site on the upwind side. He controls this distance by varying his bank; upwind he flies with little bank, downwind he flies with a steeper bank. This means that if you photograph on the downwind side you will have less time than on the unwind side since you move faster over the ground downwind. Remember that.

Make sure you tell him that you want "around pylons" not "on pylons." On pylons, his wing tip stays right on the subject throughout the entire 360 degree flight. The distance from the subject varies throughout the flight. On a windy day, he'd stand that plane on the wing tip to stay put. Not only that, but his wing tip is always in your way. Best to ask for the correct flying method.

Now a pilot can cross-control if a wingtip does get in the way on the "around pylons." By hitting one rudder or the other, he can move the tip out of the way. Rather than go around again, ask for this "yaw." I have often shot an aerial and paid for as little as twenty minutes for a plane and pilot. Rates vary, of course, but $10 has been the fee paid for years of doing this in rented planes.

Often the pilot will ask you if you want "slow-flight." What he does is slow the plane down, sometimes with flaps (which get in the way of your view) to just above stall, which gives you more time to shoot. But a poor pilot will have a nose-high altitude that might ruin your view of the subject. Flaps cause excessive vibration, too.

Beyond flying the plane, the other consideration is how to take the photographs. The best is the old rifle squeeze. Even at a 1/1000 of a second, squeezing them off is still the best way. I push the seat back (first take the locking pin out of the track before you take off) and run the seat to the rear. Then I sit on one leg folded under me; this position forces me to aim down and is the most comfortable.

It is a characteristic of an open plane window to create a venturi effect; sort of like blowing over the open end of a bottle will suck the fluid up. Either stick your camera out of the window into the slip-stream or shoot from inside; avoid like the plague

leaving the lens flush with the plane of the window. Air currents will show occasionally as waves. With a bellows type camera such as the Mamiya RB, the bellows will suck the film from the back and you are out of focus. So much for the cameras, film, lenses and planes.

How to sell? Years ago, when I first bought my plane for this purpose, the bank told me they didn't think there was any aerial photographic business around. Of course, there wasn't. You have to make it.

I photographed every plant, marina, school, industrial site, and estate. Of course, I didn't do it all at once, but over a period of time. I made 11 × 14 color prints mounted on black card stock and went around to each place depicted and peddled them for $50 each. This was in 1953. I made many sales and this is not authorial puffery. From this small beginning I built a huge business in aerial photography.

Perhaps the most important factor of these speculative shots was that it brought me to the attention of plant and industrial executives and the aerials led to industrial assignments. Anyone will see you if you use a 11 × 14 color photograph as your calling card. Prices would have to be changed to reflect the present state of the economy. It is possible to do a half dozen sites in an hour and the cost of the plane is allocated over the six sites.

The cost of having laboratories process and print 11 × 14 prints is negligible when you think about the possible returns from such projects. Then consider the public relations side benefits and it really becomes worthwhile. To say that it can't be done in your area or that everything has been milked is ludicrous. You can start doing business anywhere, anytime. I have bounced around from one type of

work to another, all were considered closed, yet, I have carved my niche and made a living. There is a never-ending storehouse of ways to make your photography pay.

As long as we build highways and new buildings, the demand for new postcards continues. Contact the local news dealers who supply magazines to the stores, they are usually the ones who need postcard views. If you are near the water hire a plane or a power cruiser and photograph all marinas, shoreside plants, mansions and large sail and power boats. Be sure to get the name and number for identification.

Regarding helicopters – they're expensive when compared to the price per hour of fixed wing. However, if there is a flying service with a helicopter for rent, check him out. He may have slow seasons, or make a deal with you. Hire him anyway. Plan your flight path carefully to fly over a number of locations fairly close together. One hour in a 'chopper might be more rewarding than the fixed wing. Remember, they can go lower than fixed wings legally. Don't think they're better camera platforms. They are for the feature of staying put in one location, but they do vibrate something fierce. You'll need the higher shutter speed.

I use only two filters and one of these, the minus blue is for black and white. The other is the Ultra Violet, used on the color negative and the color transparencies.

37 Processing of Color Films

You'd almost think the title of this chapter too simple for a book of this scope, yet I find many of my students are confused by the various methods and procedures, so I think a small discussion will be useful, even if it is just a refresher.

I started out my photographic life as a "hypo splasher," a term too low to even deserve capitalization in this text. Essentially, it meant that I mixed Sodium Thiosulphate (hypo) with a hardener and water to make a fixing solution for black and white films and papers. The chemical was purchased in 100 lb bags and relegated to the darkest, dirtiest hole in the studio. It was the filthiest job I ever had, even worse than hauling ashes in my youth.

The powder flew everywhere and seeped into everything. As they say we came a long way since then. Today very few photographers bother to mix chemicals almost every kit comes in concentrates. Within a few years all developing kits will be in concentrates.

Concentrates serve a few purposes. One is that few studios or photographer's darkrooms have consistently pure water. It is either too alkaline or too acidic, both of which are destructive to proper developing. The pH factor is not critical but it is important. When the basic chemicals are in a liquid concentrate the additional water need not be critical although photographers experiencing problems with chemical processing kits using concentrates should check their pH. This can be done by purchasing Hydrion papers from any pool supply house. A proper pH for processing water should be from 6.0 to 8.0.

Another advantage of using concentrated solutions is that you can mix what you need and thereby eliminate waste. As an example, mixed solutions of color developer oxidize in two weeks and lose their strength. Concentrates have a shelf life of at least a year unmixed and unopened.

Opened stock is good for three to four months, a far cry from two weeks. At least you won't have to throw it out because you don't process often enough. So I opt for the mixing of the required quantities from stock liquid concentrates.

There are numerous processing procedures. The most prevalent is the $3\frac{1}{2}$ gallon nitrogen burst agitation, constant replenishment system. This is only good for large volume users such as labs, and large studios where they do a volume of work. For the smaller studio there are many one gallon stainless

steel tank systems using nitrogen burst for agitation and replenishment. These need a certain amount of volume too. The tank system has another disadvantage to the smaller user; if you wish to change to process color negative, you must empty each of the nine tanks and clean them then pour the new chemistry into the cleaned tanks. Evaporation and oxidation are the enemies of the tanks system. Bottles of nitrogen must be ordered and trucked in and hooked up weekly if your volume calls for it.

Most smaller studios and laboratories and photographers who process their own film are turning to the one-shot chemistry system without replenishment. This is possible in only the tube and reel type processors. They have numerous advantages for the smaller user. For one thing, they all use a small amount of fluid per unit of roll or sheet film; they can be easily cleaned, no tanks or hardware except for the one tube or reel; and everything is self-contained.

The small quantity of fluid used is accomplished by a movable dam adjusted to the single size reel or reels. The usual quantities are three ounces per 36 exposure roll of 35mm film or a 4 × 5 sheet of film. At the end of the processing cycle the solutions are dumped down the drain. Most of these processors have storage compartments for the various mixed chemicals required for the process. These compartments are temperature controlled as is the processing section with internal heaters and blowing fans. Cycles are timed both for rotation and reversing (required for films but not papers); a re-exposure light is incorporated into the machine should one be needed. Formulas with chemical re-exposure obviously don't need the light. Many of the machines

are programmed to feed and dump the solutions on command, all have a manual override and a means of processing by hand labor should there be a power failure. Since the cycles can be altered, any type of process for either positive or negative color film or negative black and white film and all color papers can be processed. All processors are ready for the next process after a simple rinse, although the reel must be dry before loading. Considering their versatility, I would expect to see these machines available for some time to come.

The processors for quantity work are expensive, but some companies have made miniature rotary-reversing gadgets that are surprisingly good and relatively inexpensive. One in particular is the Uni-chrome Uniroller with the Unidrum, an outfit that can be purchased for as little as $75 with a capability of processing either four rolls of 120 film or six rolls of 35mm film. The forward and reverse motions are identical to the large processors, however the dumping and filling cycles are done manually. The quality is every bit as good as the bigger and more expensive units.

It won't be too long before someone like Uni-chrome will come out with a drum to handle a few sheets of cut film. I understand they have a plastic insert for the present drum that will hold either four 4×5s or one 8×10, certainly not production but more than adequate for the small professional. When you consider the savings in equipment expenditure and the savings in processing costs, the above prices are really negligible. As an example, Unicolor suggests as little as 2 ounces per roll of 20 exposure 35mm film. Using liquid premixed chemistry the savings are astonishing.

One of the reasons that I use the Unicolor developer for positive material is that the same chemistry can be used for both roll film and sheet film as opposed to separate chemistry needed by other manufacturers, for each type of film. This coupled with the savings gained using premixed chemistry and the one shot feature make it an unbeatable combination.

There are some characteristics of processing color films that are not generally known, yet I think they should be common knowledge. Facts and understanding would encourage more photographers to process their own. Let me go over some:

The various solutions used in color film developing develop to completion with the exception of the first developer which sets or controls the density of the finished negative or transparency. By "completion" I mean that the times given by the manufacturer are beyond the minimum. So if you err in time, lengthen the time. It is not critical if your time goes even a half minute over the allotted time in any process step including washes and excepting the first developer.

Accidentally shortening of the time is also not critical, but more so than lengthening, since the manufacturer has a "cushion" built into his process. 10 or 15% short won't matter that much.

When reexposing by light the minimum is critical, probably around 30 seconds, but a longer time won't have any effect on the film. Lengthening the color developer will shift the transparency more toward the magenta, say a 10 minute process step increased to 15 minutes at the absolute maximum.

Of course "push-processing" will effectively increase the film speed. For a 1 stop gain, extend the time of the first developer by 25%, for a 2 stop; 50%

and 3 stops; 75%. All other solutions remain the same except the color developer which should be increased 50%.

Some films such as Ektachrome Duplicating Film 6120 are processed at a reduced first developer time to prevent the build up of contrast. Where 10 minutes at 75 degrees might be the suggested time and temperature, this film should be exposed for 10 seconds and developed for 6 minutes at 75 degrees in the first developer.

Changes can be made in the first developer to compensate for errors in exposure. Should you have made a mistake and exposed at the wrong ASA you can compensate in the first developer. More time for higher ASA and less time for a lower ASA, plus or minus 12% in time will effect the film by $\frac{1}{2}$ stop. A change can be made in temperature too; plus or minus 2 degrees in temperature will also effect the film by $\frac{1}{2}$ stop.

Agitation controls density and contrast. Too much increases the development, too little underexposes. Some photographers feel that the constant agitation of these machines increases contrast; they forget that the film is out of solution for at least half of the time even though thoroughly soaked with developer. The two equalize themselves. Were the films constantly agitated and always immersed, they would be overdeveloped and show increased contrast.

Professional studio photographers tend to underexpose a hair on at least one of the three they normally shoot. Often these are salvageable films since most use Colorbrite Overall Reducer; a magic fluid put out by Special Products Labs Inc. of Fort Lauderdale Florida. Three minutes in Colorbrite will effectively correct for a stop underexposure. If your color

is off you can correct for too much cyan, magenta or yellow with the individual color reducers, used either consecutively or separately with the overall reducer. Best to start with the Overall since the color shift will lessen with the reduction. This is nothing more than a simple dunking in a tray full of Colorbrite, for three minutes with constant agitation then ten minutes of washing and swabbing while washing to get the solution from staining. Sounds worse than it is. I know many photographers including myself who use this regularly with normal transparencies just to clean out the highlights.

Intensification of color is possible only to those transparencies that have been run through the Colorbrite Overall Reducer. These dry to sparkling films.

The enemy of good color transparencies is temperature. When you buy your films try to buy from a supplier who refrigerates them, especially the sheet films. When you purchase, place them in the refrigerator immediately and if you are not using them for a few months, place them in a freezer at 0 degrees. Incidentally, the refrigerator should be about 37 degrees fahrenheit.

Roll films need a $\frac{1}{2}$ hour to warm up *before* use; sheet films at least 1 hour, and that's from the upper box; from the freezer just double the times.

Any photographer who carries any kind of film in his car trunk in the summer is asking for a color shift. Film must be kept cool in the car. As to processing, the quicker the better. In order not to disturb the processing labs who depend upon mail order processing, Kodak can't give an accurate time but the photographer with his own processing had better process as soon as he can. I would place 12 hours as the outside limit. The latent image can be held by

refrigeration, but don't put a holder in the refrigerator since the other enemies, humidity or condensation will cause more damage than just waiting until you have the time to process.

Drying films are like magnets and will attract dust. So after processing, dry in a dust-free cabinet and either let them hang in the cabinet or sleeve or mount them.

Vericolor II films in both the rolls and sheet sizes are easily the finest negative films photographers have ever had. The grain is almost non-existant, the shadow detail, unbelievable. These films are a Godsend to the working pro. Their smaller brother Kodacolor II is also a new beauty and needs little attention as to temperature, hot or cold. But the Vericolor II films must be handled with more care. Refrigerate the film before use and during transportation they should be stored in cool containers. Process as soon as possible, preferably before 24 hours. Don't leave them in a camera half exposed else the balances on the same roll will differ. This is a discipline that should be standard with the working professionals.

38 Special Film Processing Techniques

For a quick, easy and startling creative effect to confound your clients, nothing is quite so brilliant as the *solarization* of a *positive transparency* printed on Ektacolor *print film*. This little process only takes 30 minutes, uses less chemistry and film, and yet it can be a money maker for the professional or advanced amateur.

Pick at least ten of your best slides and tape them, unmounted to the inside of a print frame glass, emulsion facing you. Cover the pattern with a 4 × 5 sheet of Ektacolor Print Film, emulsion to emulsion. Close the print frame and turn it over so that the glass is facing you and place it under your enlarger, (this last, in darkness, obviously).

Preset your enlarger so that the image of the

light will cover the print frame. I use an easel and arrange it so that the print frame fits into one corner. I can do this in the dark.

Expose the film in the print frame to an enlarger light filtered to about 60 Magenta for about 60 seconds at f5.6. This will vary with your equipment.

Develop this film in a tray with constant agitation for 4½ minutes in darkness. I happen to use Unicolor Negative Chemistry which is designed to develop this film. The same times and procedure will work with Kodak's Color negative developer such as the C-22 process. Your total time is to be 7 minutes of which 4½ represents your first developer.

Now, with the film still in the tray and in the dark, walk to the same easel where you exposed the print frame and place the tray in the same spot. This should take no more than 30 seconds, so your total development at this moment is 5 minutes.

With the enlarger still set with the 60 Magenta filtration, change the timer from 60 seconds to 30 and reexpose the print floating in the developer.

Continue the development to the 7 minute point and go directly to the stopfix bath for 5 minutes and turn on the lights. Continue the rest of the process normally; Blix for 4 minutes and Stabilizer for 1 minute and dry. That is all there is to it.

What do you have? You should have some very brilliant solarized slides with reds, greens and blues. If your colors are muddy, try less light at the first exposure. By the way, try not to slop all over the easel and the enlarger baseboard, the developer will stain.

Contrast Reducing Masks, (see chapter 23 on Compressing Contrast Ratios) are a snap to make and the directions are in the quoted chapter.

Solarizing or flashing color negatives and or *color transparencies* during the first development cycle is not difficult but is dependent on the type of processing unit you have. All old fashioned tank units with hangers are easy to do as are the reel type modern processors, but the tube units require taking the film out of the tube for flashing. I don't recommend this technique with a tube processor. The film is delicate and easily scratched. The emulsion is soft. Interrupting the cycle is not important since flashing takes just a few seconds.

My experience is that the flashing should take place close to the end of the first developer time, say at 8 minutes of a 10 minute developing time. Obviously, the flashing for reexposure has to be done in the dark and again, remember, you will ruin other film so this process is reserved for the one roll or sheet you are processing.

Flashing is best accomplished with a 2-cell type "D" battery, flashlight with a filter or none at all held over the end for a period not to exceed 2 seconds else the film will go beyond reversal and just fog. The key to success is finding the right combination of time in the cycle and how much light and for how long a time. These are delicate decisions and a mistake one way or the other will result in ruined film.

I suggest you start with copy films, perhaps a single 4 × 5 sheet copied of a photograph from your walls. Then if you do ruin it you can reshoot. Once you have the right combination, write it down and from then on everything will fall in place.

It is characteristic of transparency processing that you can't tell if you have success until the film is in the final wash.

Another of my favorites is the processing of a

transparency to a *negative* rather than a positive. The resultant print is heavily saturated with color and extremely grainy. Quite artistic.

I use any of the Ektachromes in the roll, such as the Ektachrome Daylite High Speed ASA 160, or Ektachrome EX or the Ektachrome Type B. The ASAs must be increased else overdevelopment will render a negative too dense to print. I use EH Daylite at ASA 500 and process normally in either C-22 or Unicolor Negative Chemistry.

This results in an unmasked negative and slightly heavy, but printable. The prints are grainy with good even clumping, giving a stipple effect. Landscapes and buildings make beautiful prints.

People are not attractive in this type of photograph.

Many photographers are hesitant to *push the film in processing* for fear or two things: increased contrast and the color shift toward the green-blue. These are the problems and these are the results, however there are ways around them.

The increased contrast is caused by the agitation so we can control that by switching from a continuous agitation processing technique to a hand operation and slow the agitation down to one tilt per 30 second period.

The green-blue tendency; note I said: "tendency" because it is not always there. For instance, I have noticed that there is less shift with the slow agitation than with the reel type processor, but the best way to keep the green-blue under control is to extend the color developer time by 50%. (see chapter on Film Processing for stops and increase of time in first developer).

3M Color Key. You will find this mentioned in

(Advanced Printing Techniques chapter 40). Here is where you find out how to handle it. Color Key is a thin film produced in about a dozen colors but for our use we will concern ourselves with Red, Green, Blue, Cyan, Magenta and Yellow, and orange and black. The first three are our primaries and the second three the complimentaries also known as "process colors" by the printer.

Buy a "Rainbow Pack of 9×12 sized films. There are about 28 sheets with 4 of each color for a cost of about \$30. Buy at least three bottles of the developer. That is all.

The film is exposed in contact with either a black and white negative or a color transparency under a 650 watt quartz light for one minute. To change the time alters the density of the negative or positive. The film starts out a solid color, the more you expose it to light the more the emulsion will clear in development.

The exposure and the handling of the film can be done in subdued room light. Development is carried on in the light. The film is placed on a hard surface such as a turned over tray, with a cotton swab dipped in the developer, wipe the film all over on the emulsion side. The red emulsion (or whatever color) will rub off quickly in less than two seconds. The entire process is done in a minute. Rinse under running water and blot dry in a newspaper. It dries instantly. My turn-around time for exposing and processing including drying is five minutes.

If you make, say, three different color negatives from the same transparency, make them at different exposures, 30 seconds, 60 and 120 seconds, this will pick up and discard various tones. Try contacting one of the negatives, it doesn't matter which color, for

30 seconds and you will have a positive and a negative, each in a different color. I usually make three colors; Red, Green and Blue as I said before, 30, 60 & 120 seconds. I contact the 60 second Green onto Cyan, Magenta and Yellow, but don't change the exposure, make them all alike. (The Green onto the complimentaries is with a 30 second exposure.)

Now you have 6 pieces of film, three positive and three negative. Play with them on the light table and blow your mind. Try adding some to the original transparency and copy the effect. Instant creativity. You can even print them as negatives onto color paper. (See chapter 40 on Advanced Color Printing).

They can be printed separately, in combinations, with screens, with the original transparency, the black and white negative, or with an orange mask. Each and every effect is startling and different. The beautiful part is that it is fun, easy to do and relatively inexpensive. The most difficult part of the process is the exposing because of the high intensity of light needed. Although, 3M does make exposing units for sale, you could make your own. The film is sandwiched in contact with the 3M material and either placed in a print frame or under a heavy glass on a cushion backed up with black paper or cloth. The emulsion of the Color Key is in contact with your negative or positive.

The packages are also sold in individual colors and they do keep fairly well in the refrigerator, losing their strength in about a year. Learn which is the emulsion as you will be cutting it up to the size of your original and the notch in the upper right hand corner gets lost in the cutting. Be sure to buy negative-acting 3M Color Key, Rainbow Pack. Almost any graphic arts supply house should have it in stock.

39 Color Printing Techniques: Basic

Many photographers feel that the photograph isn't finished until the darkroom work, the printing, or whatever, is completed. I place myself in that category. This includes work done with transparencies as well as negative materials. I often do additional work in the darkroom such as changing the original color, adding a texture or even another image. Color printing includes an enormous number of miscellaneous techniques that can and do improve the final print.

Photographers who are in the business of photography and have a large amount of printing business such as the wedding photographers, school and prom photographers and the like would probably do better to use the services of the large color labora-

tories. When I say; "business of photography" I mean those engaged in mass production as opposed to "custom photography." Large volume printing requires a great deal of time, equipment and personnel and is generally not practical for the small studio.

Color printing has been around for many years but it is only in the years since 1955 that it has grown popular with the smaller professional and the advanced amateur. Using 1955 as a jumping off place, I would say this was the year that color printing became practical. At that time Eastman Kodak designed the old type "C" process of printing by either white light or tricolor printing. The tricolor method included three separate exposures through three filters; red, green and blue. This was cumbersome and difficult to gauge the exposures, requiring some degree of experience before you would arrive at a properly balanced print. The white light method used mixed filtration above the negative and a single exposure. Although the tricolor method yields a slightly cleaner color print, the white light method is easier to learn and more practical to use. This is the method in general use today.

The early papers were cloudy when the printing was slightly "off balance" but quite accurate when right on. The "milky" or "bluish" haze was apparent in all but the best prints. Fading was another problem; the dies simply weren't as stable as they might have been. The paper backing, a rag base as opposed to today's plastic base or "RC" (resin coated) papers, coupled with fibre destructive dyes made it difficult to sell knowing the paper would fade within a few years. This is the major reason why most manufacturers switched to the resin coated papers. These are akin to film and are a synthetic based material

with greatly increased dye stability. The clarity and brilliance of the color has been improved as general technology improved. Coupled with the improvements in films such as the Vericolor II negative material, the state of the art is that now the materials and processes are relatively easy to use, inexpensive and reasonably stable.

Kodak's first instructions were so stringent that many photographers were afraid to try the process. The need for accurate temperature and the hocus-pocus about the use of the filters made all but the daring blanch with fear. The advent of other manufacturers such as Agfa, Berkey, Beseler and Unicolor to name a few, have dispelled the vicissitudes and popularized color printing.

One argument was that only a large expensive machine could be used to process color prints, this sophistry scared off some otherwise brave souls. Instructions were so limiting with warnings that to deviate one iota would send the experimenter to purgatory.

Today the process is so simple that every hobbiest is turning out perfectly acceptable prints in his bathroom laboratory. For the beginner color printing is best done in either the new small rotating plastic drums or in plain old fashioned trays. Of the two I still opt for the trays. The trouble with the drum is that it must be cleaned but not dried after use and further, it can only process one print at a time or two at the most. Conversely, the trays need no rinsing or drying inbetween prints and more than one print may be processed at one time. Since it is usual to make a test print to check the "balance," washing and drying a drum to prevent contamination is needless labor. Trays need no such attention and are im-

mediately available. To make the process even more convenient, I use a tray rocker for agitation so that I may go back to the enlarger while the print is processing. This rocker is made by Rene Dugas of Taftville, Conn. 06380 and holds three 11 × 14 trays or two 16 × 20 trays and has a variable speed control. With a quart of developer in the 11 × 14 tray I can and often do process as many as twenty 8 × 10 prints, or ten 11 × 14 prints one after the other. I know of no other way to process as efficiently and economically as this.

How to start and with which filters has been and still is the problem with beginning color printers. In the early days, almost all printing required the use of an analyzer costing hundreds of dollars, and further, a course in how to run it before you could print successfully. These are still around and always will be. They have their uses, generally in the mass production laboratories, but there are many ways to solve the problem of getting a good first print without an expensive analyzer. One of the easiest is to use "test grids" made by Beseler, Mitchell or Unicolor. These are a series of miniature color printing filters in various combinations of magenta, cyan and yellow laid over the print. With the negative in the enlarger an exposure is made with an opal diffuser over the lens to "scramble" the light, and the grid placed in contact with the color printing paper. The print is then processed and compared with a sample gray card. The combination of magenta, cyan and yellow filters that yielded a gray color closest to the sample was the starting filter pack.

This was often the correct pack but more often a second print is required to refine the color, and a third to make a perfect print. Even the expensive

analyzer required a second and sometimes a third print. If the experience and judgment needed to operate the analyzer were applied to my system, it would obviate the need of the analyzer. And, I believe my way to be simpler and more accurate.

By trial and error, make one good print of each of the type of lighting you use, such as one daylight photograph outdoor, one daylight film indoors with strobe lighting, both of these using the Vericolor "S" or short exposure film balanced for daylight. Then make a photograph under quartz or incandescent light on Vericolor "L" emulsion negative film. Use the "grid" system to give you a head start on the trial and error prints if you wish. Now after the prints are dried make the color corrections for the second print using the Kodak Color Print Viewing Kit. Amateur or professional, this is still the best method of viewing corrections needed and finding color errors. Make the second print or more until you have worked out the random color fringes or until you are satisfied that you have a perfect print or so close to it that you know the next correction without making a print. Write the balances down for each of the common photographic situations. I assume that you now have as many as six different balances if you use sheet and roll films. This set of figures is your starting point in all future color printing and they should be written right on the box of color paper with a heavy marking pen for instance reference. It is true that these are not always accurate but I find them so close to the balance that they make the need for an analyzer a foolish expense. If you buy your film and paper in any sort of bulk, say a 50 sheet box of color paper and your film in packs of twenty, you will have less trouble with these test balances. I have often

opened a new roll of film, exposed, processed and gone directly to the correct balance in one print, but in general, I find that I can make a perfect print at any time by the third print. I have owned three types of analyzers in the past and I couldn't do much better.

This system coupled with the tray developing in the same room means that I can expose a print, develop it for three minutes, wash for forty-five seconds and after thirty seconds in the stop-fix, I can turn the lights on and see the color balance. If I need to make a further adjustment to the filtration, I need not complete the process thereby saving time and solution. I simply stop at the stop-fix check my balance, make the changes in filters and make another print. Tanks, drums and other processing paraphernalia require too much attention to cleaning, loading, wiping, drying and other nonsense to be practical.

I don't use a thermometer for processing prints since the ambient room temperature is about 77 degrees in my darkroom, I simply alter the enlarger time to suit the density of the print. It is not necessary to process at any one temperature, it is necessary to process with all solutions at the same temperature. This procedure eliminates the need for heating, cooling and all sorts of water jackets, prebaths and the like.

Back to the enlarger for a moment. Most color papers have a reciprocity problem. The best way to explain this is that below five seconds or above fifty seconds of exposure, the paper does not respond to the Color Printing filters (CP) *predictably*. The best exposure and the one used for testing is ten seconds; if you have to change the amount of exposure, use

the aperture of your enlarging lens. You should be able to make a print at ten seconds, with an f 11 stop if you have properly exposed a negative and properly processed the film. Slight variations are normal, but times below five seconds and above fifty are beyond the capability of the paper. The normal 8 × 10 print listed above would change if you were to want to make a 16 × 20. This is another reason for having the best enlarging lens you can afford. You would have to open up to f 5.6 or even f 4.5 with a large print and the depth would be just so-so with anything but a good apochromatic enlarging lens.

Color printing by the white light method requires some basic knowledge of the action of the filters on the paper. Again, it is not the scope of this book to be basic, but perhaps a few rules will be helpful as a refresher for the beginner.

All colors can be printed on the paper with just two filters; magenta and yellow. You must know something about the spectrum in order to understand how. As an example magenta light prints the color green on the paper; yellow prints blue; adding both magenta and yellow filters to the pack at the same time, mixes the light to a third color: red. (Yellow and magenta equal red). Red prints the color cyan on the paper and cyan is a mixture of blue and green. So you can readily see how cyan, green and blue are printed in the paper by using just the two filters, magenta and yellow in the filter pack or in the light path. So far I have been discussing the "adding" of magenta and yellow filters to the pack to create the color effects. Now, let's use the same two filters but *withdraw* them from the pack. This is possible since the neutral or starting pack is near the balance of 50 magenta and 50 yellow.

Withdrawing some of the magenta filtration from the pack lessens the amount of green color printed on the paper and in effect, prints the color magenta on the paper. This is a most important principle and must be understood.

Withdrawing some of the yellow filtration from the pack lessens the amount of blue color printed on the paper and in effect, prints the color yellow on the paper. So if you wish to print magenta, you lower the number of magenta filters in the pack; the same with the yellow filters if you wish to print yellow. Now withdraw both filters simultaneously and you are printing magenta and yellow on the paper. Magenta and yellow mixed are the color red. So to print red you withdraw both filters. All of this should be memorized. Now you can print three more colors; magenta, yellow and red for a total of six with the cyan, green and blue. Any mixture of those six print any color.

One last item about color basics; the filters have a density and adding or subtracting them from the light path alters your exposure time. The yellow filters have a negligible effect on the time but the magenta filters do make a large difference in time. About ten percent of the time for every ten value in Color Printing filters.

Photographers who sell to agencies, magazines, record album cover publishers, book publishers and greeting card publishers, have to shoot with original transparency material since this is customarily used for the finest reproduction of the printed photograph. Yet, the occasion often arises that a print is needed for one reason or another, in addition to the transparencies. To shoot color negatives at the same time is a nuisance and it destroys the continuity of

your work. Most photographers or art directors had to go to internegatives and have prints made from those for their purposes. This procedure was costly and time consuming.

For years Kodak had a product called "R" paper for making direct positive to positive prints from transparencies but it was never popular because of the poor quality and the processing time needed for successful printing. Even when completed properly, the prints weren't as good as the internegative to paper prints. All that has changed. Kodak's new paper called Ektachrome RC Paper, Type 1993 is highly successful either processed in their R-5 or R-500 chemicals although I personally like the Unichrome Kits PFS.

The process used to take an hour and now it is down to thirteen minutes and the prints are full scaled without the high contrast of the older papers and entirely suitable for reproduction. I use the Unicolor Drum for processing and find that I can make two 8 × 10s or one 11 × 14 for as little as four ounces of chemistry and once the paper is balanced for my enlarger, I can repeat or print any transparency once without resorting to test prints or trial balances.

What a blessing this process is — to be able to shoot my beloved transparencies and never have to worry about the need of negatives or internegatives and more important, to have the ability to make a high quality print in less time than it takes to make a print by any other process. I foresee portrait photographers shooting with transparencies which they will show as proofs and having prints made in their own labs from these originals. About the only fault I can find is that you absolutely must clean the slide or

transparency since the spots are not white on the prints, but black.

One other possible problem is in clear film areas such as skies, snow, sand and high key backgrounds. The film had better be clean since any mark will show and it is almost impossible to spot as well as the negative to paper process.

For the creative illustrator, this process is a Godsend since sandwiches, multiple images, screens, textures and all of the other goodies used in creative color printing can be done on this paper just as with others. In many ways it may even pay to show a print of a multiple image for an assignment rather than a transparency made on 6120 film. I know that there are many times when I need a print in addition to transparencies and this is the process I will use and have been using for the last few months. Investigate it if you have similar problems.

40 Color Printing Techniques: Advanced

Assuming you have some printing experience and at least know everything in the previous chapter, you're ready to take yourself out of the realm of the ordinary printer and move into the real fun of creative color printing.

Let's improve your color printing skills with such techniques as dodging and burning in; techniques that are common to the black and white printer but rare with the beginning color printer. Dodging is normally done with any opaque, flat material attached to a wire wand, usually a black piece of paper. In effect this is "waved" over the area you wish to hold back in printing, for a portion of the total exposure time. The technique is useful in opening up

blocked shadows. Heavy or lengthy dodging will obviously cause a shift in the hue or saturation of the color on the paper where dodged. If ten seconds prints a certain shade of blue on the paper and you dodge for six seconds, your blue will be forty percent lighter. The problem is compounded if you dodge over an area where the color is mixed; then all the colors desaturate, not always proportionately. More care must be taken when dodging in color; care in the design of the dodging tool is critical, and the length of time must be accurate. Dodging with color filters is possible and creates the opposite effect when used this way. A magenta dodger prints green on the paper at the same time it holds back some density. This is one way the creative printer either corrects or adds color to an area in the print. A green dodger will add magenta to a weak area.

Burning in is easier. Use an opaque piece of stiff card stock and make a variety of different shaped holes in the center and edges. A card about 8 × 10 inches with a half dozen odd shapes of about an inch in area would do nicely. There are some on the market similar to my description. The burner is held in the light path similar to the dodging method, but instead of blocking the light from a specific area, the odd shaped hole burns in or gives more exposure to the area over which it is held. Burning in is done after the first exposure is finished, where dodging is done while the first exposure is being made.

In both dodging and burning, the tool must be kept in motion to prevent a line or mark. The motion can be up and down in the light path or in a ring-around effect. For some types of burning in I like to use just my hands held together in such a way as to make a hole for the light path. This method allows

you to move quickly and to change the size of the hole momentarily.

Multiple printing is printing two or more negatives one after the other or simultaneously on the same piece of color paper. The simultaneous printing of two negatives usually yields a mish-mash of color and where the three color layers of one negative mix with the three colors of another, a muddy brown color appears in the print. This is called; "neutral density." A careful workman can combine two negatives in a "sandwich" if he has a negative where there is a clear area in one to match an image area in another; this is rare.

A better system would be to print one after the other as this approximates the effect of a camera double exposure photograph. Place the negative in the carrier and expose normally. Withdraw the first negative and replace with the second and make the second exposure. The result is often exciting, sometimes a mish-mash, again because of the neutral density created by the mixture of too many colors. A better way might be the double print.

Start with one negative and expose normally except that during the entire exposure dodge out the center with an opaque dodger. Feather the edges by vigorous up and down and side to side motions. After the exposure, replace the first negative with the second and during this exposure on the same piece of paper, reverse the procedure and use a burner using the same area as before. The effect will be of two images welded together with feathered edges. This is still crude and not a refinement. I call it a double print.

For a creative double print follow this technique: Make a test of the first negative holding back with a

dodger a section roughly three inches around. Mark the area on the test print with a black crayon and also place an old piece of paper in the easel and mark the same area on the back of it. You use this to line up the combination of a dodger and a burner. Now print the first negative somewhat lighter than normal holding back the area you want. Withdraw the first negative and place the second negative in the carrier and with the burner cast the image onto the old piece of paper with the line of the marker on it. Make sure the burner over-covers the area and when you have this position fixed in your mind, re-place the paper with your color paper with the first dodged image on it. Make the second exposure burn-ing in the center which is holding back the edges. Process and you should have a double print without marks of the dodging or burning. Refine the tech-nique until you can do it quickly. Changes can be made from one negative to another by raising or lowering the enlarger to alter sizes to fit your con-cept. Use an old paper box as a safe to hold the paper between lineups.

A refinement of the double printing method is the multiple printing system; difficult to all but the technician. This method is used to print one, two, three or even more Kodalith negative films of varied densities on one piece of paper but through two or more solid color filters. This process creates a multi-colored image in a form of posterization. It requires a registration negative holder so that one after an-other, negatives can be printed in register, each through a red, green and blue filter or any other for that matter. The effect on the paper is a vivid highly saturated color image, separated by the color and the films. If you use process filters you need not have an

orange mask. For other filters a mask can be made by processing an unexposed piece of Vericolor II film either roll or sheet. Any filter will give you colors with this system; the mask should be used above the films.

Printing is accomplished by printing successively through each of three filters changing the negatives for each filter.

An easier printing system that produces a print similar to the one mentioned above is to use 3M Color Key film without any filters. Make three or more negatives or positives on different color 3M Color Key. Sandwich these together in the negative carrier and make one white light print exposure using an orange mask above the films. 3M Color Key comes in many colors but I suggest using the six colors; blue, green, red, cyan, magenta and yellow.

Another of my favorite creative printing techniques is to place a color negative or a color transparency in the enlarger carrier and print through one filter of a full density. As an example, gather all the magenta filters and place them in the filter holder. No yellow or cyan filters are used. You would expect all this magenta to print pure green on the paper. Perhaps it would if you processed the print as it was exposed, but follow the process through. Assuming you placed 150 CP of magenta in the filter drawer, and exposed the print for 30 seconds at f11, you should have about the right formula. Place the print in the developer and develop for two thirds of the normal developing time in my case using Agfa Pa60 Developer, I would develop for two minutes since the formula calls for three minutes at 77 degrees or thereabouts. (I couldn't care less what the temperature is so long as it is between 70–85 de-

grees; I just alter the time of exposure). The print is now rinsed in a tray of water and pushed to the bottom of the tray. Using a two-cell flashlight with a green filter over the lens, wave this over the print as a reexposure of about three seconds. The distance should be about a foot away. Make sure the entire print is exposed to this green light. Replace the print in the developer and continue the development process to completion.

Now it is a characteristic of this step that the print will look very dark and muddy in the stop bath; disregard the color and continue to bleach and then wash. The colors will appear at the end of the final wash step, quite brilliant and heavily saturated.

Altering of the time at the enlarger and the time of reexposure materially alters the effect and the color. Changing filters will change the color, of course. Some filters are more successful than others. Using the two colors in the procedure above should guarantee you a good looking print.

Instead of a color negative, place a transparency in the carrier; the results will be astonishing. No mask is needed for a vibrant effect. I call this; "instant creativity." For another effect, try using one filter at the enlarger as above and no filter on the flashlight. Try less exposure at the flashlight if the print is muddy.

Certain attachments enhance the image on a color print. Probably the best and most useful I've ever owned is the *Mistmaker* made by Spiratone Inc. I mentioned this is Chapter 21, Special Effects Attachments where it is used to soften lines in portraits. It has a further use and most important at the enlarger stage. Held under the lens during the total or even partial exposure it eliminates blemishes and

wrinkles on portrait prints. Make no mistake, this is not a diffuser, the effect is that the sharpness is retained, but the skin is smoothed out. You must compensate for the color of the glass filter though, by five CP magenta since the glass is green. This Mistmaker is another of those rare pieces of equipment that are more useful than their price implies.

Another creative trick is printing with screens. The texture screen is placed over the paper in the easel, not in the carrier with the negative. The screens that I use are made by ByChrome Inc. They have literally over a hundred to choose from. I find the best for my needs to be first a 50% Mezzotint, then a Silk, Denim, Linen and a Cross Hatch. In using screens, the exposure is divided so that the first two thirds are with the screen over the color paper and for the final one third the screen is removed, else the print look too "screeny." Don't forget to make a compensation in the exposure for the screen. The screen should be in contact with the paper; preferably used in a vacuum easel. Incidently, ByChrome makes an inexpensive vacuum easel. If you don't have one, place the screen dull side toward the lens and smooth it out with the hands. Some effects are attractive, others useless; the screen having overpowered the image. My suggestion on the use of screens is to select strong powerful compositions without busy details. In portraits or groups of people the heads should be fairly large else the screens break it up.

Other attachments used over the camera lens can be used over the enlarger lens, such as the Centerspot and the various prisms. You will have to try all of them, some work well others not so well.

Black and white halftone negatives can be

printed in color by a process that is quite easy. Use an orange mask above the negative in the carrier and print with either a single filter or a combination.

Still another way to print color from a black and white negative is to make a high contrast halftone negative then print three exposures through three process filters, each exposure having twice the time of the previous one. The filters are red, green and blue. The effect is of tone separation colors. Each color will respond to its opposite in the paper.

Some other effects that deserve your attention are fun for an evening of experimentation. One of these is the zoom effect of raising the enlarger head during the exposure. Best results come when you make successive stops during the exposure much more effective than the smooth motor-driven enlarger head. The step effect definitely makes the photograph.

Sliding the easel during the exposure creates motion blurs that enhance otherwise dull sports images. Tilting the easel is another creative technique similar to "curving" the paper for a like effect. These are a few tricks of the creative color printer.

41 Color Printing Techniques On Films

The color enlarger is one of the most useful tools that a photographer can have. When used for its primary purpose, it performs well, but when used as a creative darkroom camera, which is what it really is, it has capabilities that are rarely explored. Because so few become involved with the enlarger on this basis, I decided that I'd list some of the ways in which I use this most creative tool in the hopes that photographer readers would catch my enthusiasm and experiment with some of the techniques.

We all know the "normal" use of the enlarger to make larger prints from small negatives. There are references to the enlarger in previous chapters; this chapter will list some I use.

Many of the assignments for national magazines require I make many pieces of films that I call "elements" (see Creative Color Photography book by the author). These elements are to be combined into a single sheet of film for submission to the art director. One of the staples of my studio is Ektachrome Duplicating Film #6120, a sheet film of extremely low contrast but a full scale of tones that is admirably suited for copying multiple images.

In practice, I usually load either a 4 × 5 or an 8 × 10 cut film holder with a sheet of 6120 on one side and a plain piece of white paper on the other. This holder with the white paper exposed is placed up against the back and left side of the easel for positioning. The white paper is a focusing point for the image. For exposure the holder is inverted and the slide pulled in the dark and the film exposed. That is a simple explanation, but from this beginning, refinements are made.

All of the techniques mentioned in the last chapter for advanced paper printing can be done with film; just substitute the word, "film" for "paper." All the zooming, sliding of the easel, use of texture screens, double printing, multiple printing, exposing through three color filters, using 3M Color Key instead of a negative and all the special effects attachments, all will work just as well on this film as it does on the paper.

This film requires an exposure of ten seconds, much more or less either way will cause reciprocity failure and yield unpredictable results, so once again, use the diaphram or aperture control on the enlarger. Ten seconds is a good time for dodging and burning; ten seconds can be split well for texture screen printing and it's perfect for tricolor printing.

Sometimes the easel is easier to use; especially when I have to use texture screens. I can't get the proper contact using the holders, so I use the film just as if it was paper and slide it into the easel groove then I tape the screens in place. All of this has to be accomplished in the dark, of course.

Processing of this film is easy and even shorter than other transparency material since the first developer time is shortened. Depending on what chemicals you are using, a ten minutes first developer time is shortened to six minutes. It is axiomatic that shorter developing times reduce contrast so this is the reason for that. The film is adjusted for the shorter time.

Submitting 8 × 10 films to art directors drives them bananas trying to figure out how you took that aerial view, but isn't that the name of the game? If you've ever been embarrassed when you submitted a 35mm slide with a bill for $500 then this film is the answer. Another reason that I like 6120 for copy work from a 35mm slide is that it gives me the opportunity to improve the original. I can change the color, enlarge a section, darken or lighten. And nothing looks quite so impressive as an 8 × 10 sheet film transparency. A recent assignment is worth the telling:

I was to supply a mood photograph of a dream sequence for an illustration for a story in Woman's Day magazine. The original was on 35mm exposed through a magnifying glass instead of a lens. The raw element was a good illustration in itself, but it lacked that special something that I like to think they pay me for. So I have colored screens with 50% dot structures, you might say these were colored texture screens; one each in magenta, cyan and yellow. I placed all three on a light table and taped them together so as to avoid moire patterning. In the dark,

I laid this "assemblage" over a piece of 8×10 6120 in the paper slot in the easel, and made the exposure. The effect was incredible.

Incidentally these screens were made by contacting the 50% mezzotint ByChrome screen onto three pieces of 3m Color Key. So simple yet so effective.

Sometimes I have a need for print films. These are positive color films from color negatives. They look like transparencies except that the borders are clear instead of black. Print films are useful to illustration photographers who submit transparencies but due to certain conditions had to shoot the assignment in negative film. Engravers or separators like to work from transparencies and I try to fullfill that request. I use negative material under mercury vapor lighting as one example. I find that with the filtration exposure and reciprocity problems of transparency material, it is easier to make as many corrections as I can at the shooting and then finalize or fine tune the color balance in the enlarger and expose onto 6120. This is especially true where I am making an interior view of a large factory, plant or mill. The filtration for mercury vapor is sometimes as high as 80 magenta and 60 blue. The density and the uncertainty of filtration make the use of negative color mandatory. Corrections this way are never as good as a properly corrected original transparency, but the present state of the art of copying is pretty close and in many cases it's an improvement of the original. Kodak's Ektacolor Print Film is a superior film used in the above connection and also to make enlarged transparencies of negatives. Another reason for this use is that all dodging, burning and other corrective procedures can improve the original.

Most photographers are not aware that both of

these two films have one color balance for all subjects. This means that once you have the balance for a standard test transparency or standard negative, that balance applies to all transparencies or negatives you wish to copy. The only variations being those you wish to make to alter the color for whatever reason. Kodak's balance sheet included with each box is quite accurate if you use their recommended lamps. If not, you will have to expose and process until you find the balance for your enlarger. I find it easy to do if you have a standard gray card negative and a positive, and keep a record of previous balances. The variation from box to box is negligible. Once the balance is found, it applies to everything you copy or print.

Internegatives are something else again. Kodak has a special process for use with this film. I send some out on rare occasions since I don't use their developing kit for this film. I find that about 95% of my need for internegatives are not critical so I make my own with Kodak's Vericolor II "L" film. I used to use the old Ektacolor "L" but the newer materials are finer grained and have a much better scale and hold the shadow detail well.

Using the same cut film holder technique outlined above, I over-expose and under-develop in order to cut the contrast. My development shortens the first developer from 3:15 minutes to 2:30. The internegatives yielded by using this film under the enlarger are as good as I have ever seen although I have not made extensive tests. I seem to satisfy myself and I find some of mine better than those I get from laboratories.

It is most important that the color enlarger be one that has an Ultra Violet filter (CP-2B) and an

Infra Red Cut Off Filter as well as a heat absorbing glass. Most really good color enlargers have all of these built into it. Mine is a Super Chromega Pro Lab with Dichroic color head.

Try to buy the film in 50 sheet boxes; 10's are too small, by the time you get the balance, you've used a few sheets and soon you have to start all over again. If you freeze it, it will last for years, don't pay any attention to the dating. Your only real problem is that Kodak will improve the film while you still have a large stock. This is one you will have to live with.

One of my all-time pet films is little known in this country but is sold in Europe and Canada: Agfacontour Film; the photographer's dream film, guaranteed to make you an instant graphic artist. Any continuous tone original black and white or color negative or positive film can be reproduced on this black and white film that has both line and continuous tone characteristics on the same sheet of film. These strange lines reproduced are called: "equidensities." I first came on this film when it was experimental in the mid sixties, used it, saw some of the graphic possibilities, and fortunately, bought heavily, but I am fast running out. It can't be purchased in the United States, but it is sold in Canada. The film uses a special developer of it's own. A one gallon developing kit and 25 sheets of the film might cost as low as $35 for the set.

Expose this as you would enlarging paper. To give you an idea of the basic exposure; I have used a Leitz Focamat 11 C as well as the Chromega and I like to use this enlarger for this film because the condensers give me a sharper, contrasty light. With the lens wide open the exposure is 100 seconds for the average black and white negative or a color

transparency. The average negative is right on that exposure but if by chance you need to double the exposure it doesn't work that way. The equivalent of double exposure is 10X or a 1000 seconds. No need to worry though, any exposure gives you an effect. The lower the exposure the more the film looks too "continuous tone" like. The higher exposures look closer to Kodalith line film. The only filtration is a yellow filter needed only if your original is too contrasty.

Development is in their developer for two minutes and you must use an acid rinse; fixing is twice the clearing time. What you get is a weird black looking piece of film with both line and half tones residing in a brownish color base. Print this on any color paper without a mask in the carrier but use any straight filter either in the filter drawer or under the lens. Use another filter at the developer stage and you will have one of those rare prints that are somewhere between posterization and a solarization. Check my previous book for samples of this system.

The enemy of all of these processes is dirt in the carrier or on the negative or transparencies, especially with multiple printing. Dirt or dust particles are everywhere and you no sooner clean the negative and place it in the carrier than you find more specks. I have tried everything and finally developed a procedure that is satisfactory to me. It's a pain, but it works.

I brush first with a camel's hair brush then I use the blower. (I have a compressor that supplies me with air and I have lines running into each darkroom). I clean the carrier and try to use glassless carriers as much as possible. Glass has the color of a green filter so every balance must be written for glass and glassless carriers. If I haven't got every bit of

dust out of the system I may have to resort to Edwal's No-Scratch, especially with small transparencies that have been used over and over again. This is a fluid applied with a small brush that comes with the bottle. I coat both sides of the film and of course, it must be used in a glassless carrier. Every darkroom has dust, those who are careful and are clean workmen have less trouble.

There is a type of carrier that is used by the big laboratories, called "oil immersion" carriers. These are air tight and glass bottomed. The transparency is floated in oil and a cover glass is placed over the top and held tight by the mouth of the enlarger, squeezing the oil onto a film covering both sides. Light passing through the oil and transparency refracts and the dust and scratches don't show on the projected image. The oil is wiped off after printing with no harm done to the transparency. It's a bit messy but it really works. Berkey Marketing Inc of Flushing N.Y. and Carlwen Industries of Rockville, Maryland are the two manufacturers.

The last but by no means the least of those techniques of printing on films is one that I devised from the old black and white trick of making photograms: the placing of objects on the paper, turning the enlarger light on without anything in the carrier and making a "shadowgraph" of the objects on the paper. This is then developed and fixed. These photograms are often used as an introduction to photography by grade school teachers.

By changing the process somewhat I have made and sold many exquisite pastel-like color photograms for stationery box tops, record covers and greeting cards.

Fix the enlarger so that the light covers an 8 × 10 cut film holder placed underneath and up against the

back and side of the easel. Color balance the light of the enlarger so that with no film in the carrier, the white light would print a pure gray. You should know the color balance of the enlarger anyway so make a test by printing on paper until you get a pure gray. It won't be accurate since the paper has a characteristic other than the film, but it will be near enough for this purpose. I use this balance sometimes when I am printing black and white negatives using pure filters under the lens.

As an example, my enlarger balanced by a Spectra Tricolor Meter is 150 yellow and 100 magenta. I use a Super Chromega with a Dichroic II head and quartz lamps. Yours might need a different filtration. Another hint is to balance the enlarger with an orange mask in position, but no negative. This is useful when using the 3M films and I wish to have the same response on the paper as is the film color. My enlarger balance is 60 yellow and 50 magenta.

Pull the slide on the 8 × 10 holder exposing the Ektachrome Type B film to the enlarger light, obviously, in the dark. Place the objects on the top of the film. Since you can't see what you are doing practice by taking two small rose buds for instance and in the light, try placing them with your eyes closed until you make a composition. In the dark, I feel for the edges of the holder, the rest is a guesstimate. The objects you select should have color, and an easily recognized shape; flowers are perfect for this process but again, they should be colorful and recognizable.

Process the film normally. The background will be white or clear and the colors will be reflected onto the film. The images are actually abstractions of the objects in delicate water colors. Quite artistic.

42 End Papers

Few photographers are well-to-do; those that are
didn't make it in photography; they either inherited
it; a patrimony we all wish for, or they married into it,
but that's rare. As to myself I never met any unat-
tached ladies of wealth. The point is, that if you pick
photography for a career, you pick a life of financial
struggle unless you make a big business out of photo-
finishing or develop a string of studios, but for the
average professional in the United States today, he
picked an impoverished way of life compared to most
other trades or professions.

Yet, each year so many switch from better pay-
ing jobs to be photographers. Why? why should
ordinarily intelligent human beings give up a decent

job, perhaps with a future—whatever that is—to become a photographer? Yet, they do, and in droves.

I know of one man who had a career in advertising and was well on his way to financial security when, quite suddenly, he quit to become a photographer. Another acquaintance was in publishing and yearned for the day when he could be released so he could enter photography. My courses often contain a photographer who has decided to switch horses as they say.

Sometimes I wonder if they're aware of what they're doing. I try to explain that if you set your heart on being wealthy, photography isn't the way to do it. Oh, of course, you can build up a business and become rich using photography as the business, but you cannot do this and actively practice photography, you're needed at the desk too much. When you run a business, you can't take photographs. The more employees you have, the more time you must devote to finding work for them. If you have employees you have to work for them at least two days a week and because you do employ people you must work for the government for at least one day. It is only when the concern becomes very large that you can get some freedom from the desk, but then, wouldn't you have been better off being an amateur instead of a psuedo- professional? At least the dilettante has the freedom to play the game of photography without the onus of having to make a living and doing what others wish him to do; take the photographs they want.

We've all been through the game of "empire building," I know I have. I had so many employees that I ran from job to job. I soon realized that I wasn't a photographer as much as I was a "timeographer" selling time; the photographs were the commodity.

The only real advantage to the big photographic business is the equity gained plus the fact that the business can be sold to someone else since it is the studio that has the identity, not the photographer. And, this is the very reason why I backed down to being the photographer. Then I achieved my identity.

We all love photography; and we're a heterogeneous group if there ever was one; we come from all kinds of trades and professions. Yet, we all have that one characteristic; a complete and consuming love of photography and everything connected with it. What is this fascination? What is the mystique? Just why do rational humans find photography so irresistible? Why should anyone knowingly give up the possibility of becoming rich to dedicate their lives to something so elusive, so vague and so hard to do, for the rest of their lives?

I think the answer lies first in the challenge that photography presents to the practitioner. The constant search for perfection; the need to satisfy the client whether it be a large corporation producing an ad, brochure or annual report, or a portrait of a child. Because the product cannot be seen photography becomes a service, but as soon as the photograph is visible then it becomes a product that someone has commissioned or purchased before it was manufactured.

Secondly, photography fulfills the need we all have for an ego boost. There's nothing so sweet as the pleasure of a happy client. Instant admiration is the reward of good photographs. And, it's repeated over and over again, each and every time you satisfy the customer you are complimented on your photographic ability.

These two psychological traits; the challenge and ego fulfillment definitely govern your decision

to become a photographer. Think of it, without challenge your character disintegrates; you become complaisant, lethargic and quite dull. You are interesting because of your intense drive toward some goal; without this interest you really aren't worth knowing. All of life is a challenge and we must constantly be challenged; haven't you noticed that when everything is easy, you become bored with it? As much as we think we might like to have everything handed to us on a silver platter, we really want to strive because *it is in the striving that we derive the most satisfaction*. Each little success spurs us on toward other goals. Each success reinforces your confidence in yourself. Without these little reinforcements and on a regular basis, you will collapse like a balloon. This is the real reason why so many choose photography.

Photography is unique in this respect since the photographic process is relatively short. The first step is conception, in good photography, uniquely the sole responsibility of the photographer. The processing and printing if a print is the result desired takes little time and the finished product is available for admiration within a days time.

Even the steps in between are rewarding. Processing to get a high quality negative or transparency yields an ego boost when achieved. The print, color or black and white is another source of reinforcement to the ego. Printing can be done over and over again relatively inexpensively until a well balanced print results.

The fact that these minor reinforcements are visible at early stages keeps the interest of the photographer from flagging. This "quickness" of the process is one of photography's biggest assets.

Another is the fact of completion. The finished photograph is an "entity", a completed piece of art or a product if you will. Whatever, it is finished and needs no long time consuming process to tire the worker or discourage him. You might call photography: "instant art." Therein lies another of photography's assets; it's akin to art. And, who doesn't like to be considered an artist? Since artists are notoriously penurious doesn't this give the poor photographer identification? His very impoverishment becomes a badge of respect. In a world where all are supposed to achieve goals, the photographer can relax; no pressure to aspire to financial success; no corporate structure to climb; his goals are achievable.

Interestingly, one need not be a professional to harvest this crop of psychological support. Anyone who practices photography and is successful is awarded the adulation of the populace. For the professional earning a living it is almost too good to be true. Most professionals; those who do their own work, reap this cornucopia daily. And for money yet!

What matters that sometimes you work day and night? What does it matter that you will never be a captain of industry? The key is to understand these considerations and live by and with them so that you will not be subject to the frustrations that plague others. Understanding your love of photography and the demands it places on your time, your interest and the very fibre of your soul is the key that will let you relax and enjoy your hobby or profession.

For those that use money as the gauge of worth, and this may be true of most of the world, every time you are paid for photographic work you have produced, you have a measure of your value. In many ways this is a false premise since the public is not

always the best judge of photographic excellence. Conversely, the photographic judges are not always the best judges either since a photograph besides being product is also a personal expression when properly done by an expert. But, money is a gauge to a degree and far be it from me to denigrate selling photography for money, especially since that is exactly what I do for a living.

Personally, I wish that all people experience the love that I have for photography. I would hope that photography as a profession grows in stature full realizing that it is the stature of the individual practitioner; how he is regarded by his fellow man, that determines his place in the community and his personal happiness with the profession of photography. For whatever reason one becomes a photographer, it is surely, a most rewarding profession or craft. May we all flourish and be able to work until the day we die.

The End

Sample

COMMERCIAL COLOR AND BLACK & WHITE PHOTOGRAPHS
(catalogue and product photography)

LOCATION OR STUDIO Color or
black & white

Each view with either a 4 X 5 color transparency or an 8 X 10 color print, or an 8 X 10 b&w print	first view	$90.00
ADDITIONAL views at the same time, b&w only		50.00
An 8 X 10 color transparency, original only	each	150.00
Mileage is charged, portal to portal		.25¢
STUDIO TIME, is charged in AD-DITION to the photograph price list, on a per hours basis		35.00

DUPLICATE PRINT PRICES,
BLACK & WHITE

8 X 10 glossy or matte single weight prints	each	4.00
11 X 14 glossy or matte single weight prints	each	9.00

DUPLICATE PRINT PRICES,
COLOR

8 X 10 glossy or matte color prints	each	15.00
11 X 14 glossy or matte color prints	each	25.00
16 X 20 glossy or matte color prints	each	60.00

MODELS

We maintain or own model file and can supply models to enhance catalogue and sales literature. Rates run from $60 per hour to $600 per day depending on the model and nature of use.

EXPENSES

Items such as props, tolls, cab fares, luncheons, dinners, motels air fares are properly the expenses of the client and are charged for at the prevailing rates.

(Effective January 19 – , subject to revision)

Sample

<u>THE DAY RATE</u>

The Day Rate is intended for certain specific situations and conditions. One is when the agency or client has a requirement for a large amount of photographs either in black & white or color and more important on location.

Generally, this type of rate pertains to the use of small cameras such as a 35mm or 6 × 7. The assignment might be an annual report, facilities brochure, photo-journalism or sales pieces.

Another type of situation might be the use of the large format camera such as a 4 × 5 or an 8 × 10 where all day is spent getting one photograph for an advertisement, and usually, on location.

Multiple large format photographs are properly priced on a per photograph basis using the Commercial Price List.

Both price lists consider expenses as the responsibility of the client. All labor, models and props are charged for separately.

Individual rolls of film, either negative or positive are charged for at the rate of $2.50 a roll. Processing unless done by the studio is charged for at the rate of $35.00 per hour or what ever the laboratory charges. The sleeved or mounted transparencies are the property of the client or agency. On negative color, contact proofs are made and retained by the client. Negatives are turned over to the client or printing is performed by the studio and the prints are charged using prices on the Commercial Price List.

It is not the policy of this studio to retain either negatives or transparencies of the client or agency—these are turned over to the client at the end of the job or payment of the invoice.

Photographs taken on location not pertaining to the client's needs at the time of the shooting are the property of the photographer.

Travel time is charged for at the rate half-day rate. In some cases where travel time is short, it is included in the day rate.

The day is considered to be from 8:30 A.M. to 5:00 P.M. or any reasonable eight hour period. Any day running from early morning until late evening is considered a day and a half. This is the only case where a half day is used. A half-day as such, cannot be ordered.

The Day Rate is priced at $600 per shooting day.

(Effective January 19—, subject to revision.)

Sample

NATURAL COLOR PORTRAIT PRICE LIST

This studio does not make the old-fashioned black & white portraits simply because natural color portraits are far superior both in photographic craftsmanship and in the ability to record a flattering likeness. Since the best way to judge natural color is from finished portraits, we do not supply or make proofs. The photographer may make a number of photographs, perhaps of different expressions, and in some cases, maybe different poses, but these are for his selection. Mr. _____ will select the best photograph of the subject, using his judgment. This will be hand-retouched and finished into the finest photograph that you can own or give as a gift.

The exquisite and delicate colors require the careful, considered selection of clothes. For this reason, we ask you to have a presitting conference with Ms _____, the stylist. Please call her at the studio for an appointment.

Because of the great deal of technique and artistry that's required, the minimum price for the first 8 × 10 photograph is $50. This is delivered to you in a beautifully designed mount, and is suitable for framing. Duplicate original photographs this size are priced at $35 each.

If you prefer our 16 × 20 Heirloom Portrait, tastefully framed, with a bronze viewing light and a brass name tag, it is reasonably priced at $250.

(Effective January 19—, subject to revision.)

NOTES

NOTES

NOTES